Walter Foster

COLLECTIBLES

How to Draw & Paint

Pin-Ups

& Glamour Girls

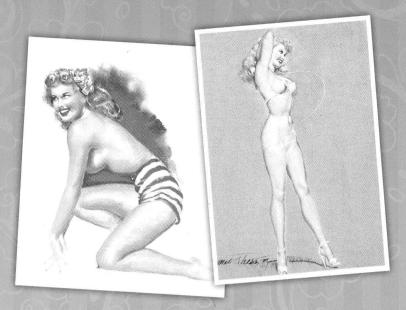

Associate Publisher: Elizabeth T. Gilbert
Project Manager: Rebecca J. Razo
Art Director: Shelley Baugh
Associate Editor: Emily Green
Production Designers: Debbie Aiken, Rae Siebels
Production Manager: Nicole Szawlowski
International Purchasing Coordinator: Lawrence Marquez

www.walterfoster.com
Walter Foster Publishing, Inc.
3 Wrigley, Suite A
Irvine, CA 92618

Printed in China.

1 3 5 7 9 10 8 6 4 2

Table of Contents

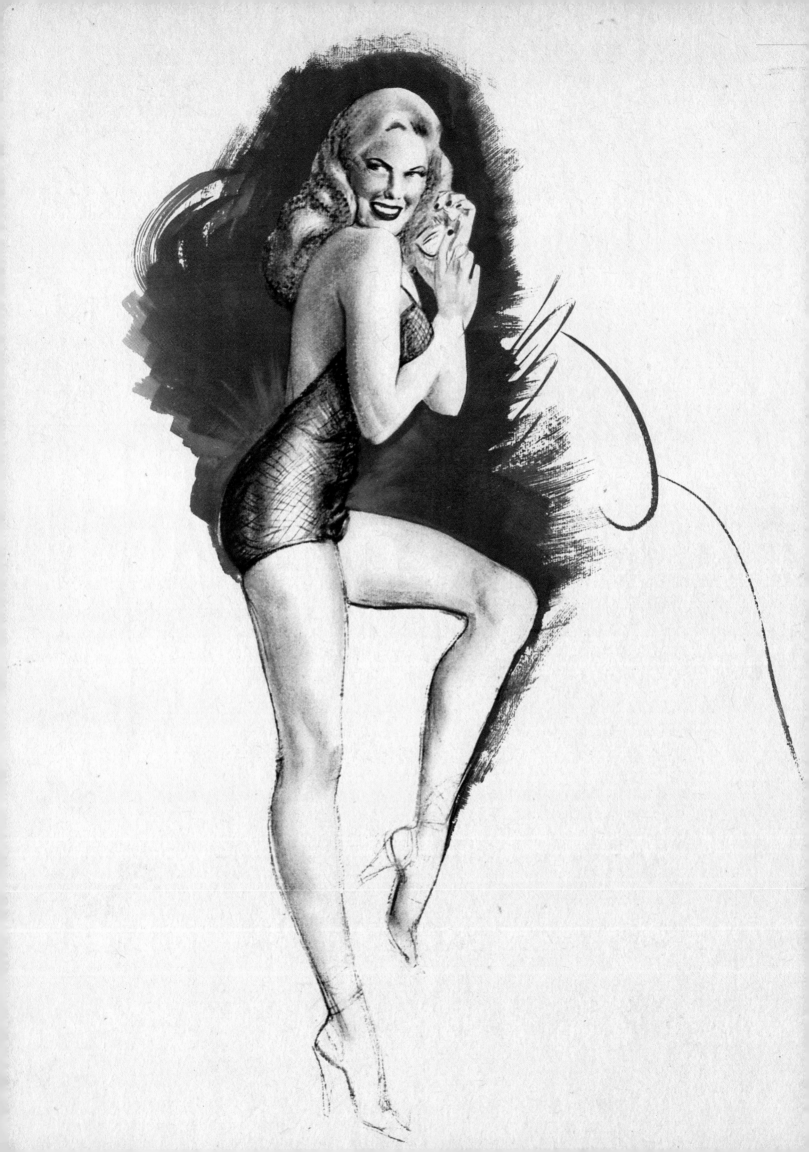

Chapter 1: Introduction

How to Draw & Paint Pin-Ups & Glamour Girls hails back to an era when Betty Grable set the standard for female beauty and Bettie Page set the standard for female allure. This extraordinary collection includes original art from a variety of vintage Walter Foster titles. From Earl MacPherson's quintessential pin-up girls to the classic nudes and faces of Fritz Willis to Russell Iredell's graceful female figures, you will learn to draw a range of subjects and portraits. Along the way, you will encounter a variety of art media, including pencil, pastel, oil paint, and watercolor. Packed with vivid artwork, professional art tips, and easy-to-understand drawing and painting instructions, this keepsake book is suited to artists of all levels—particularly those fond of art with a retro flair and nostalgic for simpler times gone by.

Tools & Materials

On the following pages, you'll learn all about the tools and materials you will need to begin drawing and painting the glamorous women featured throughout this book.

DRAWING SUPPLIES

Sketch Pads Sketch pads come in many shapes and sizes. Although most are not designed for finished artwork, they are necessary for working out your ideas.

Paper Drawing paper is available in a range of surface textures: smooth grain (plate finish and hot pressed), medium grain (cold pressed), and rough to very rough. Rough paper is ideal when using charcoal; smooth paper is best for watercolor washes. The heavier the paper, the thicker its weight. Thick paper is better for graphite drawing because it can withstand erasing better than thin paper.

Erasers There are several types of art erasers. Plastic erasers are useful for removing hard pencil marks and large areas. Kneaded erasers can be molded into different shapes and used to dab an area, gently lifting tone from the paper.

Tracing and Transfer Paper Tracing and transfer paper are used to transfer the outlines of a photograph or another work to drawing paper or canvas. You can purchase transfer paper that is coated on one side with graphite (similar to carbon paper).

Colored Pencils There are three types of colored pencils: wax based, oil based, and water soluble. Oil-based pencils complement wax pencils nicely. Water-soluble pencils have a gum binder that reacts to water in a manner similar to watercolor. In addition to creating finished art, colored pencils are useful for enhancing small details in a watercolor or pastel painting.

Drawing Pencils Artist's pencils contain a graphite center and are sorted by hardness, or grade, from very soft (9B) to very hard (9H). A good starter set includes a 6B, 4B, 2B, HB, B, 2H, 4H, and 6H. Pencil grade is not standardized, so it's best for your first set of pencils to be from the same brand for consistency.

- Very hard: 5H–9H
- Hard: 3H–4H
- Medium hard: H–2H
- Medium: HB–F
- Medium soft: B–2B
- Soft: 3B–4B
- Very soft: 5B–9B

Other Drawing Essentials Other tools you may need for drawing include a ruler or T-square for marking the perimeter of your drawing area; artist's tape for attaching your drawing paper to a table or board; pencil sharpeners; blending stumps, or "tortillons," to blend or soften small areas; a utility knife for cutting drawing boards; and an open, well-lighted work station.

OIL PAINTING SUPPLIES

Oil Paint There are several different grades of oil paint, including student grade and artist grade. Artist-grade paints are a little more expensive, but they contain better-quality pigment and fewer additives. The colors are also more intense and will stay true longer than student-grade paints.

Supports Oil painting supports usually consist of canvas or wood. You can stretch canvas yourself, but it's much easier to purchase prestretched, primed canvas (stapled to a frame) or canvas board (canvas glued to cardboard). If you choose to work with wood or any other porous material, you must apply a primer first to seal the surface so the oil paints will adhere to the support.

Fixative A fixative helps "set" a drawing and prevents it from smearing. Varnishes are used to protect paintings. Spray-on varnish temporarily sets the paint; a brush-on varnish permanently protects the work. Read the manufacturer's instructions for application guidelines.

Painting and Palette Knives Palette knives can be used to mix paint on your palette or as a tool for applying paint to your support. Painting knives usually have a smaller, diamond-shaped head; palette (mixing) knives usually have a longer, more rectangular blade. Some knives have raised handles, which help prevent you from getting paint on your hand as you work.

Brushes Painting brushes vary greatly in size, shape, and texture. The six brushes featured here are perfect for a beginning painter. To preserve the longevity of your brushes, always clean them thoroughly. Use turpentine to clean oil brushes, and use warm, soapy water for watercolor brushes. When not in use, store brushes flat or bristle-side up.

Other Oil Painting Essentials Other oil painting tools you may need include additives to thin out your paint (linseed oil) or to speed drying time (copal), glass or metal containers for additives, an easel, turpentine for cleaning your brushes, paper towels, and a mixing palette.

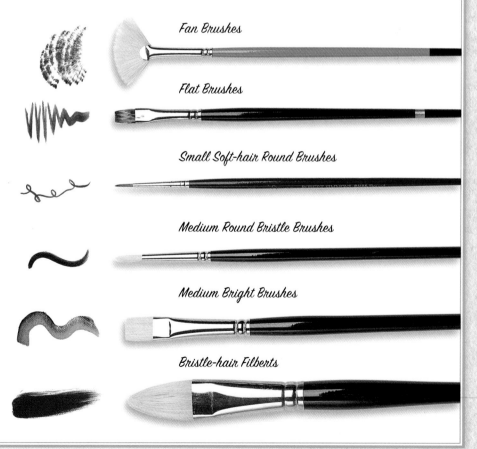

Fan Brushes

Flat Brushes

Small Soft-hair Round Brushes

Medium Round Bristle Brushes

Medium Bright Brushes

Bristle-hair Filberts

WATERCOLOR SUPPLIES

Purchasing Watercolors Watercolors are available in pans or tubes. Pans, which are dry or semi-moist cakes of pigment, are best for outdoor painting. Tubes contain moist, squeezable paint and are great for creating large quantities of color. Like oil paint, watercolors come in artist grade and student grade. Artist-quality paints are made with a higher ratio of natural pigments to binders, so they are generally more concentrated and brighter in appearance. Student-quality watercolors use more synthetic pigments or mixes of several types of pigments. These are fine for beginners, but you'll achieve greater quality with the higher-grade artist paint.

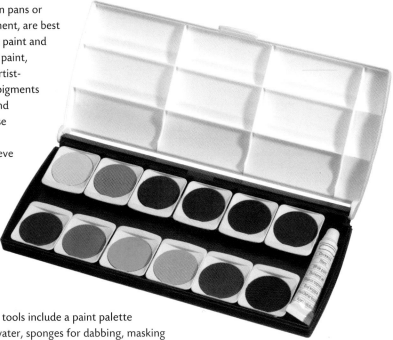

Each paint color usually has a lightfast rating of I, II, or III. This rating refers to how much a color will fade under sunlight. A rating of I is the most permanent and III is the least permanent. Some common colors, such as alizarin crimson, are known for fading; however, permanent substitutes are also available.

Other Watercolor Painting Essentials Other useful tools include a paint palette (porcelain or plastic both work well), a container for water, sponges for dabbing, masking fluid, paper towels, and artist's tape.

PASTEL SUPPLIES

Supports The texture and color of the support you choose will affect the outcome of your painting. Because of the delicate nature of soft pastels, you need paper that has some "tooth," or grain, for pigment to stick to. A rough support will "break up" the applied strokes and create texture. A smooth surface, such as paper especially for pastel or watercolor, will make the unbroken colors appear more intense. Pastel supports are available in a variety of colors. You can choose a color that offers a contrasting background tone or one that is in the same color range as your subject. For more on using colored supports, see "Working with Colored Supports" on page 17.

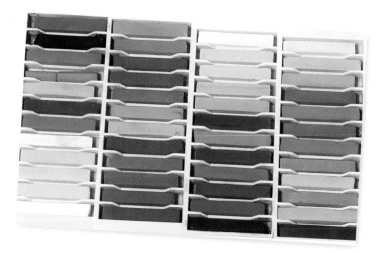

Purchasing Pastels Pastels come in several forms, including oil pastels; hard, clay-based pastels; and soft pastels, which are chalklike sticks. Soft pastels produce a beautiful, velvety texture and are easy to blend with your fingers, a chamois, or soft cloth. When purchasing pastels, keep in mind that colors are mixed on the paper as you paint; therefore, it is helpful to buy a wide range of colors in various "values"—lights, mediums, and darks—so that you will always have the color you want readily available.

Other Pastel Painting Essentials Other helpful tools include scissors to trim supports, vine charcoal to lay out designs, a sandpaper block to sharpen pastel sticks, a paper stump for blending, and a razor blade to break pastels off cleanly. You can also paint over your work with denatured alcohol on a soft brush to wash the color thoroughly into the paper.

Introducing Color Theory

Knowing a little about basic color theory can help you tremendously when painting in oil, watercolor, or pastel or when drawing with colored pencils. The primary colors (red, yellow, and blue) are the three basic colors that cannot be created by mixing other colors; all other colors are derived from these three. Secondary colors (orange, green, and purple) are each a combination of two primaries. Tertiary colors (red-orange, red-purple, yellow-orange, yellow-green, blue-green, and blue-purple) are a combination of a primary color and an adjacent secondary color.

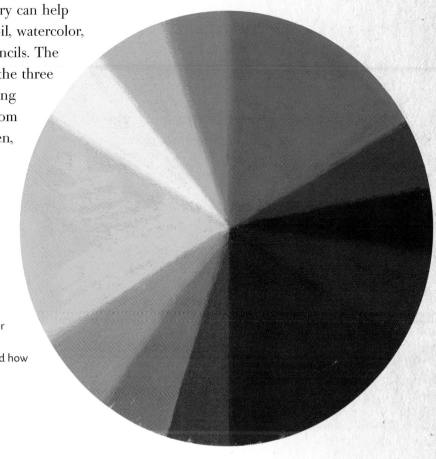

Color Wheel Knowing where each color lies on the color wheel will help you understand how colors relate to and interact with one another; it will also help you understand how to mix and blend your own hues.

Complementary Colors

Complementary colors are any two colors directly across from each other on the color wheel (such as red and green, orange and blue, or yellow and purple).

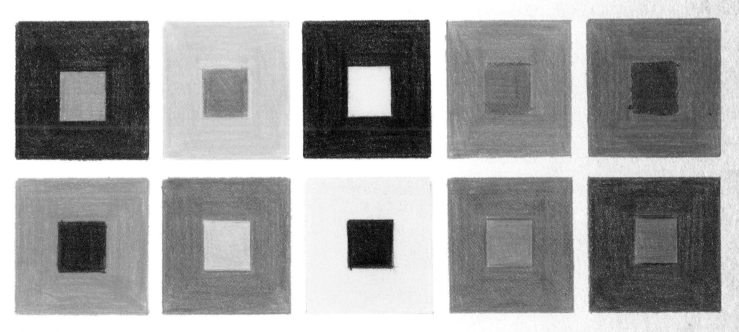

Using Complements When placed next to each other, complementary colors create lively, exciting contrasts. Using a complementary color in the background will cause your subject to "pop." For example, you could place bright orange poppies against a blue sky, or you could draw red berries amid green leaves.

Drawing Techniques

Drawing consists of three elements: line, shape, and form. The shape of an object can be described with a simple one-dimensional line. The three-dimensional version of the shape is known as the object's "form." In pencil drawing, variations in *value* (the relative lightness or darkness of black or a color) describe form, giving an object the illusion of depth. In pencil drawing, values range from black (the darkest value) through different shades of gray to white (the lightest value). To make a two-dimensional object appear three-dimensional, you must pay attention to the values of the highlights and shadows. When shading a subject, consider the light source, as this is what determines where highlights and shadows will be.

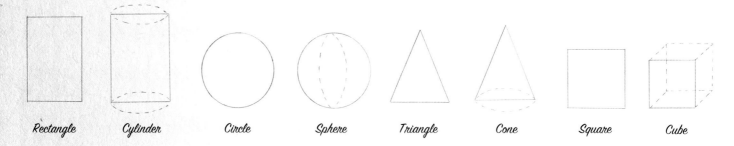

Rectangle Cylinder Circle Sphere Triangle Cone Square Cube

Moving from Shape to Form The first step in creating an object is establishing a line drawing or outline to delineate the flat area that the object takes up. This is known as the "shape" of the object. The four basic shapes—the rectangle, circle, triangle, and square—can appear to be three-dimensional by adding a few carefully placed lines that suggest additional planes. By adding ellipses to the rectangle, circle, and triangle, you've given the shapes dimension and have begun to produce a form within space. Now the shapes are a cylinder, sphere, and cone. Add a second square above and to the side of the first square, connect them with parallel lines, and you have a cube.

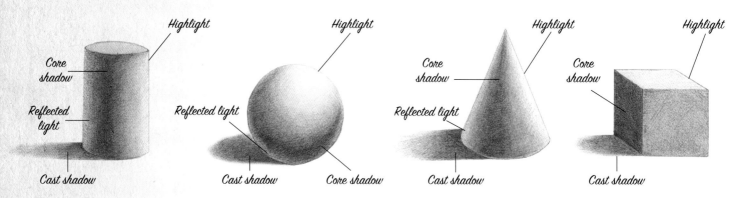

Adding Value to Create Form A shape can be further defined by showing how light hits the object to create highlights and shadows. Note from which direction the source of light is coming; then add the shadows accordingly. The core shadow is the darkest area on the object and is opposite the light source. The cast shadow is what is thrown onto a nearby surface by the object. The highlight is the lightest area on the object, where the reflection of light is strongest. Reflected light is the surrounding light reflected into the shadowed area of an object.

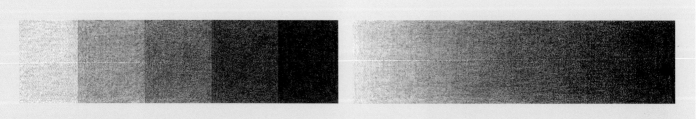

Creating Value Scales Just as a musician uses a musical scale to measure a range of notes, an artist uses a value scale to measure changes in value. You can refer to the value scale so you'll always know how dark to make your dark values and how light to make your highlights. The scale also serves as a guide for transitioning from lighter to darker shades. Making your own value scale will help familiarize you with the different variations in value. Work from light to dark, adding more and more tone for successively darker values (as shown above left). Then create a blended value scale (as shown above right). Use a tortillon to smudge and blend each value into its neighboring value from light to dark to create a gradation.

Practicing Lines

When drawing lines, it is not necessary to always use a sharp point. In fact, sometimes a blunt point may create a more desirable effect. When using larger lead diameters, the effect of a blunt point is even more evident. Play around with your pencils to familiarize yourself with the different types of lines they can create.

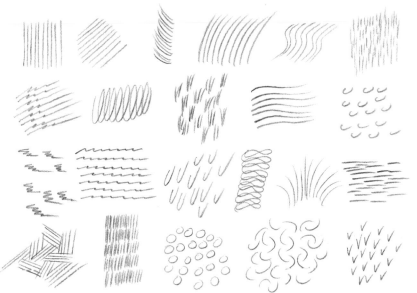

Drawing with a Sharp Point The lines at left were drawn with a sharp point. Draw parallel, curved, wavy, and spiral lines; then practice varying the weight of the lines as you draw. Os, Vs, and Us are some of the most common alphabet shapes used in drawing.

Drawing with a Blunt Point The shapes at right were drawn using a blunt point. Note how the blunt point produced different images. You can create a blunt point by rubbing the tip of the pencil on a sandpaper block or on a rough piece of paper.

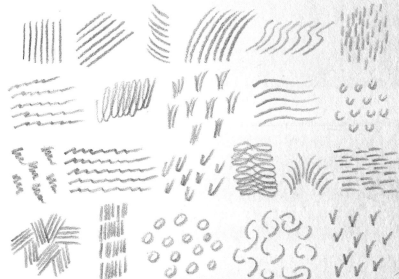

"Painting" with Pencil

When you use painterly strokes, your drawing will take on a new dimension. Think of your pencil as a brush and allow yourself to put more of your arm into the stroke. The larger the lead, the wider the stroke; the softer the lead, the more painterly the effect. The examples shown here were drawn on smooth paper with a 6B pencil, but you can experiment with rough paper for more broken effects.

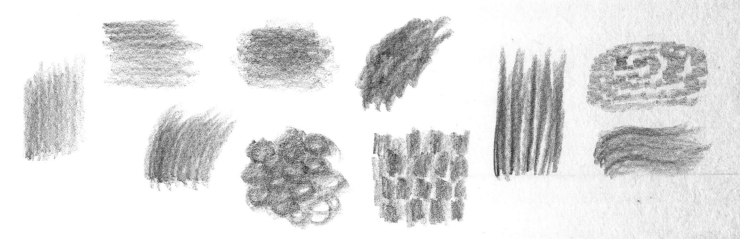

Oil Painting Techniques

Painting Thickly Load your brush or knife with thick, opaque paint and apply it liberally to create texture.

Thin Paint Dilute your color with thinner, and use soft, even strokes to create transparent layers.

Sponging Apply paint with a natural sponge to create mottled textures for subjects such as rocks, trees, or foliage.

Stippling For reflections or highlights, use a stiff-bristle brush and hold it very straight, bristle-side down. Then dab on the color quickly, creating a series of small dots.

Wiping Away To create subtle highlights, wipe paint off the support with a paper towel or blot it with tissue. To lighten the color or erase mistakes, use a rag moistened with thinner or solvent and then wipe away the paint.

Blending Lay in the base colors, and lightly stroke the brush back and forth to pull the colors together. Don't overwork the area, as overblending can muddy up the color and erase the contrasts in value.

Drybrush Load a brush, wipe off excess paint, and lightly drag it over the surface to create irregular effects.

Scumbling Lightly brush semi-opaque color over dry paint, allowing the underlying colors to show through.

Colored Pencil Techniques

Painters mix their colors on a palette before applying them to the canvas. With colored pencil, mixing and blending occur directly on the paper. With layering, you can either build up color or create new hues. To deepen a color, layer more of the same over it; to dull it, use its complement. You can also blend colors by burnishing with a light pencil or using a colorless blender.

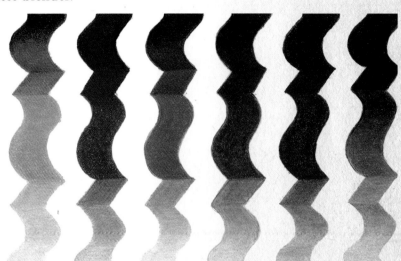

Tints, Shades, and Tones Colors can be tinted with white to make them lighter, shaded with black to make them darker, or toned with gray to make them more muted. Here each color was applied using graduated pressure—light, then heavy, then light. Black was applied at the top and white at the bottom to tint and tone the colors, respectively. To tint a color without muting it, apply the white first and then the color.

Layering Layer one color directly over the other to blend them together. This can be done with as many colors as you think necessary to achieve the color or value desired. The keys to this technique are to use light pressure, work with a sharp pencil point, and apply each layer smoothly.

Burnishing with a Colorless Blender Burnishing is a technique that requires heavy pressure to meld two or more colors together for a shiny, smooth look. Using a colorless blender tends to darken the colors.

Burnishing Light Over Dark You can burnish using light or white pencils. To create an orange hue, apply a layer of red and then burnish over it with yellow. Place the darker color first; if you place a dark color over a lighter color, the dark color will overcome the lighter color, and no real blending will occur. Try not to press too hard on the underlayers of the area you intend to burnish; if you flatten the tooth of the paper too soon, the resulting blend won't be as effective.

Optical Mixing In this method, the viewer's eye sees two colors placed next to each other as being blended. Hatch, stipple, or use circular strokes to apply the color, allowing the individual pencil marks to look like tiny pieces of thread. When viewed together, the lines form a tapestry of color that the eye interprets as a solid mass. This is a lively and fresh method of blending that will captivate your audience.

Watercolor Techniques

Transparent watercolor relies on the white of the paper and the translucency of the pigment to communicate light and brightness. A well-painted watercolor seems to glow with an inner illumination that no other medium can capture. The best way to make your paintings vibrant and full of energy is to mix most of your colors on the paper while you are painting the picture. Although it seems counterintuitive to what you may have been taught, allowing the colors to mix together on the paper, with the help of gravity, can create dynamic results. It is accidental to a certain degree, but if your values and composition are under control, these unexpected color areas will be successful and exciting.

Wet on Dry

This method involves applying different washes of color on dry watercolor paper and allowing the colors to intermingle, creating interesting edges and blends.

Mixing in the Palette vs. Mixing Wet on Dry
To experience the difference between mixing in the palette and mixing on the paper, create two purple shadow samples. Mix ultramarine blue and alizarin crimson in your palette until you get a rich purple; then paint a swatch on dry watercolor paper (near right). Next paint a swatch of ultramarine blue on dry watercolor paper. While this is still wet, add alizarin crimson to the lower part of the blue wash, and watch the colors connect and blend (far right). Compare the two swatches. The one at the right uses the same paints but has the added energy of the colors mixing and moving on the paper.

Variegated Wash

A variegated wash differs from the wet-on-dry technique in that wet washes of color are applied to wet paper instead of dry paper. The results are similar, but using wet paper creates a smoother blend of color. Using clear water, stroke over the area you want to paint and let it begin to dry. When it is just damp, add washes of color and watch them mix, tilting your paper slightly to encourage the process.

Applying a Variegated Wash After applying clear water to your paper, stroke on a wash of ultramarine blue (near right). Immediately add some alizarin crimson to the wash (right center), and then tilt to blend the colors further (far right). Compare this with your wet-on-dry purple shadow to see the subtle differences caused by the initial wash of water on the paper.

Wet into Wet

This technique is like the variegated wash, but the paper must be thoroughly soaked with water before you apply any color. The saturated paper allows the color to spread quickly, easily, and softly across the paper. The delicate, feathery blends created by this technique are perfect for painting skies. Begin by generously stroking clear water over the area you want to paint, and wait for it to soak in. When the surface takes on a matte sheen, apply another layer of water. When the paper again takes on a matte sheen, apply washes of color and watch the colors spread.

Painting Wet into Wet Loosely wet the area you want to paint. After the water soaks in, follow up with another layer of water and wait again for the matte sheen. Apply ultramarine blue to your paper, both to the wet and dry areas of the paper. Now add a different blue, such as cobalt or cerulean, and leave some paper areas white (far left). Now add some raw sienna (left center) and a touch of alizarin crimson (near left). The wet areas of the paper will yield smooth, blended, light washes, while the dry areas will allow for a darker, hard-edged expression of paint.

Glazing

Glazing is a traditional watercolor technique that involves two or more washes of color applied in layers to create a luminous, atmospheric effect. Glazing unifies the painting by providing an overall underpainting (or background wash) of consistent color.

Creating a Glaze To create a glazed wash, paint a layer of ultramarine blue on wet or dry paper (near right). After this wash dries, apply a wash of alizarin crimson over it (far right). The subtly mottled purple that results is made up of individual glazes of transparent color.

Charging In Color

This technique involves adding pure, intense color to a more diluted wash that has just been applied. The moisture in the wash will "grab" the new color and pull it in, creating irregular edges and shapes of blended color. This is one of the most fun and exciting techniques to watch—anything can happen!

Creating a Charged-In Color First apply a wash of phthalo blue (far left); then load your brush with pure burnt sienna and apply it to the bottom of the swatch (left center). Follow up with pure new gamboge on the opposite side, and watch the pigments react on the paper (near left). Pigments interact differently, so test this out using several color combinations.

Pastel Techniques

Applying Unblended Strokes In this example, magenta is layered loosely over a yellow background. The strokes are not blended together, and yet from a distance the color appears orange—a mix of the two colors.

Blending with Fingers Using your fingers or the side of your hand to blend gives you the softest blend and the most control, but be sure to wipe your hands after each stroke so you don't muddy your work.

Blending with a Tortillon For blending small areas, some artists use a paper blending stump, or tortillon. Use the point to soften details and to reach areas that require precise attention.

Using a Cloth For a large background, it is sometimes helpful to use a cloth or a paper towel to blend the colors. To lighten an area, remove the powdery excess pastel by wiping it off with a soft paper towel.

Removing Pigment When you need to remove color from a given area, use a kneaded eraser to pick up the pigment. The more pressure you apply, the more pigment will be removed. Keep stretching and kneading the eraser to expose new, clean surfaces.

Creating Patterns To create textures or patterns, first lay down a solid layer of color using the side of the pastel stick or pencil. Then use the point of a pastel pencil to draw a pattern, using several different colors if you wish.

Using Tape You can create straight, even edges by using house painter's tape. Just apply it to your support, and make sure the edges are pressed down securely. Apply the pastel as you desire, and then peel off the tape to reveal the straight edges.

Gradating on a Textured Support Creating a smooth, even gradation on a textured ground can be a little tricky. Add the colors one at a time, applying the length of the stick and letting it skip over the texture of the paper by using light pressure.

Glazing Create a "glaze" just as you might with watercolor by layering one color over another. Use the length of the pastel stick with light pressure to skim over the paper lightly. The result is a new hue—a smooth blend of the two colors.

Mixing Colors

Although it is more convenient to have a wide range of colors and values in your pastel set, you can mix additional colors directly on your support by layering and blending your soft pastels. The samples to the right demonstrate various ways you can mix colors on your paper. You can blend the strokes thoroughly to create a solid area of smooth color, or you can leave visible strokes of various hues if you want more texture.

Smooth Blend Here side strokes of yellow are layered smoothly over blue to create a bright green, which has more life and interest than a manufactured green.

Unblended Strokes Choppy, unblended strokes of yellow and blue create the impression of green. Instead of blending the colors on the paper, the eye visually mixes them.

Three Color Mixes Here strokes of lavender and turquoise are layered over blue. This creates a richer color than does a mix of just two colors.

Working with Colored Supports Here you can see how the color of the paper affects the same flower image. On the beige paper, the dark center has the greatest visual impact; on the gray paper, the green stem has less strength; and on the black paper, the contrasts are very striking.

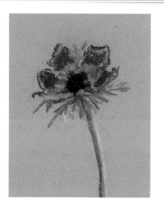
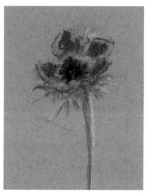
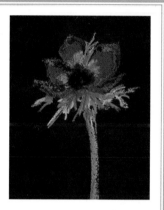

Applying Fixative

Because soft pastels have less binder than hard pastels, they crumble easily, and your finished work can be smudged. Many artists use some type of spray-on sealer or fixative to set their work and prevent it from smearing. (See "Fixing, Stage One" and "Fixing, Stage Two" below.) Some artists don't fix their paintings because they don't like the way the varnish affects the quality of the pastel. Instead they preserve the artwork by keeping the layers of pastel very thin as they paint. Then they tap the support several times so that the excess pigment falls off. To preserve your painting, you may want to have it double-matted and framed under UV light-protected glass. A pastel painting that's properly mounted on archival paper will last for centuries.

Fixing, Stage One To determine whether the fixative you have will adversely affect the colors, test it first by laying down a thick layer of pigment on a piece of pastel paper.

Fixing, Stage Two Spray the piece with an even layer of fixative. If the color stays true, you can varnish your work as you go, painting over each fixed layer without the risk of smudging.

Sharpening Pastels A sandpaper block is a good sharpening tool for both charcoal and pastel. You can also hone pastels with a razor blade, but rubbing the stick gently across sandpaper or another rough-grained surface is a safer way to form a point or chiseled edge.

17

PIN-UP ART

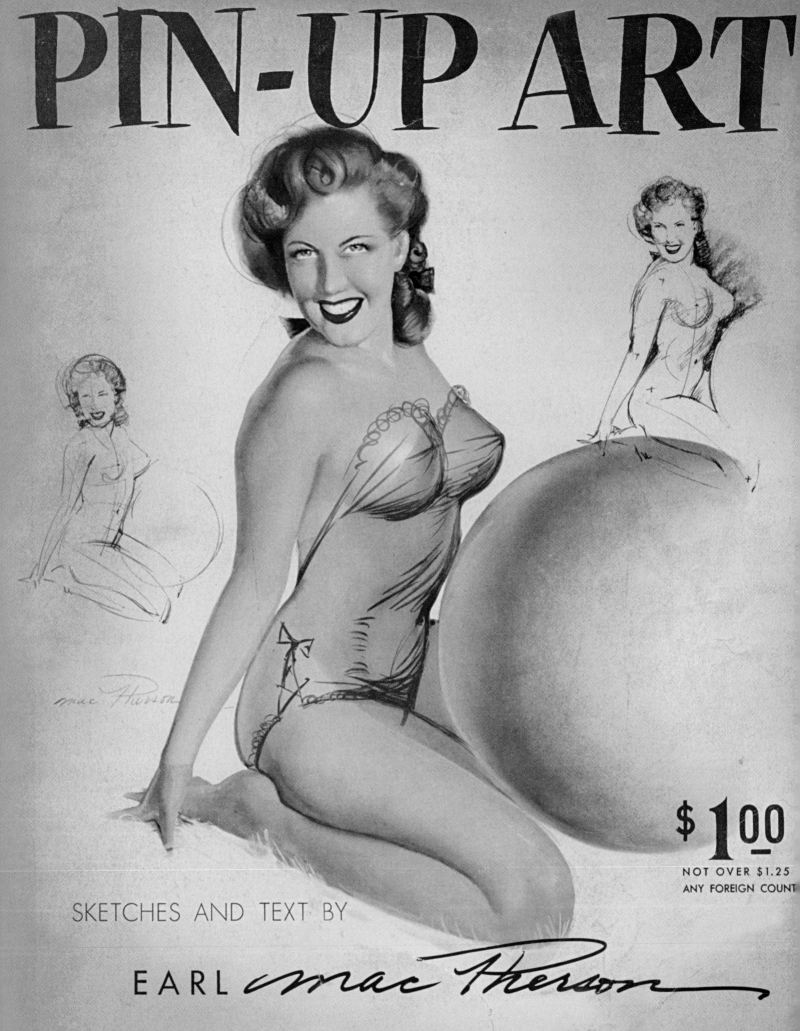

$ **1**⁰⁰

NOT OVER $1.25
ANY FOREIGN COUNT

SKETCHES AND TEXT BY

EARL *mac Pherson*

HOW TO DRAW AND PAINT BEAUTIFUL GIRLS

A WALTER T. FOSTER PUBLICATION

Chapter 2: Pin-up Art

with Earl MacPherson

Pin-up art is one of the few true American art forms. It is a fine art that first gained widespread popularity through extensive publication in the magazine, calendar, and advertising worlds. The term "pin-up" became popular during World War II, as servicemen sought to brighten their otherwise dreary surroundings with color illustrations of beautiful girls. Unlike figure painting, where artists concentrate on defining the body's muscle and bone structure, the pin-up artist paints idealistic renderings of the beautiful and the glamorous. I have tried to excel in this art by giving my sketches a very lifelike quality both in facial expression and figure delineation. In this chapter, I have tried to instruct through my sketches and paintings, rather than through lengthy copy. It is helpful to pay particular attention to proportion, the gracefulness of the poses, and my techniques of rendering, whether the art is in black and white or color.

—Earl MacPherson

Choosing the Model

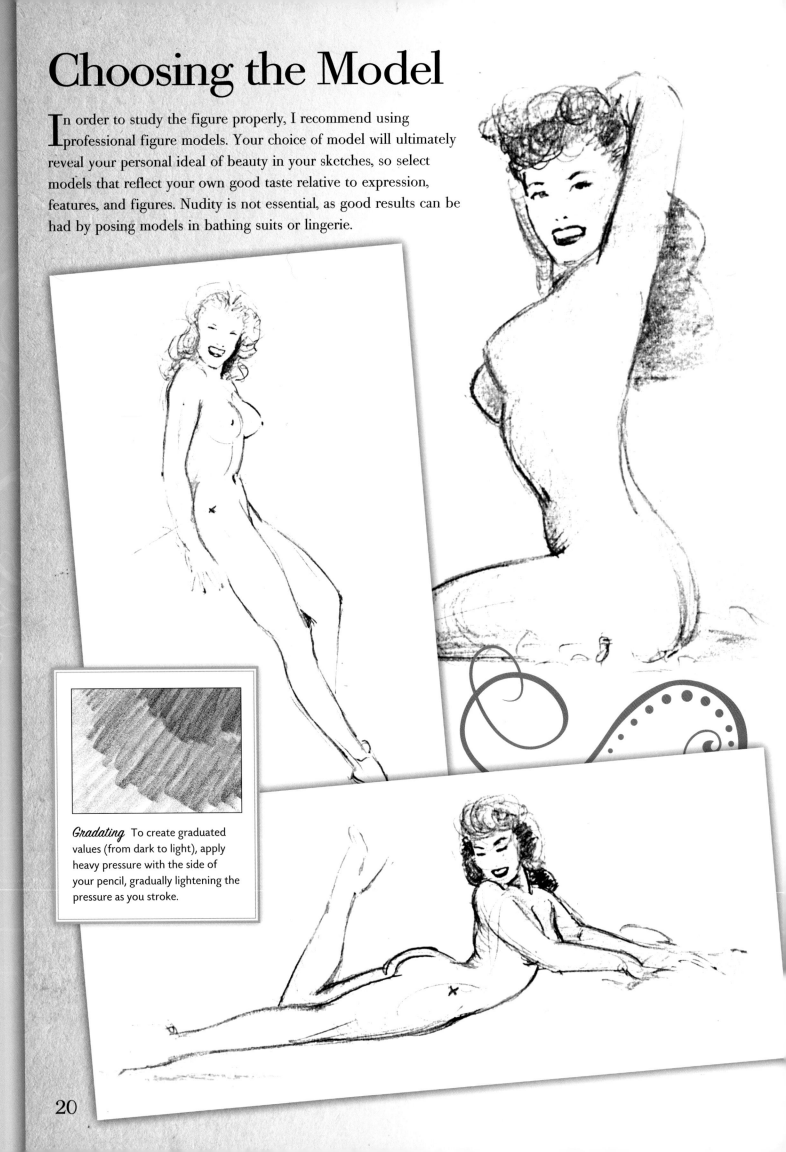

In order to study the figure properly, I recommend using professional figure models. Your choice of model will ultimately reveal your personal ideal of beauty in your sketches, so select models that reflect your own good taste relative to expression, features, and figures. Nudity is not essential, as good results can be had by posing models in bathing suits or lingerie.

Gradating To create graduated values (from dark to light), apply heavy pressure with the side of your pencil, gradually lightening the pressure as you stroke.

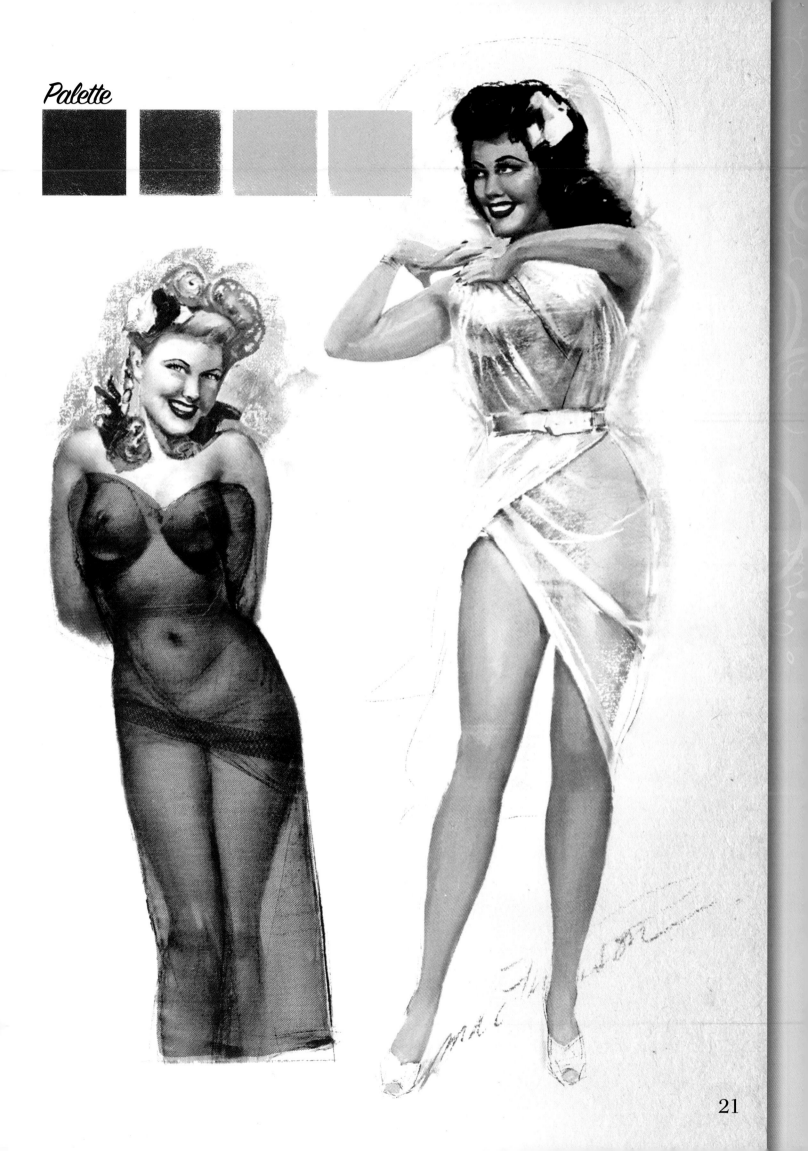

Basic Poses

Position the model in one of the basic poses shown on the opposite page, which were rendered with charcoal on white paper. Allow anywhere from 5 to 30 minutes per pose. With the model in position, check your lighting to ensure that you have the same amount of illumination from head to foot. Natural light is best. If you do not have access to a model, use a sheet of tracing paper and a photograph of your choice for overlay sketching, using the sketches on opposite page as a guide. You will get quick results and begin to develop a sense of the proportion and techniques involved in creating pin-up art.

Blending To smooth out the transitions between strokes, gently rub the lines with a tortillon or tissue.

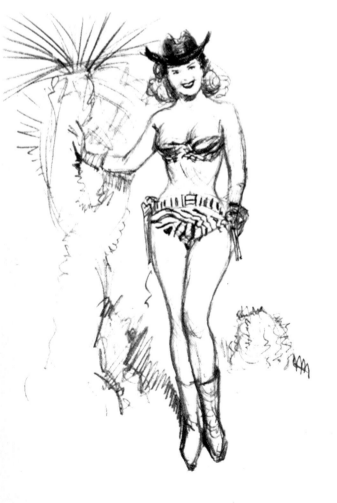

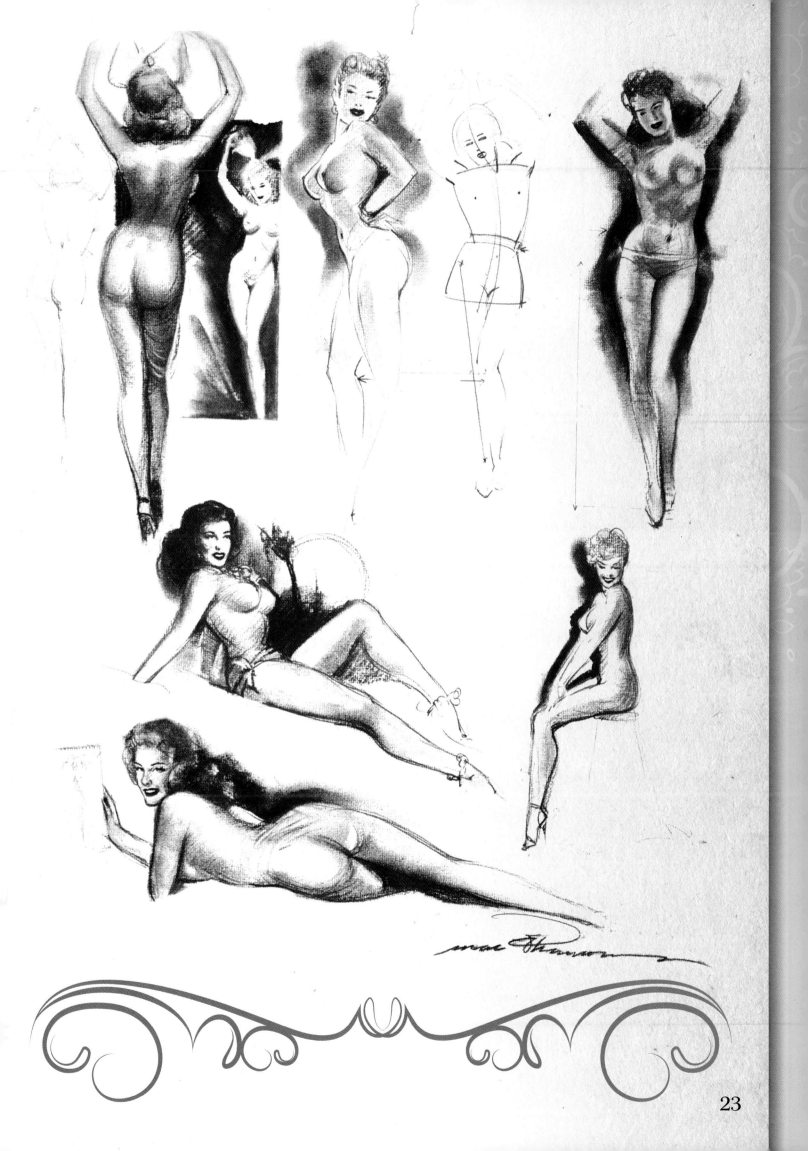

Standing

These sketches were rendered on smooth-surface sketch paper using a 5B lead pencil with an HB for the details. Balance, action, and idealized proportion are the points to watch here. On the opposite page, note the rhythm and lines of balance in the front view, as well as the three-quarter angle of the chest and torso in the side view, which helps accentuate the curves. Develop a sense for posing the model in ways that flatter her best points.

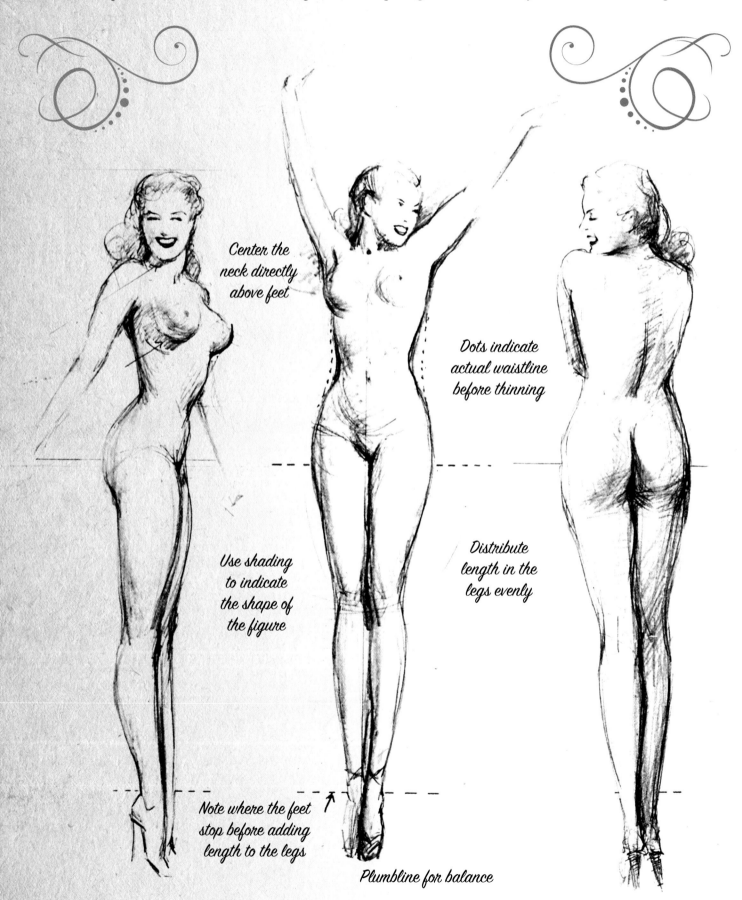

Center the neck directly above feet

Dots indicate actual waistline before thinning

Use shading to indicate the shape of the figure

Distribute length in the legs evenly

Note where the feet stop before adding length to the legs

Plumbline for balance

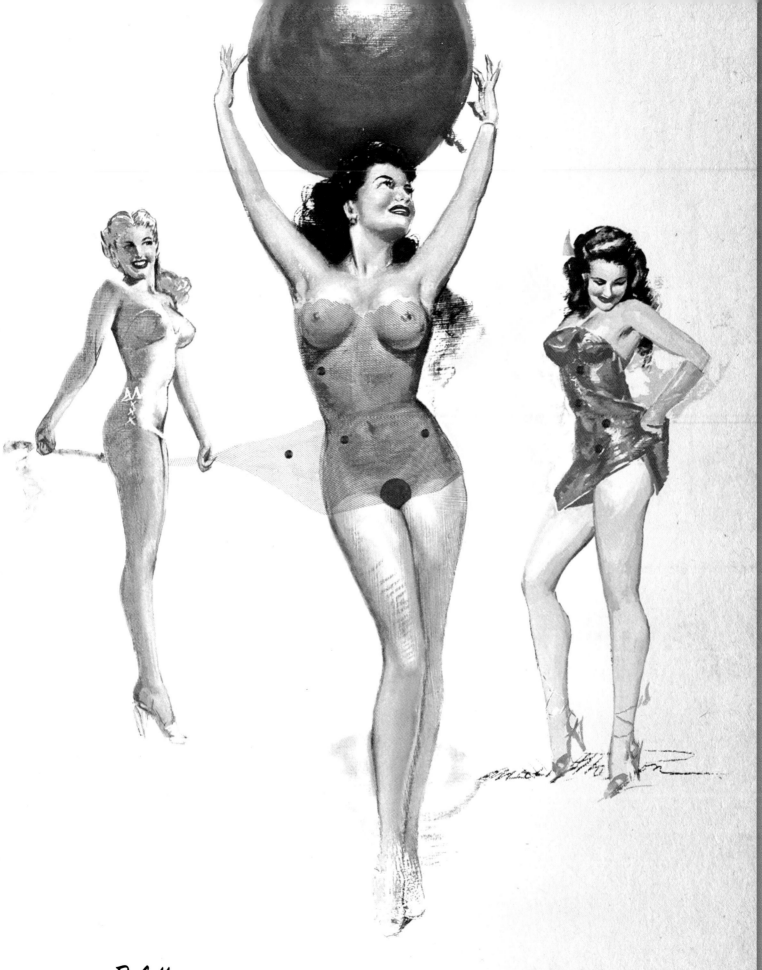

Palette

Sitting

The seated pose is easiest for the model to hold and offers many possibilities for expression. Props, such as those shown on the opposite page, can add to your drawings and paintings and give the model an atmosphere for her poses. Flowers, leis, hula skirts, jewelry, and drapes can add a bit of color and also help pose the hands.

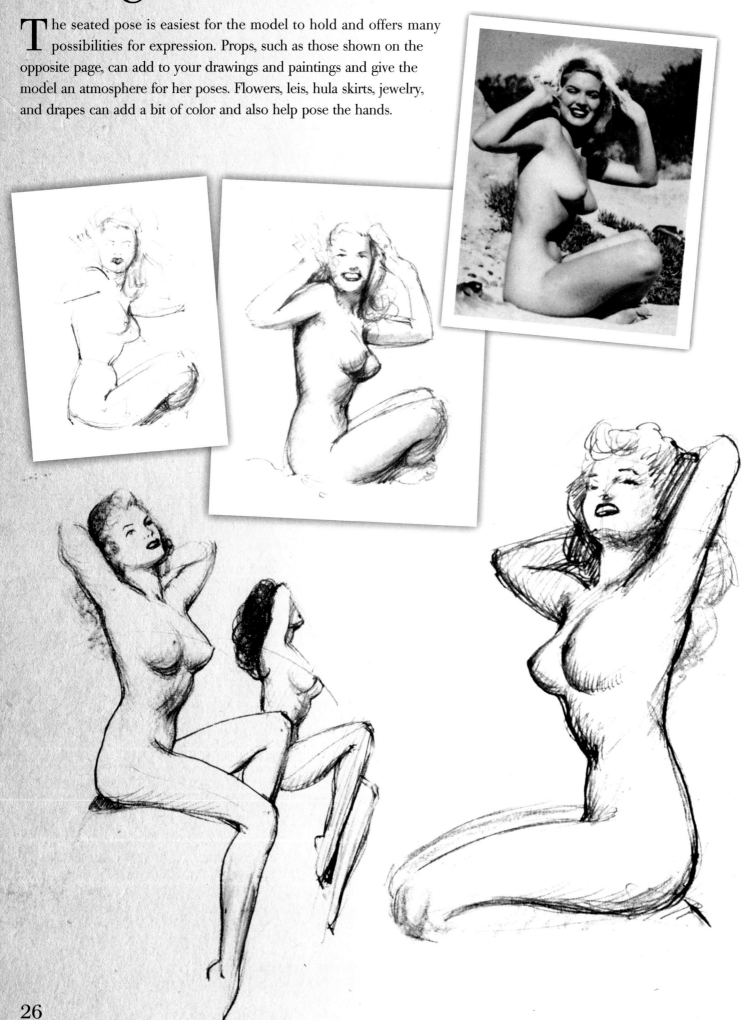

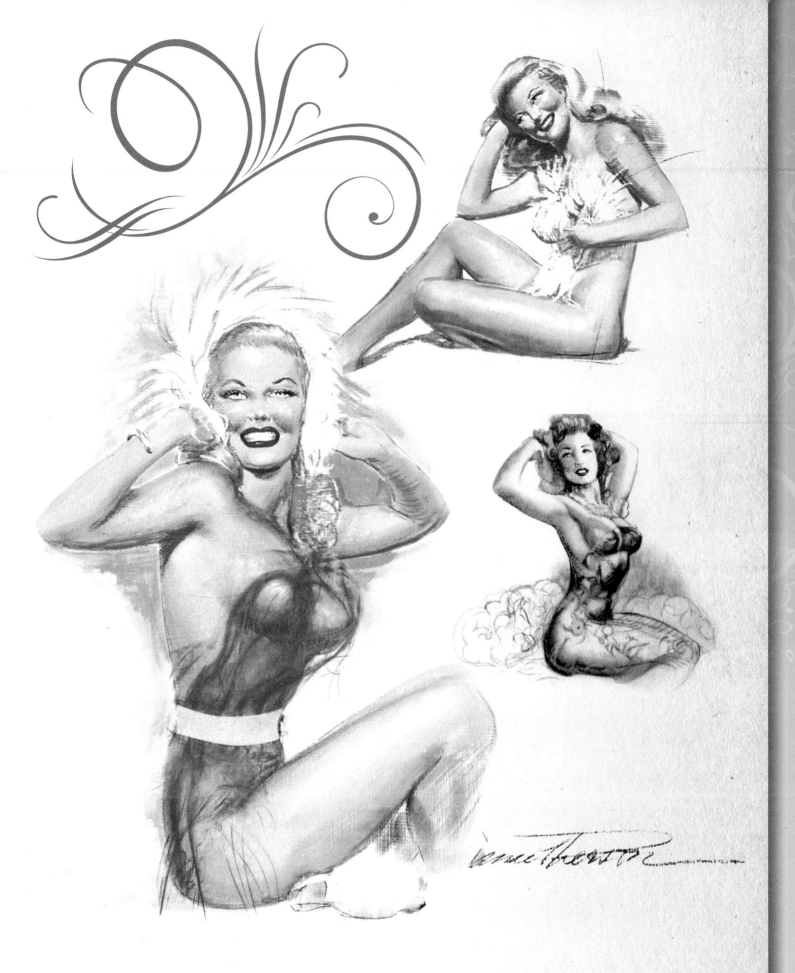

Palette

Kneeling

The kneeling pose is another popular position for the pin-up model. When drawing a model in the kneeling pose, begin by blocking in the large areas first before moving on to establish an expression and a theme. Don't forget to use shading to give the figure its form.

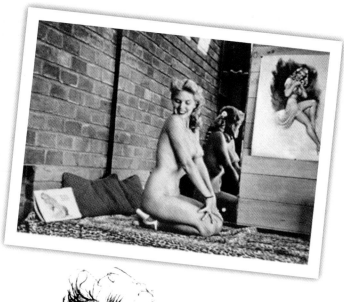

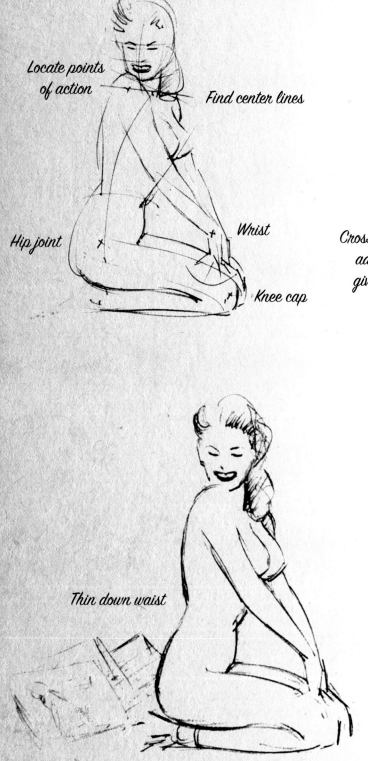

Locate points of action

Find center lines

Hip joint

Wrist

Knee cap

Thin down waist

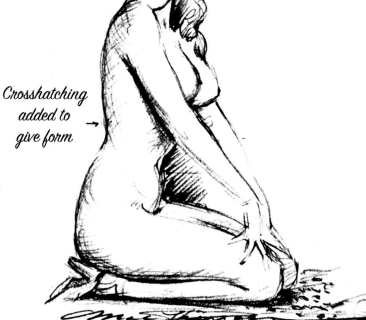

Crosshatching added to give form

Crosshatching For darker shading, place layers of parallel strokes on top of one another at varying angles. Make darker values by placing the strokes closer together.

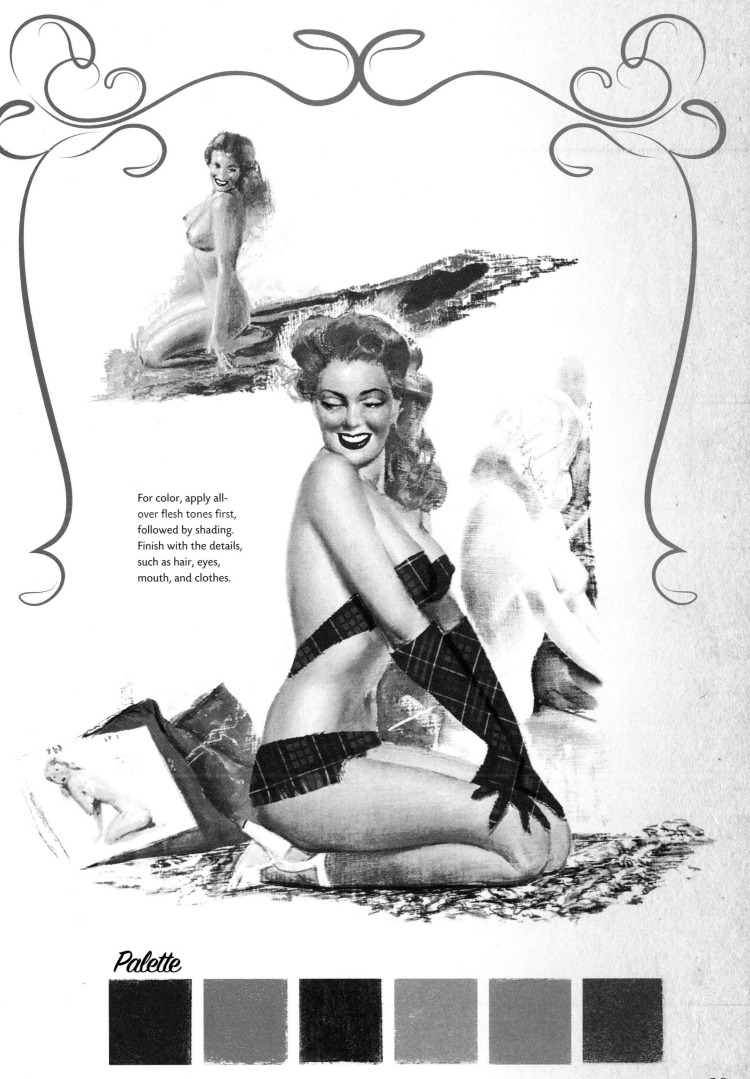

For color, apply all-over flesh tones first, followed by shading. Finish with the details, such as hair, eyes, mouth, and clothes.

Palette

29

Reclining

Keep reclining poses simple so that foreshortening does not become a problem. Foreshortening is an optical illusion that causes objects near the viewer to appear larger than those farther away, which can cause awkward distortion in your figures. Lay in your lines of action first, followed by your perspective lines and then your outline. Keep your shadows and shading simple. These poses are easy for a model to hold and are therefore excellent for the study of color and surface anatomy.

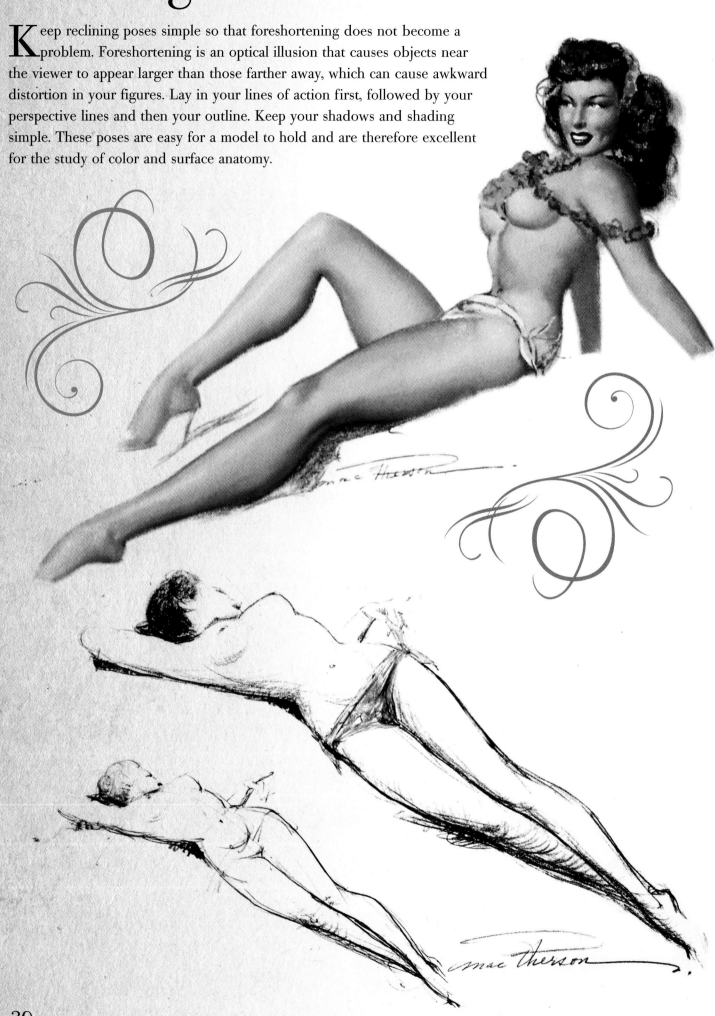

Action

Most of these illustrations reveal action that is suggested by the theme and the models' expressions rather than by the actual poses. This is because most models cannot hold action poses long enough for the artist to sketch properly. Quick sketches in action are good practice, but it may be necessary to work from a photograph in order to complete a painting.

Drawing on Location

You can experiment with other poses by sketching outdoors, which offers a number of backgrounds and possibilities. When on location, draw set-up sketches on a small pad. You can finalize and paint them when you are back in the studio.

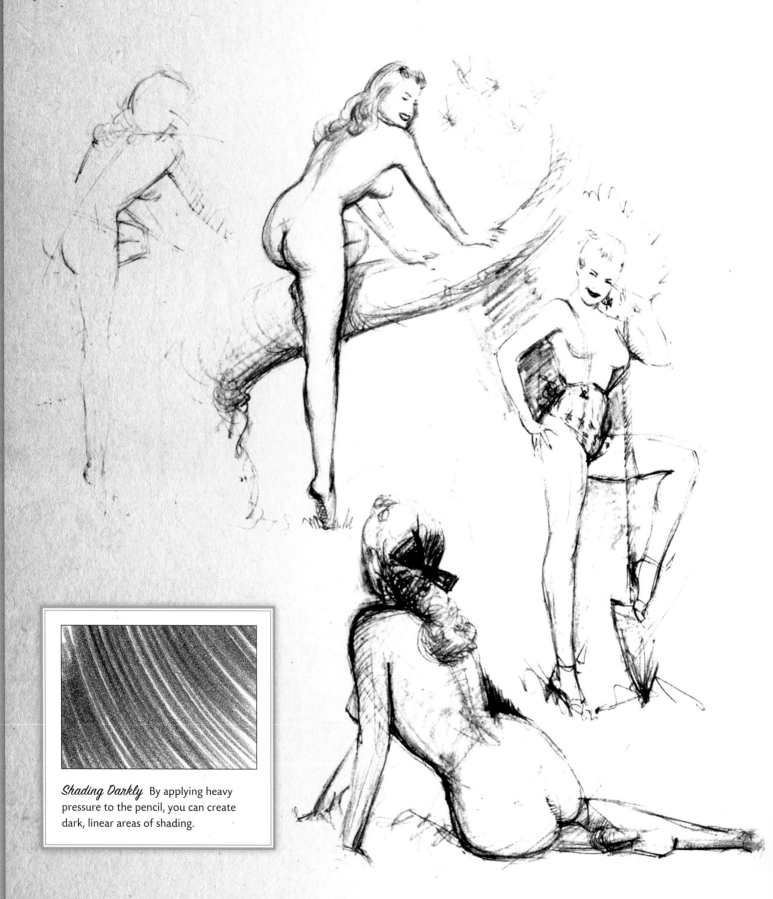

Shading Darkly By applying heavy pressure to the pencil, you can create dark, linear areas of shading.

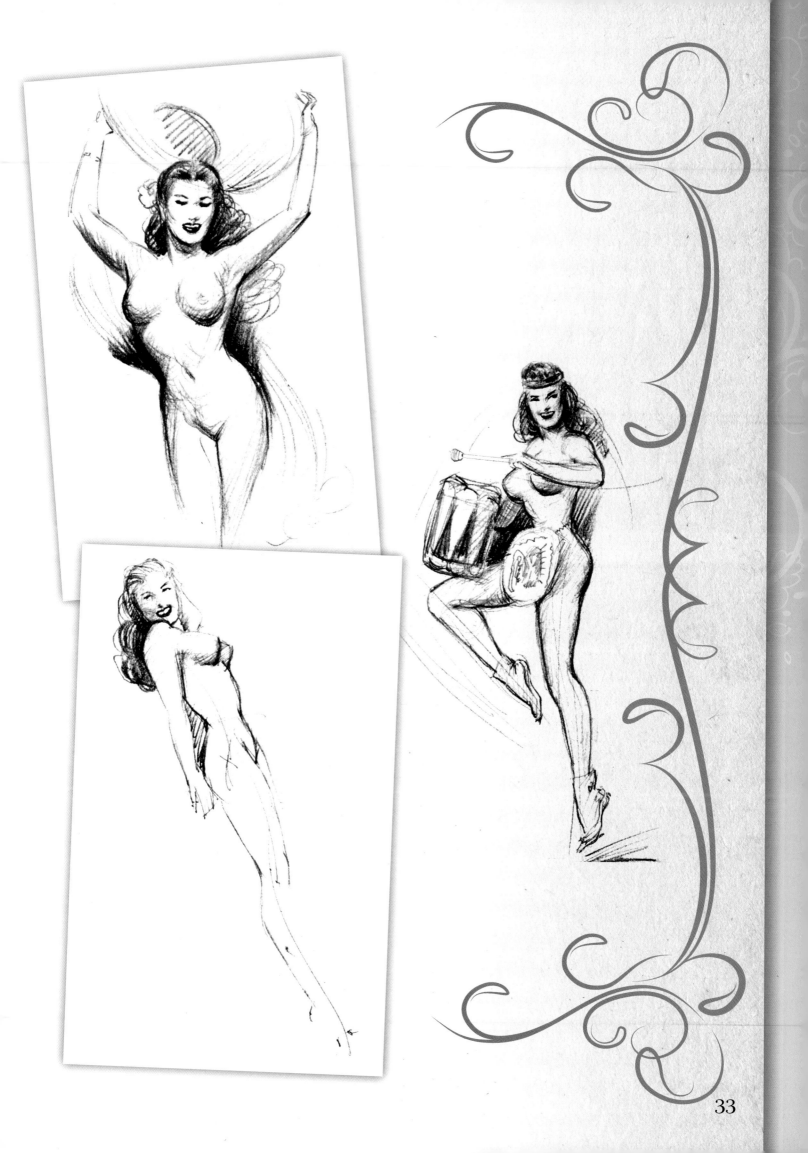

Adding Color

Artists should first master their drawing techniques—using either pencil or charcoal—before moving on to color. Prepare your sketch in charcoal or pencil, paying particular attention to proportion, shadows, and values of expression. You can use either white charcoal paper or illustration board to create your set-up sketch. When you are ready to paint, you will only have to worry about issues related to color. Artists should study color carefully before attempting to paint, whatever their medium. I have always used a premium grade of flesh-colored soft pastels, which I apply flat over large areas. I then blend the closely related hues with my fingers to create a soft texture. (See "Practice Blending with Your Fingers," below right.) Pastels have delicate tints, which make them perfect for painting pin-ups. To apply color to the details, such as the lips, eyes, teeth, and hair, break the pastel to get a sharp workable edge. You may also use colored pencils or watercolor with small brushes to define areas that are too small for pastel.

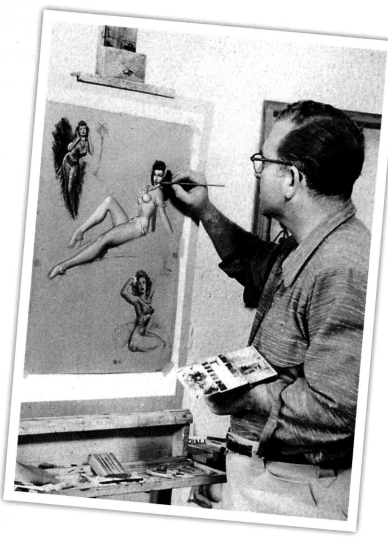

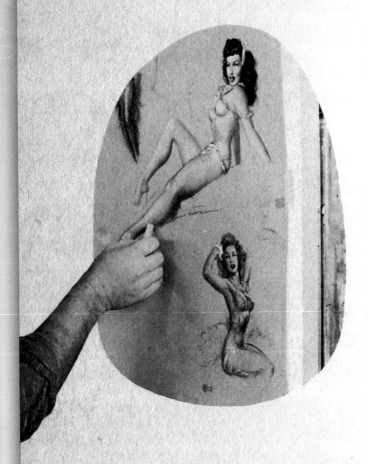

Practice Blending with Your Fingers
Put down an even layer of purple. On top of that, place a layer of yellow ochre. Blend with your finger, striving for even color.

Palette

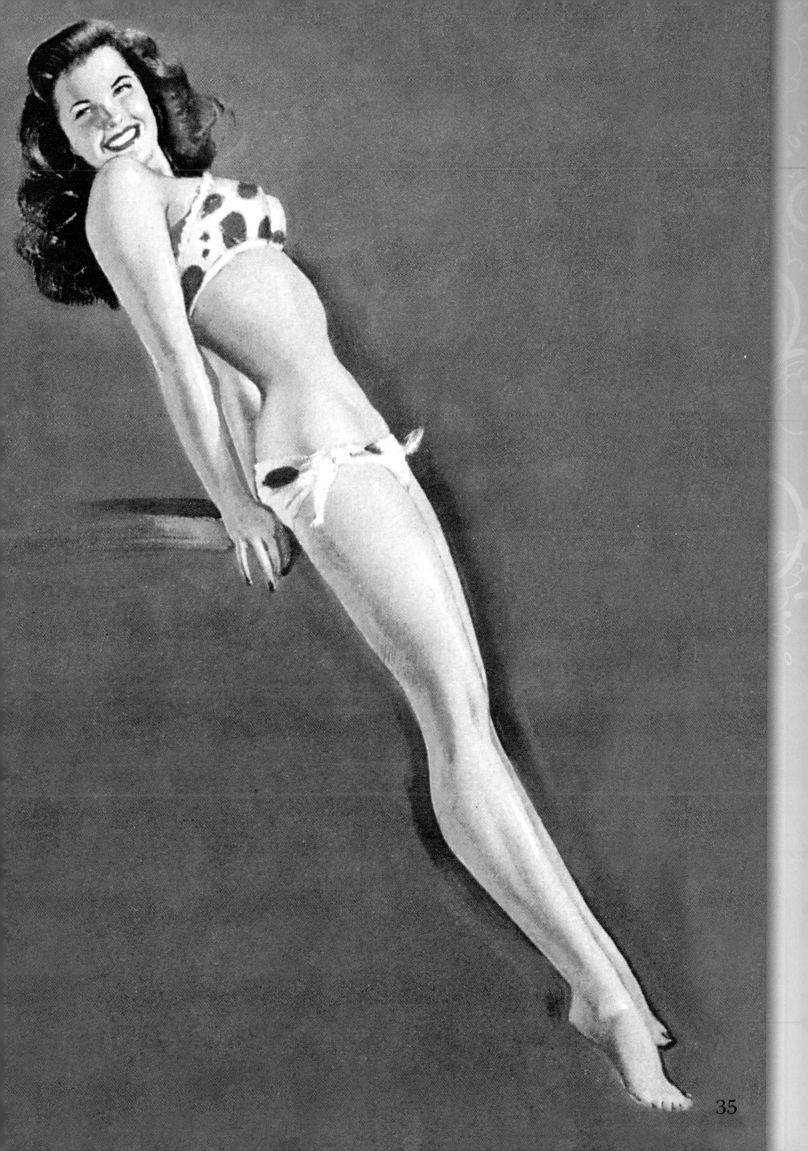

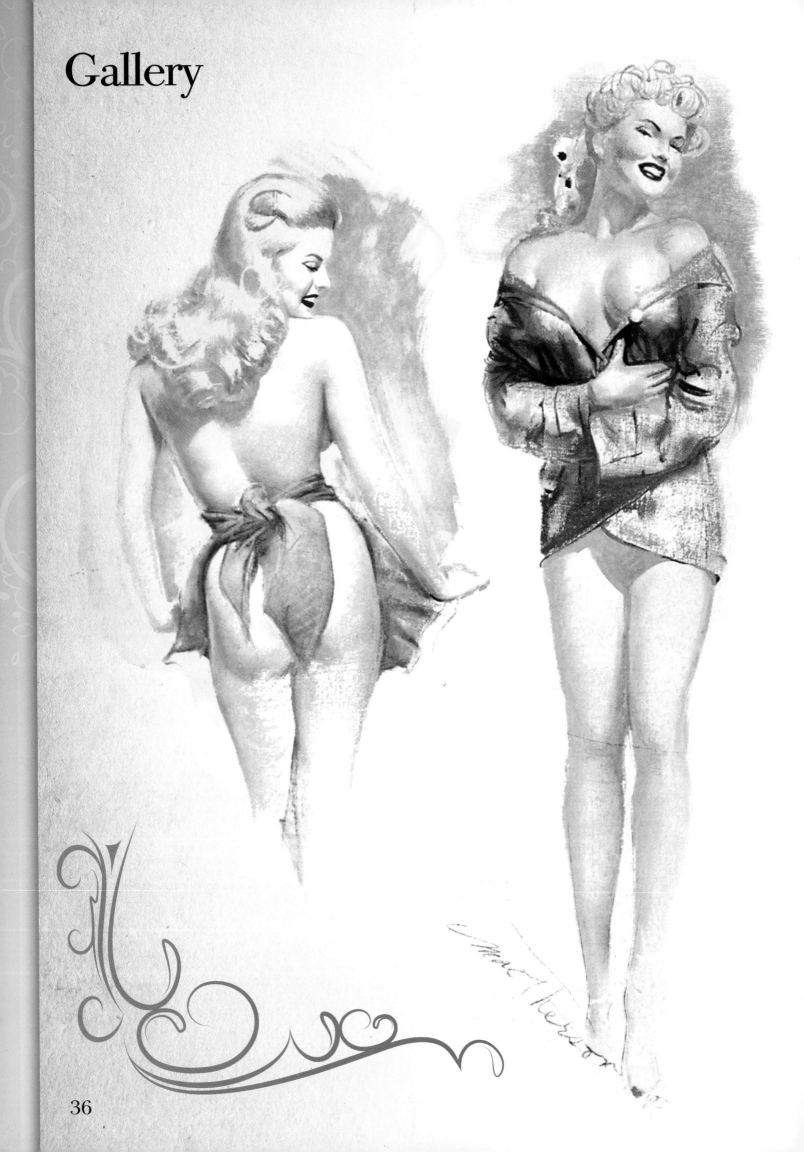

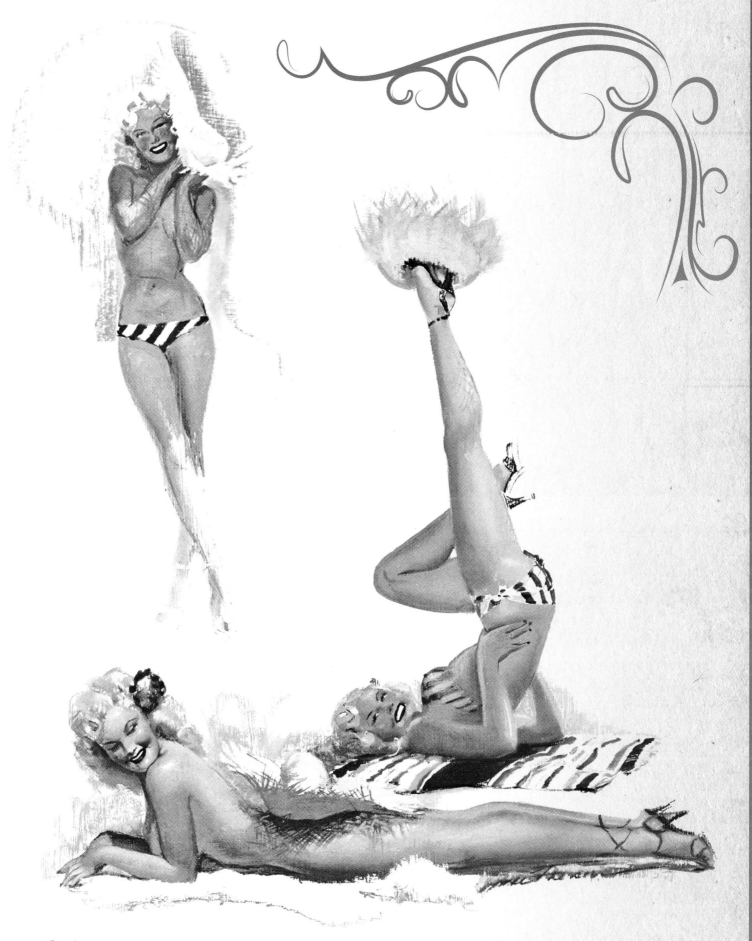

Palette

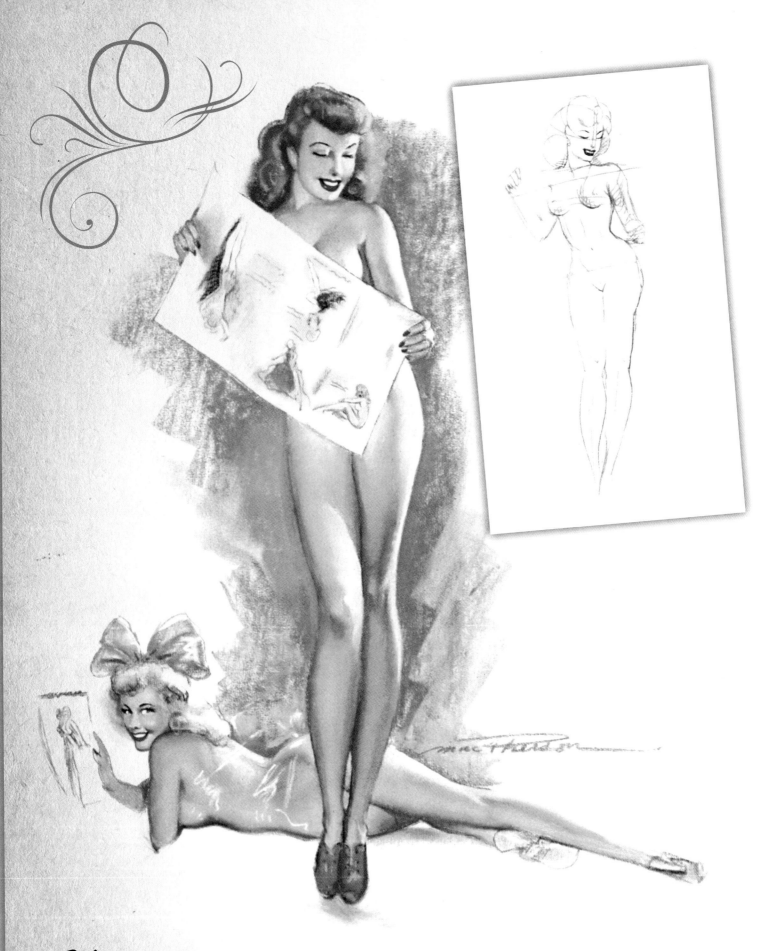

Palette

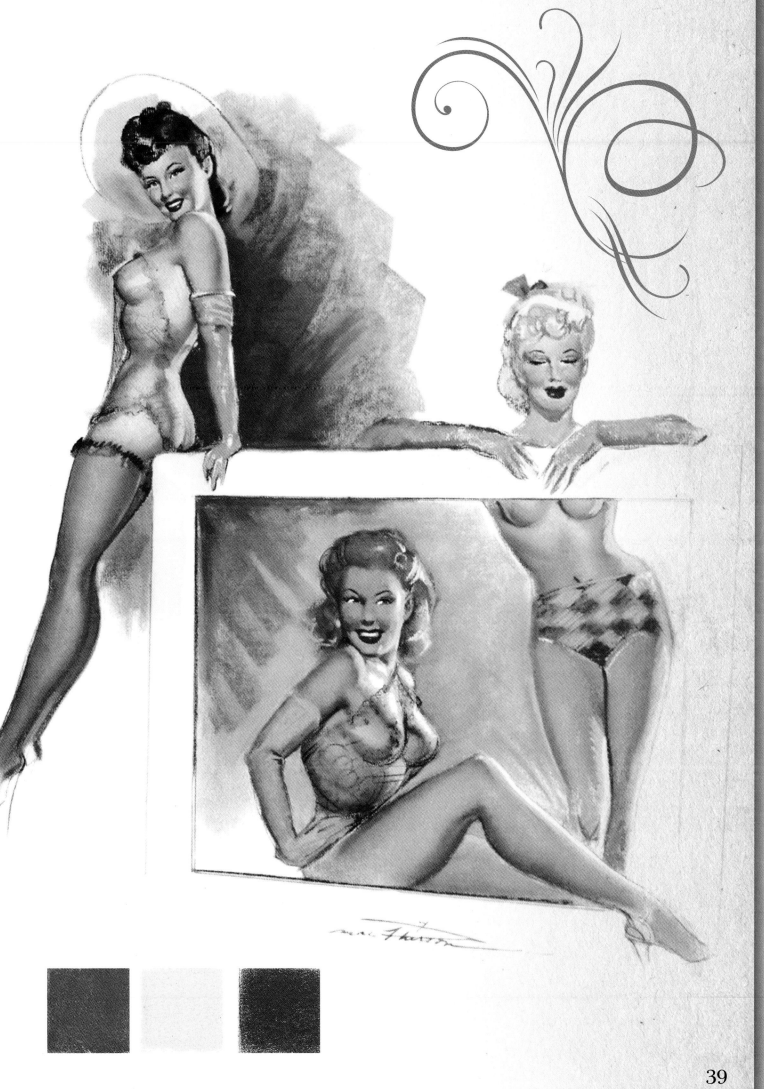

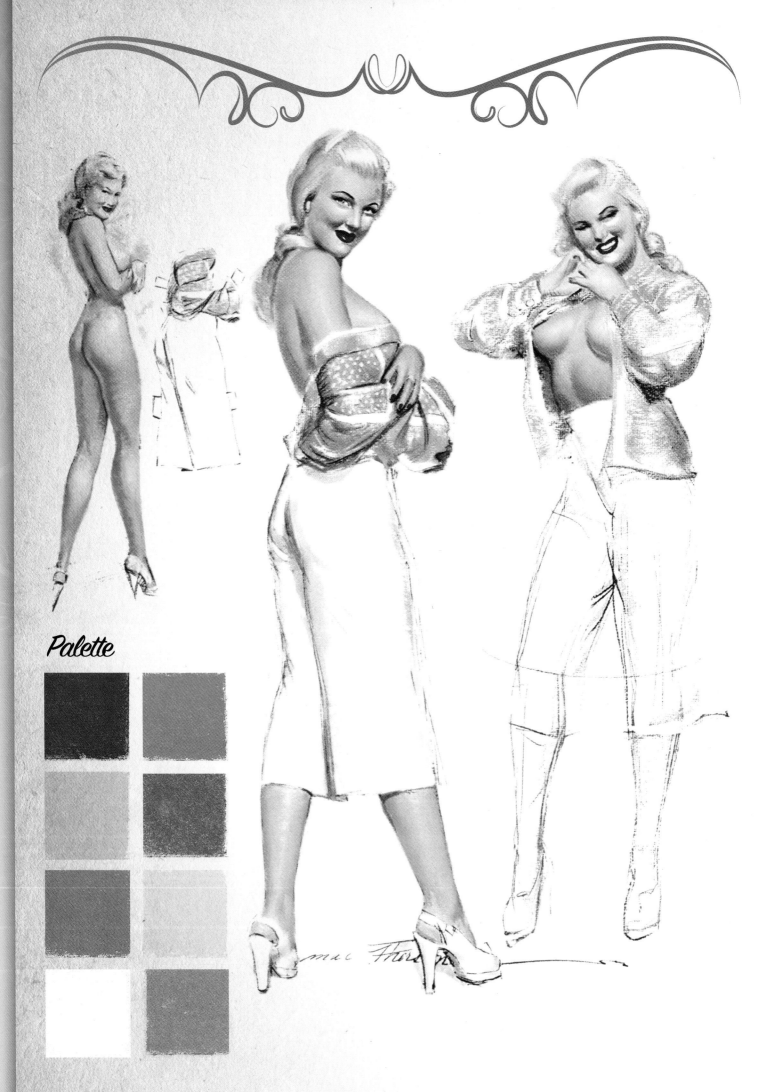

Palette

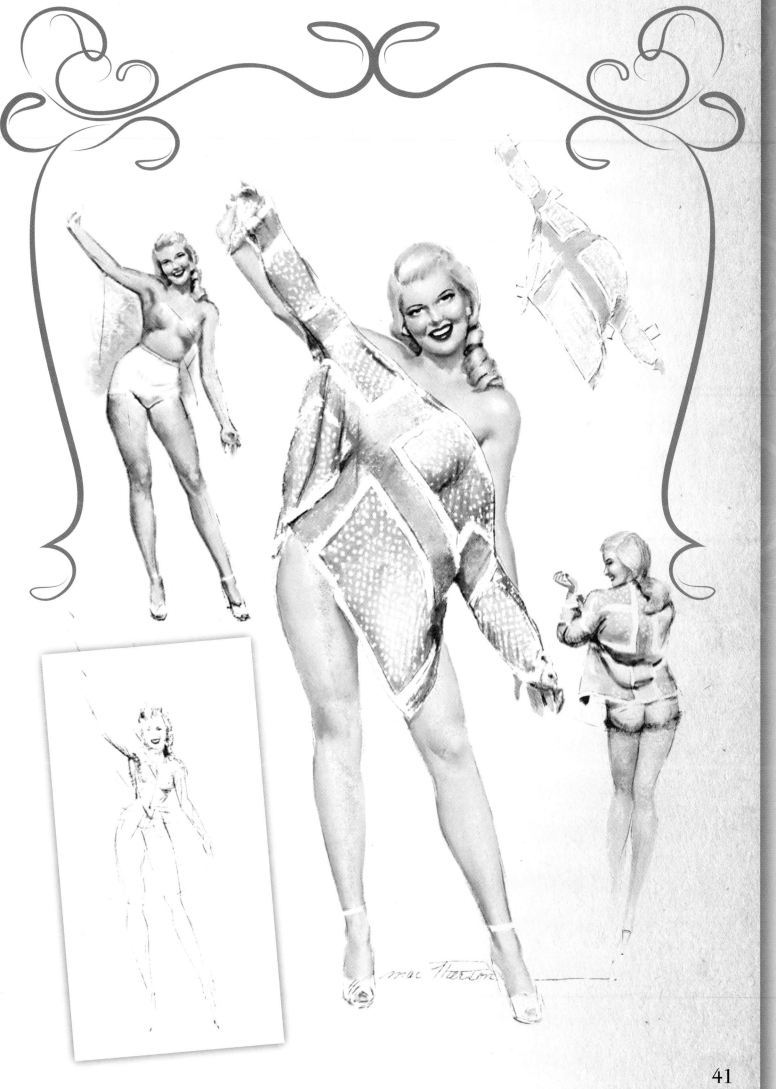

41

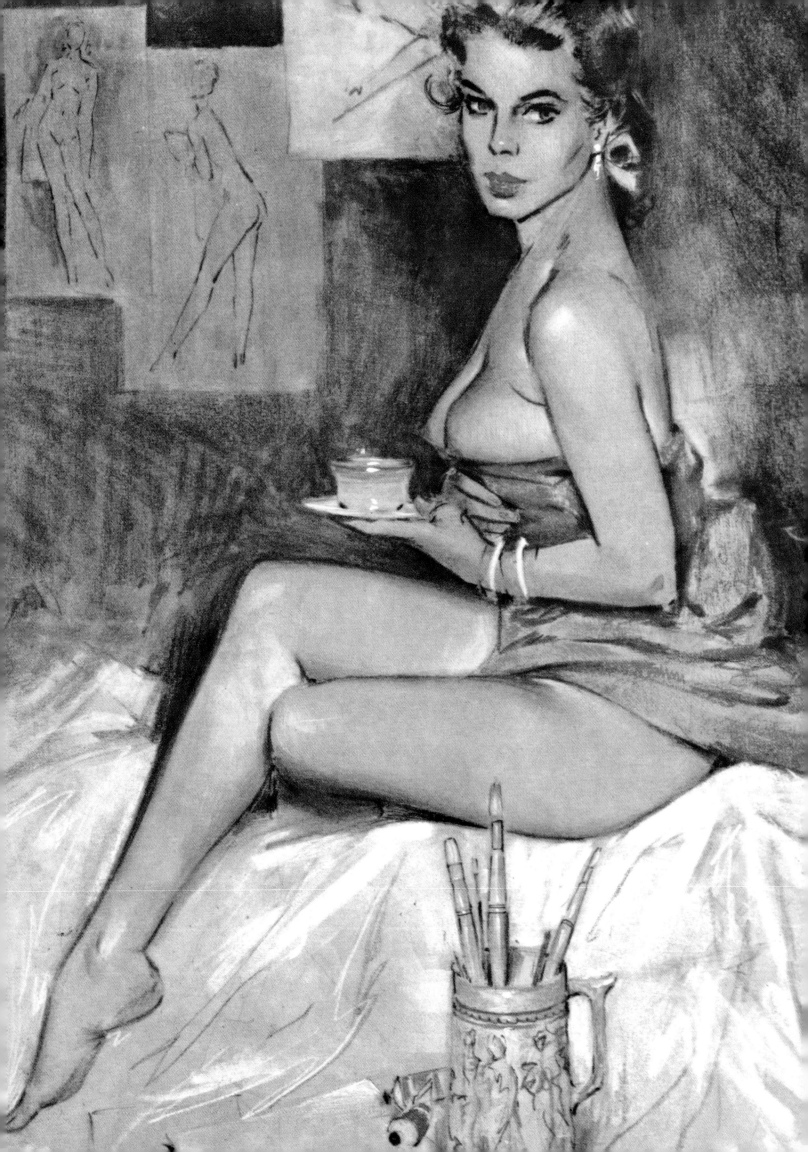

Chapter 3:
The Model &
The Nude
with Fritz Willis

Since the beginning of art history, the female figure has been a subject of interest to painters. Almost every great artist has rendered his or her impression and interpretation of the figure. Learning to draw the figure is not difficult. As in all drawing, the basic principle is to learn to see. That is, to analyze by observation. Once you have done this, drawing or painting becomes relatively easy. How well you do depends on sustained interest and continual practice. Figure drawing is not an exact science. I know of no rules that say, "This is how you must do it." I can only say, "This is how I do it; try it this way." In time, you will find the way that works best for you. This chapter will instruct you on some basic techniques. Then you can go on to vary them to your own taste.

—*Fritz Willis*

Kneeling Figure

I sketched this figure with charcoal pencil; then I lightly sprayed the drawing with a matte, or "workable," fixative. I applied the overall tone with the flat side of a bluish-green pastel stick and smoothed it out with the palm of my hand. I used colored pastel pencils and chalk sticks to complete the drawing.

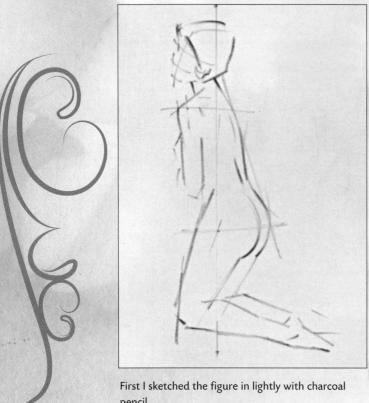

First I sketched the figure in lightly with charcoal pencil.

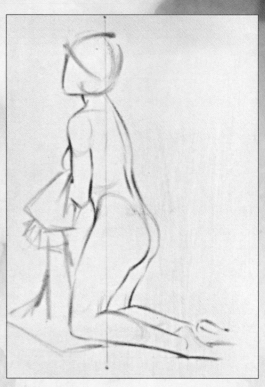

Next I strengthened the drawing and removed the construction lines with a kneaded eraser.

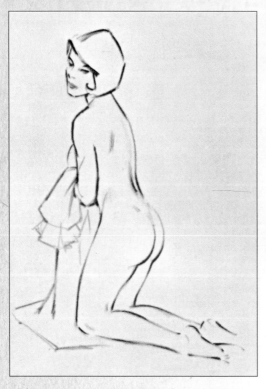

I refined the drawing and added tone and a bit of color.

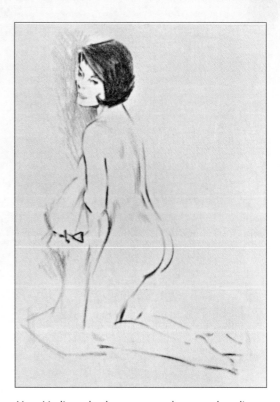

Here I indicated color masses and accented my lines.

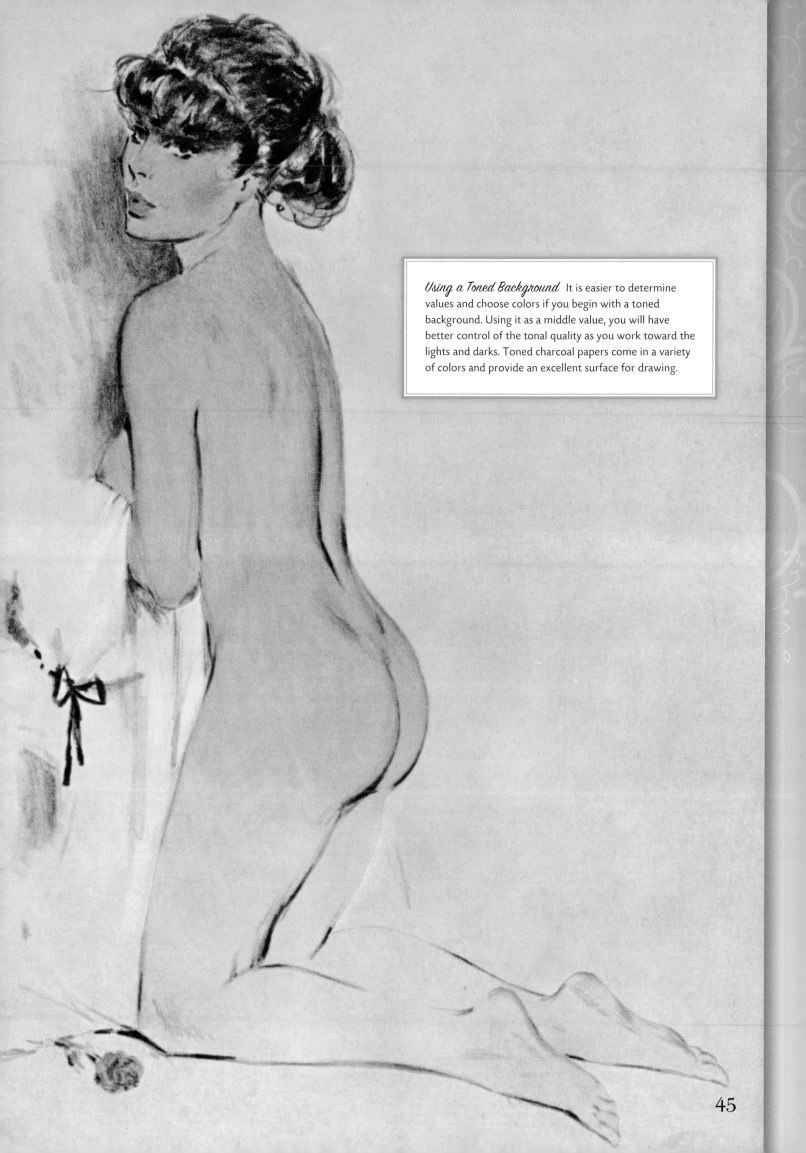

Using a Toned Background It is easier to determine values and choose colors if you begin with a toned background. Using it as a middle value, you will have better control of the tonal quality as you work toward the lights and darks. Toned charcoal papers come in a variety of colors and provide an excellent surface for drawing.

45

Standing Figure

When drawing figures, treat form as if you are moving all the way around the figure and not as a flat surface that comes to an edge and stops. You can help prevent a stilted or "posed" look by ensuring that your model is comfortable, relaxed, and able to take frequent breaks, which also gives you an opportunity to analyze the progress of your painting.

I sketched the simple value drawing above on tracing paper. Then I placed a new sheet of tracing paper over the line drawing and indicated the shadows. I then transferred the sketch to the canvas at right.

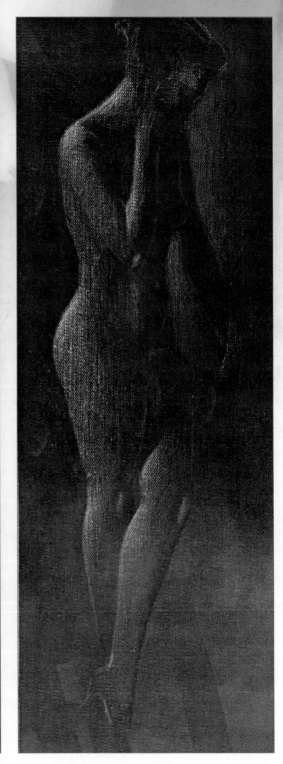

I painted the canvas with burnt umber and allowed it to dry. I rubbed the reverse side of my sketch with white chalk; then I placed it on the canvas and traced over it.

Next I painted in the light areas of the figure, using the tonal sketch as a guide.

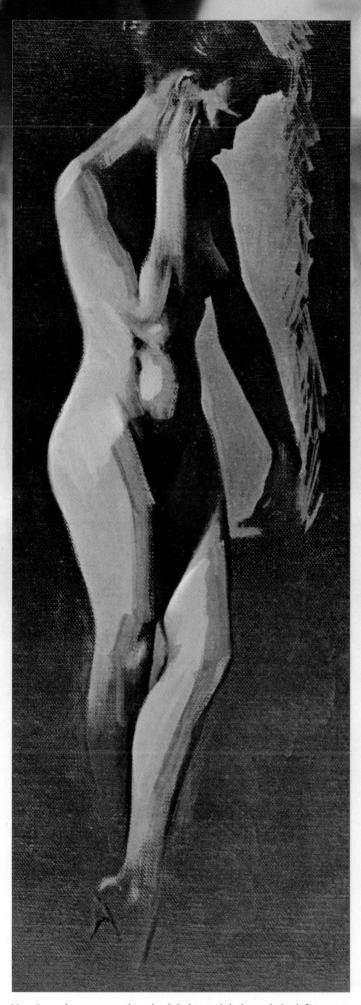

Here I put down truer values, both lights and darks, to help define the form.

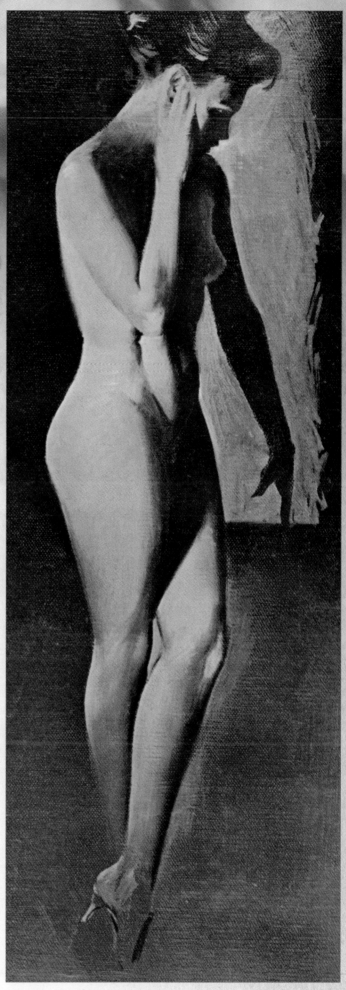

Then I softened some of the edges and further defined the figure by lightening some of the background areas next to the arm in the shadow.

Figure in a Composition

When drawing a figure in a composition with other elements, I use the step-by-step method illustrated below. It keeps the design more flexible and gives me the opportunity to add or move shapes around to ensure I create the best composition. Essentially, the background is the stage. The figure should be placed on it in the best position possible.

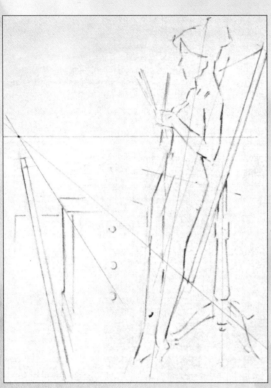

First I established the eye level and then roughed in the general composition for placement of the elements.

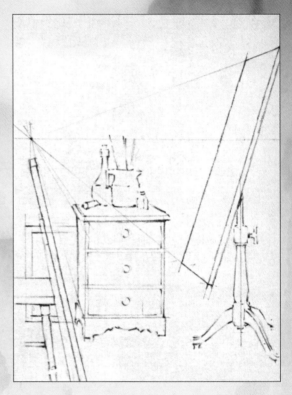

I laid tracing paper over the first sketch and then drew in the background elements.

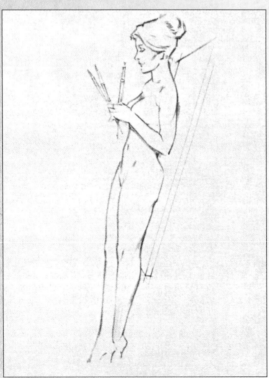

Then I added another sheet of tracing paper and drew the standing figure.

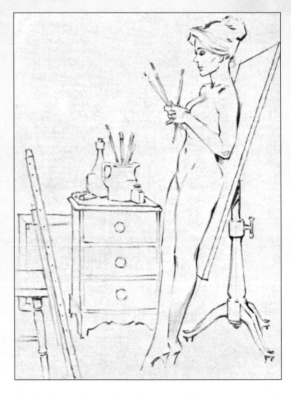

Finally, I placed my third sketch (at left) over my second sketch (top right) to assemble the complete composition.

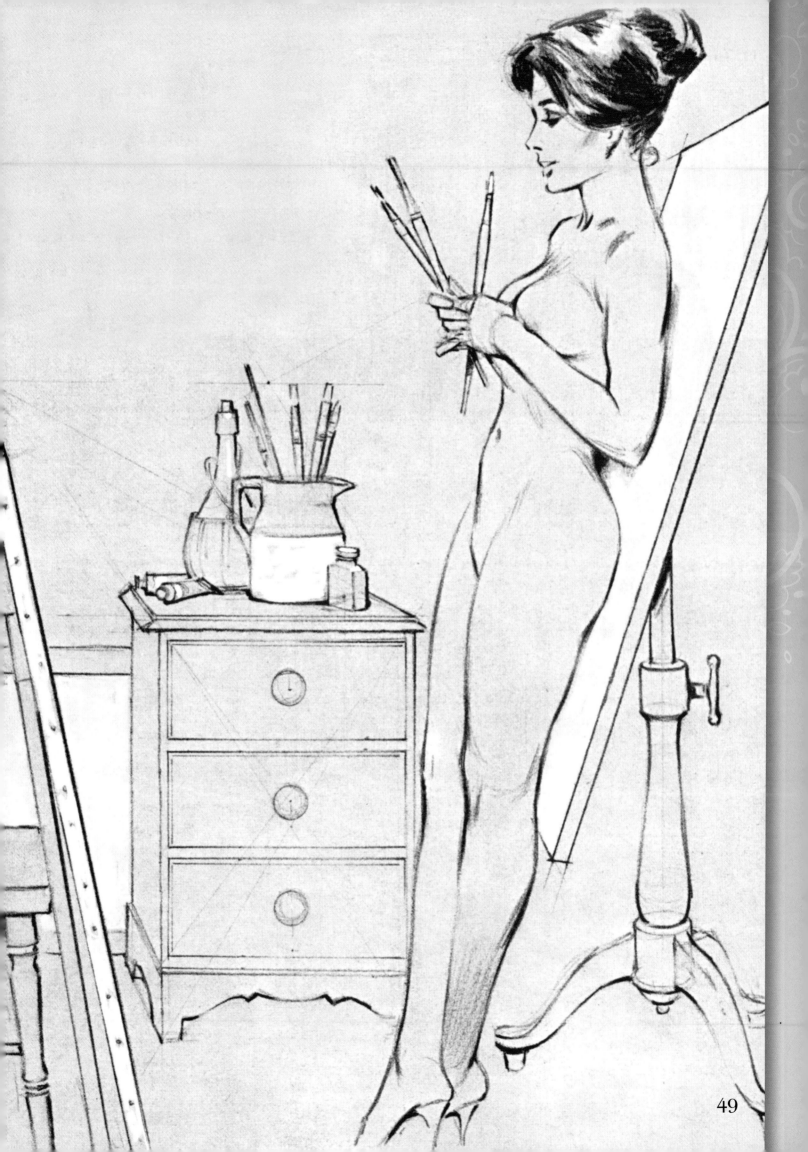

Creating Flesh Color

Flesh color doesn't have to be the actual color of flesh any more than the sky has to be blue or a tree has to be green. It is only important that the color relates to the background. What we normally think of as flesh color will look too pink or orange against a blue or green background, or too gray against a red background. Tone the flesh color with some of the background color to keep it in harmony with the rest of the painting.

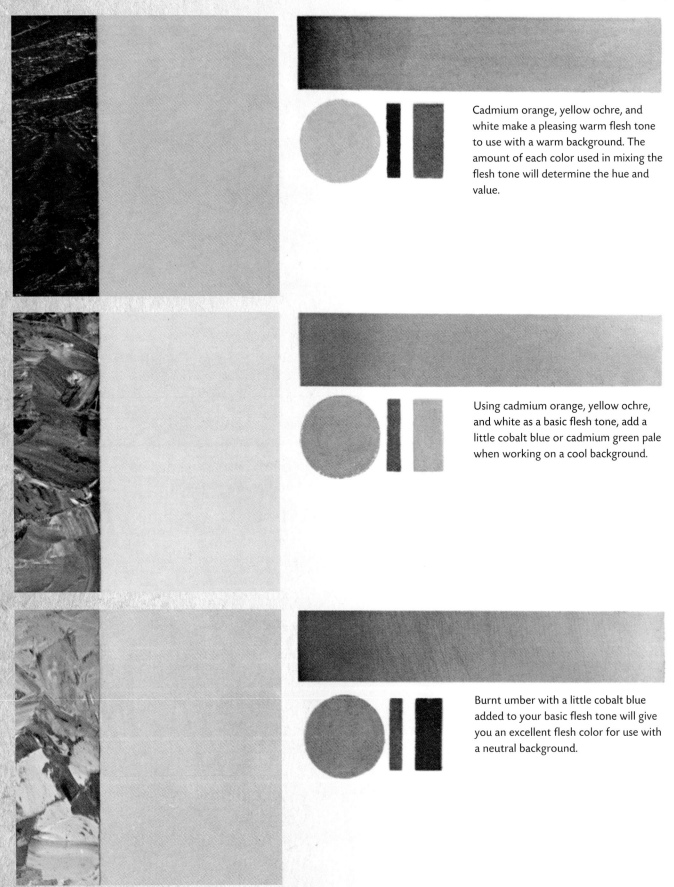

Cadmium orange, yellow ochre, and white make a pleasing warm flesh tone to use with a warm background. The amount of each color used in mixing the flesh tone will determine the hue and value.

Using cadmium orange, yellow ochre, and white as a basic flesh tone, add a little cobalt blue or cadmium green pale when working on a cool background.

Burnt umber with a little cobalt blue added to your basic flesh tone will give you an excellent flesh color for use with a neutral background.

Staging & Direction

The props and accessories you use in your paintings are as important as the choice of color and total value. It isn't a question of the intrinsic value of objects. A chair or bowl can be of the most ordinary origin, but if it is the right shape, size, and color for the composition, your painting will be better than if you used a rare vase that looks as though it doesn't belong. In this painting, the jewelry box, cushion, and the model's jacket were not chosen for their individual qualities but for what they contributed to the painting from the standpoint of texture, color, and shape.

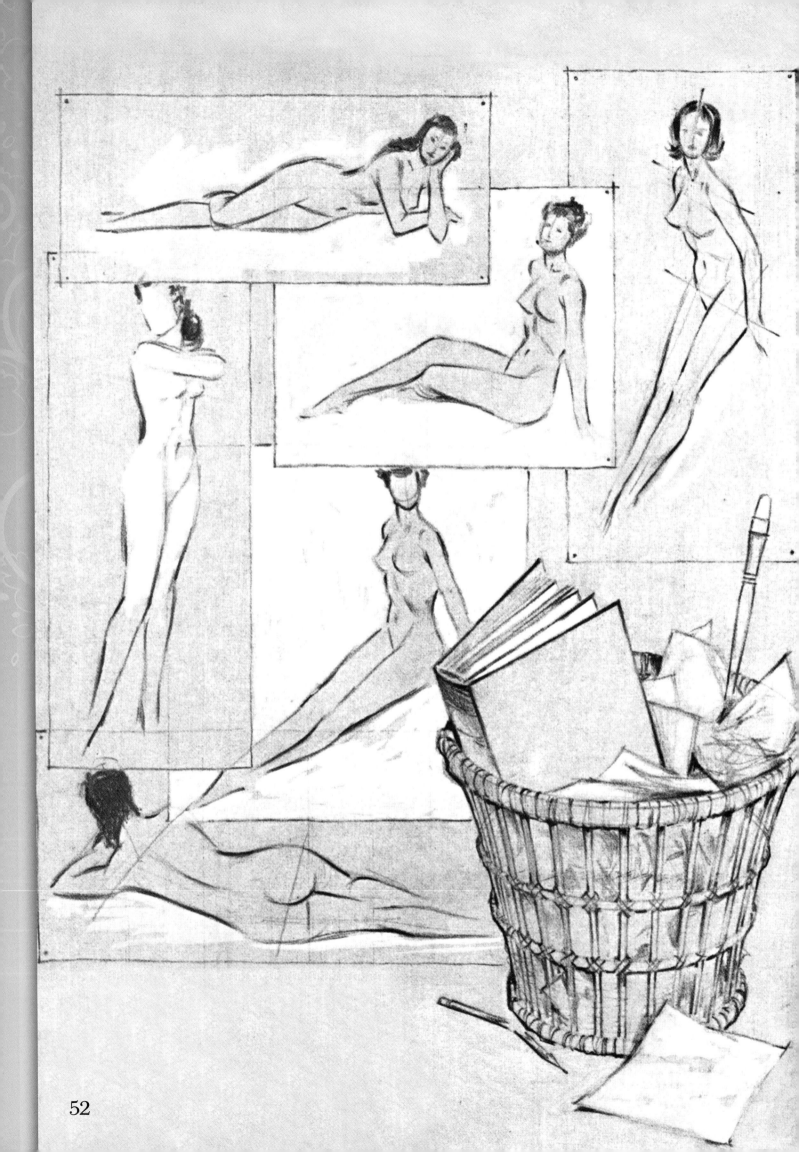

Reclining Nude Sketch

The rough drawings on this page were preliminary sketches for the finished painting on pages 54-55. Although a reclining figure is usually a study of soft curves, there is also a great amount of action to be expressed. The skeletal lines in the top sketch define the action and indicate the proportions. Although these are rough drawings, they contain much of the information needed for the finished painting.

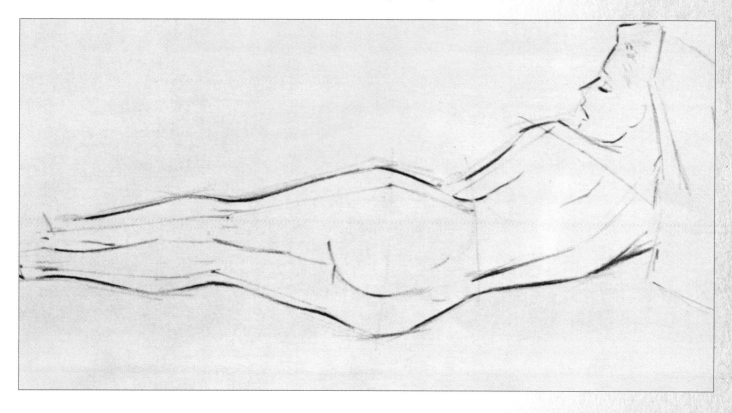

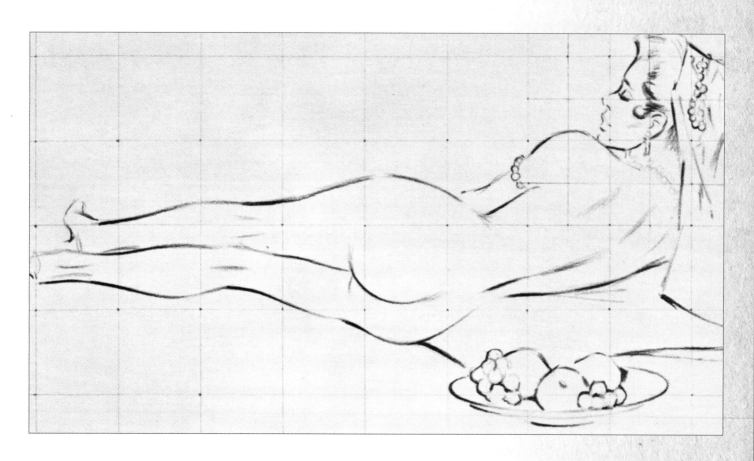

Reclining Nude Painting

Palette

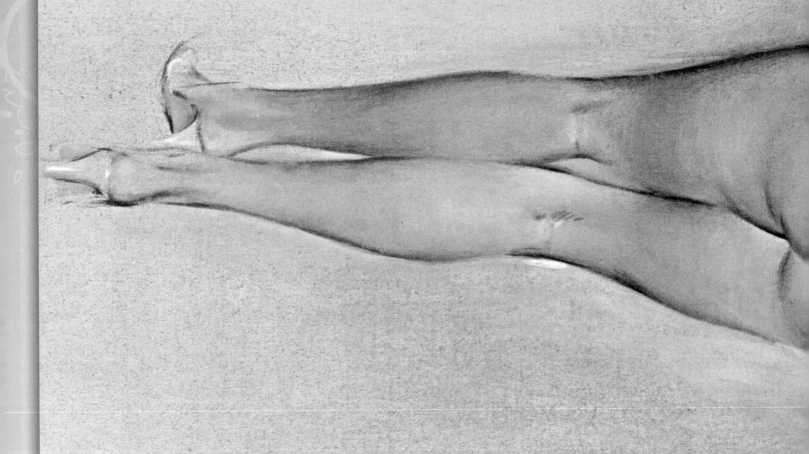

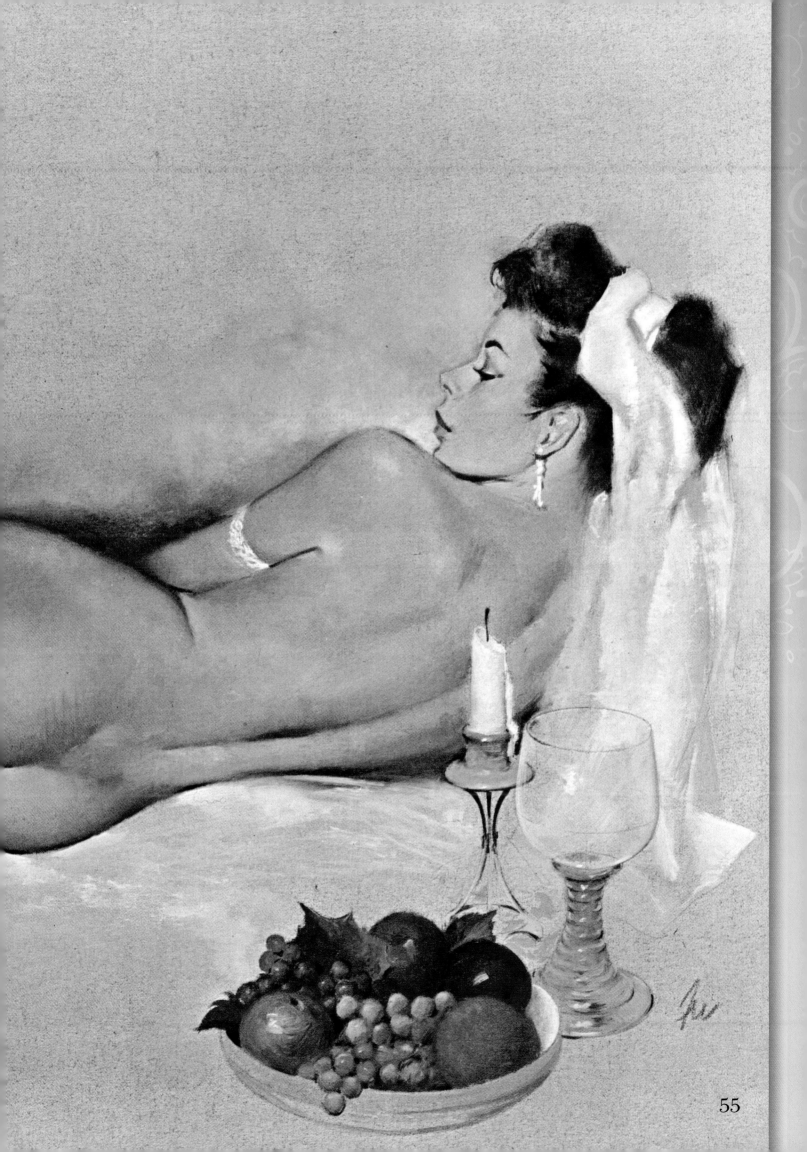

Sitting Nude Sketch

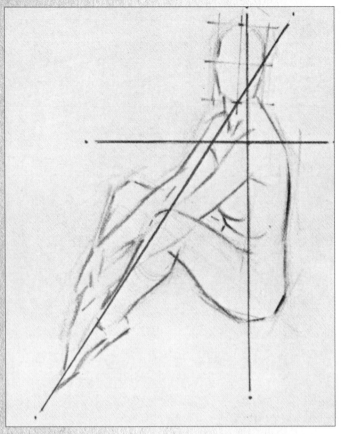

I put down the horizontal, vertical, and diagonal lines to help me locate where to place the figure on the page. I then blocked in the drawing.

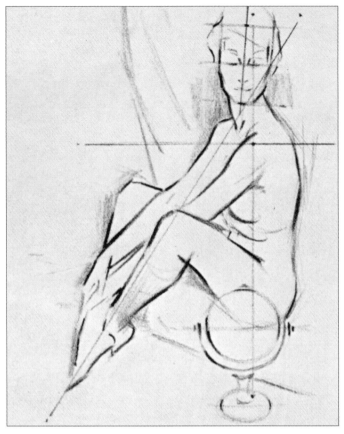

I used the diagonal line to guide the action, weight, and mass of the figure. Adding the mirror at the base minimized the diagonal thrust of the pose.

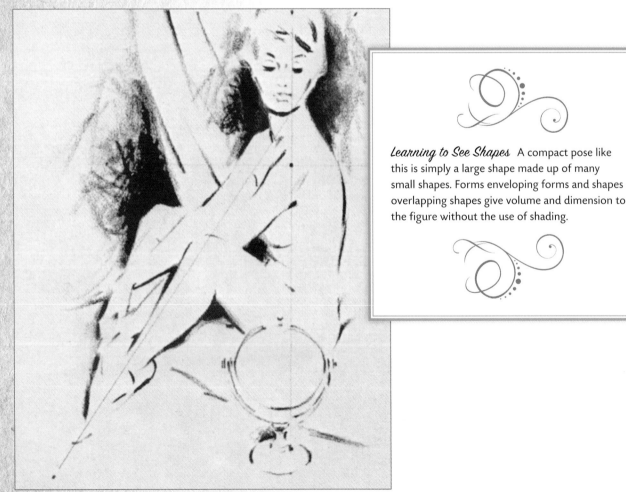

Finally, I indicated the dark areas to bring the composition into balance.

Learning to See Shapes A compact pose like this is simply a large shape made up of many small shapes. Forms enveloping forms and shapes overlapping shapes give volume and dimension to the figure without the use of shading.

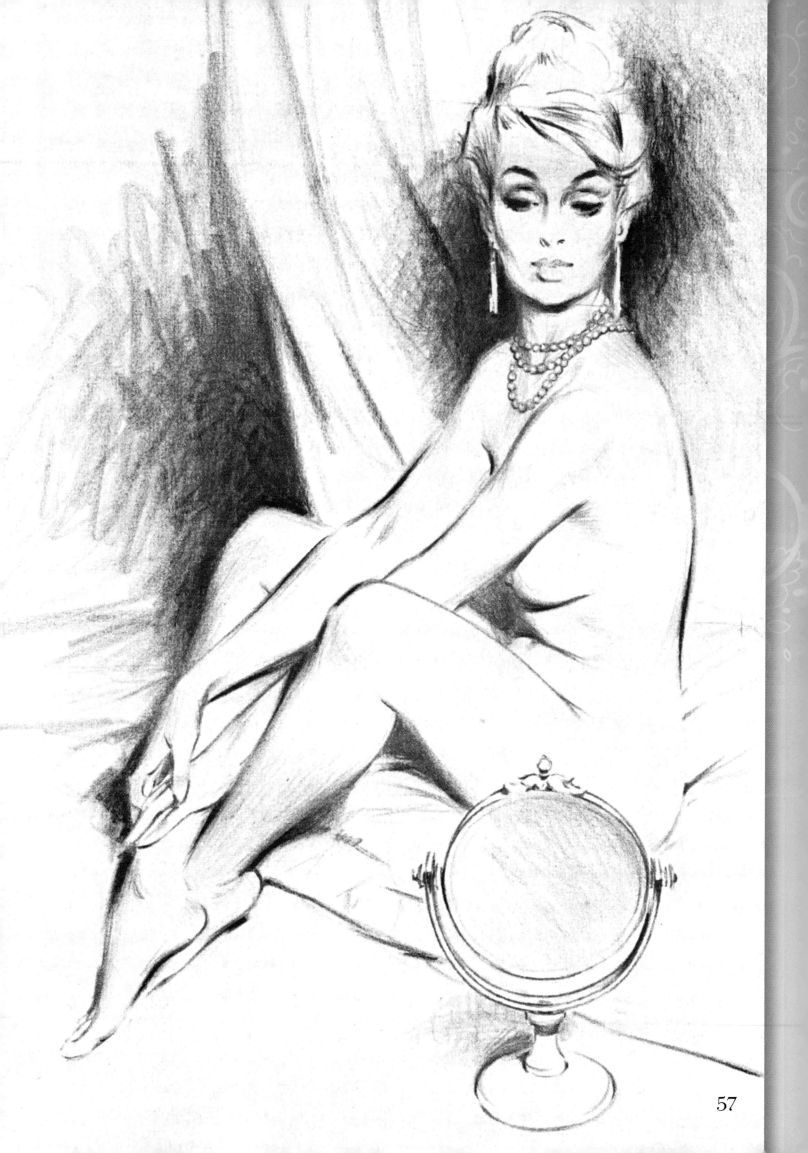

Sitting Nude Painting

If background shapes are put in their proper places, they can almost draw the figure for you. By painting the background first, you establish a key to the value color of the flesh. This is a good way to work if you have a tendency to paint flesh in too high a key. In painting, value is just as important as color; in fact, value changes are crucial for creating the illusion of form.

In the step above, I blocked in the general background until I achieved the desired shape of the figure.

I continued adding color around the subject until I was satisfied with the outline of the figure.

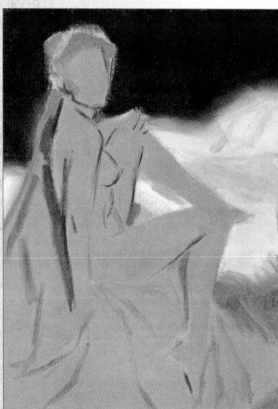

I then applied color to the figure itself.

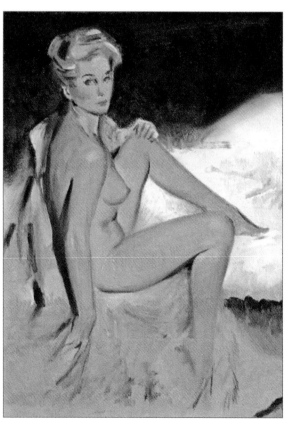

I further refined the figure, as well as the facial expression before moving on to the final details.

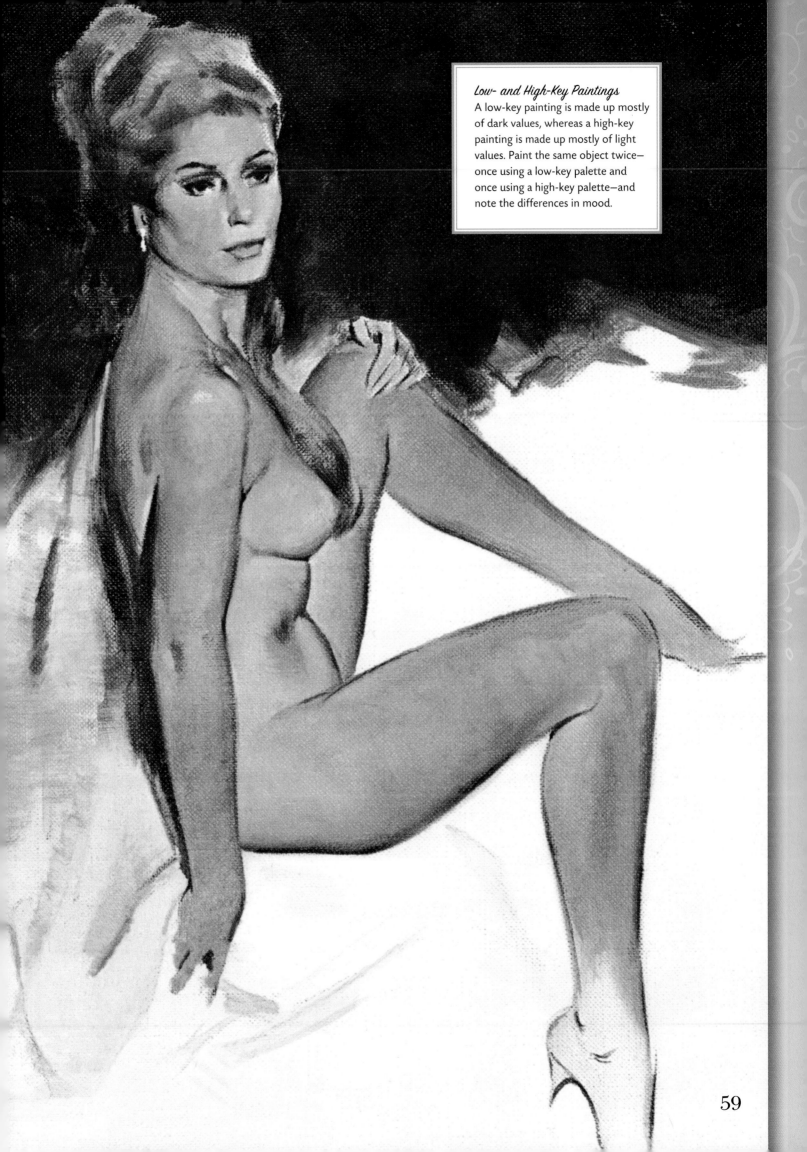

59

Standing Nude Sketch

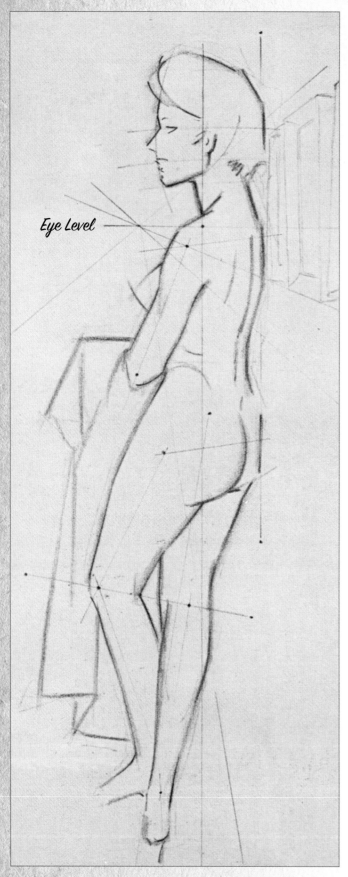

Eye Level

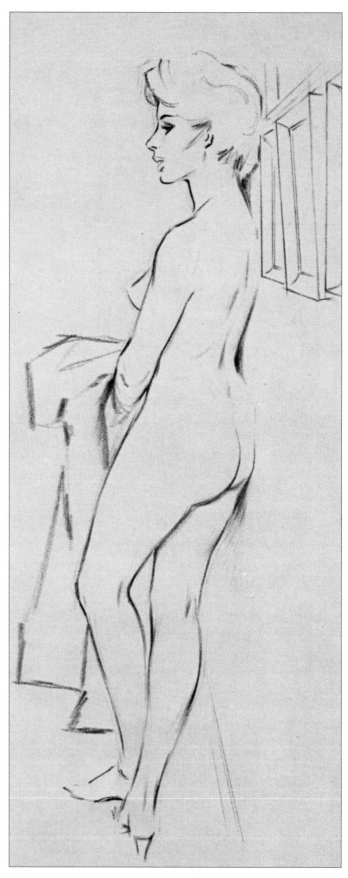

First I sketched the figure; then I added the construction lines and joint areas to help me double check proportion, perspective, and the action of the pose.

I traced the sketch onto a canvas and drew over it in raw umber with a fine-pointed sable brush. The fast-drying qualities of raw umber and burnt umber make them ideal for laying in a painting.

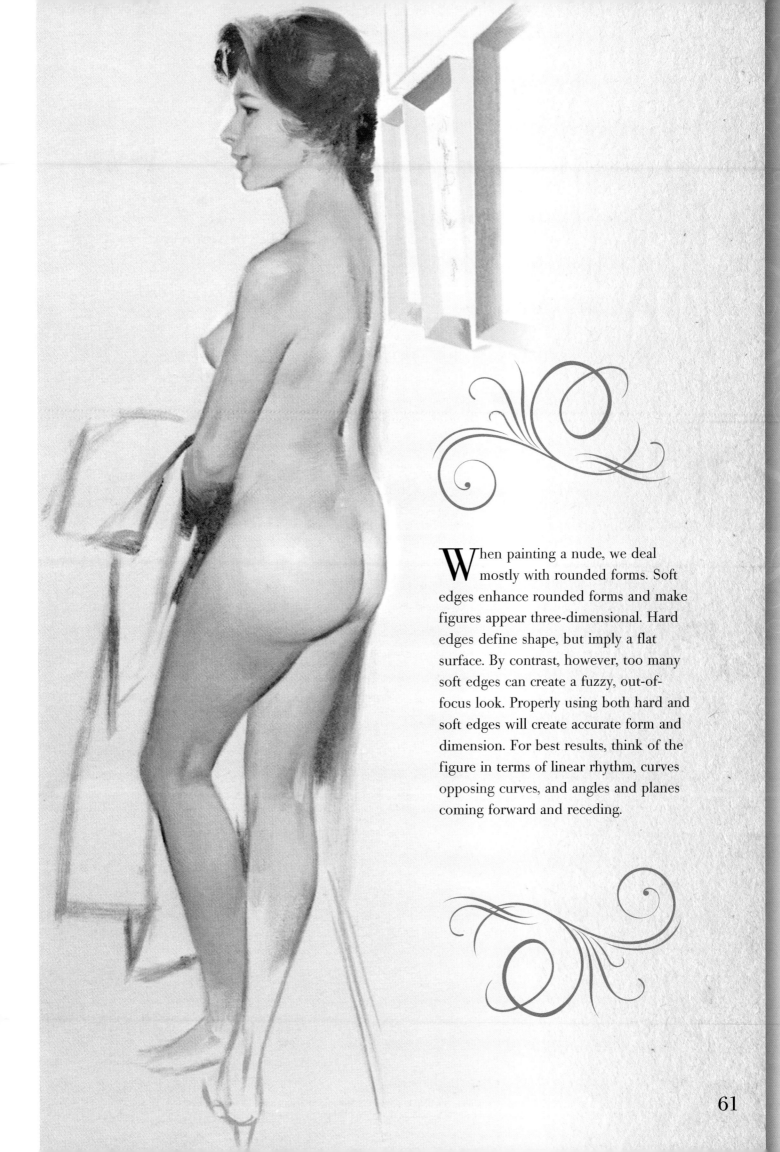

When painting a nude, we deal mostly with rounded forms. Soft edges enhance rounded forms and make figures appear three-dimensional. Hard edges define shape, but imply a flat surface. By contrast, however, too many soft edges can create a fuzzy, out-of-focus look. Properly using both hard and soft edges will create accurate form and dimension. For best results, think of the figure in terms of linear rhythm, curves opposing curves, and angles and planes coming forward and receding.

Sepia Pencil on Tracing Paper

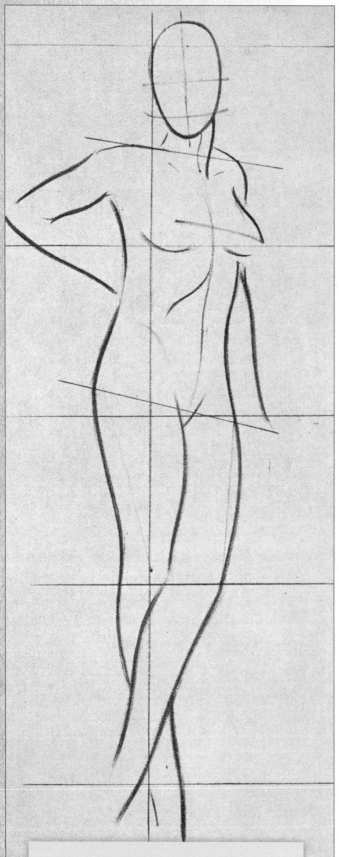

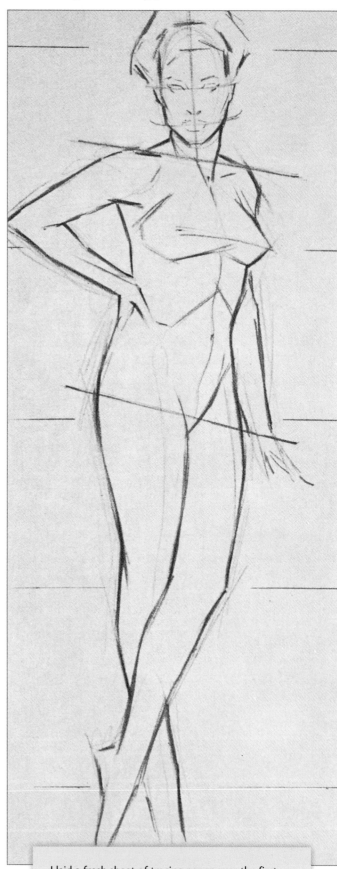

I put down the vertical line first, which gave me a support to "hang" the pose on and establish the action. At this stage of the drawing, the figure is composed of a series of shallow "S" curves, which give fluidity and femininity to the shape.

I laid a fresh sheet of tracing paper over the first drawing and modified the shallow "S" lines at the points where the bone nears the surface, including at the knee, elbow, and shoulder. Doing this helped identify the rib cage and facial features.

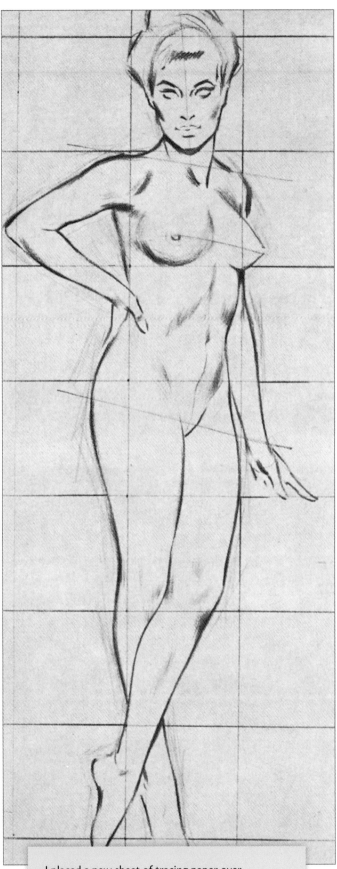

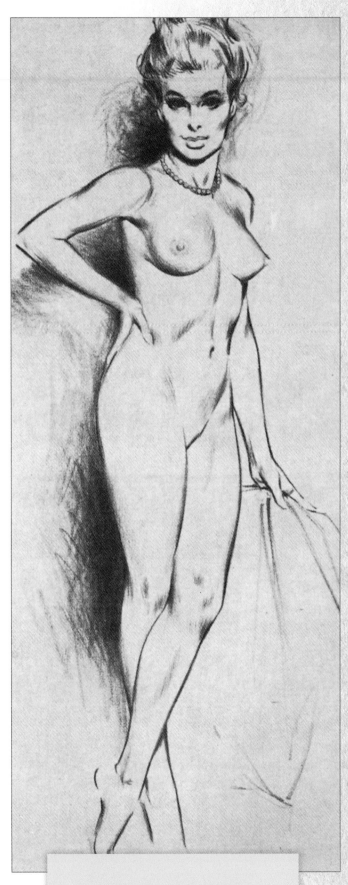

I placed a new sheet of tracing paper over the drawing and squared it off to help check proportions; then I further defined the details. By using a new sheet for each step, you always keep your original drawing intact. If something goes wrong, you'll still have your foundation drawing.

I completed the drawing on a fourth overlay of tracing paper. As an experiment, I mounted the final drawing on a firm surface and painted directly on it.

Ballet Dancer on Tracing Paper

The encircling folds of a glove, the line of a necklace around the throat, a bracelet, and garter are all elliptical shapes that help tell the direction a form is taking. When working in line, a foreshortened arm or leg sometimes presents a tricky drawing problem. (For more about Foreshortening, see page 30.) What looks right in line may look wrong when tone and modeling are added. Whether you are drawing an apple, a tree, or a figure, you must think of form and volume as well as shape. A drawing is not a collection of outlines—it is a statement of shape.

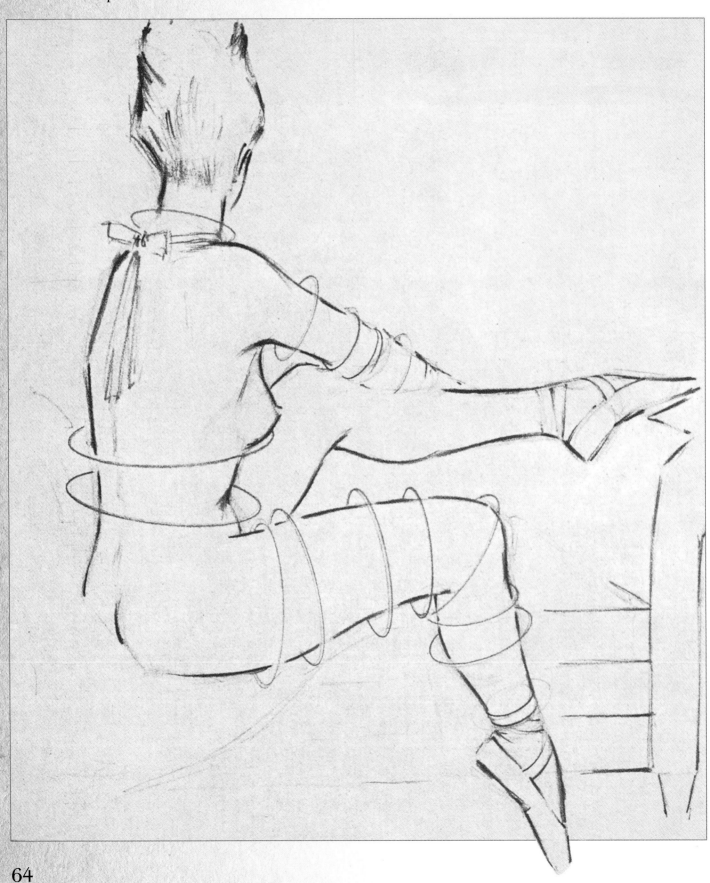

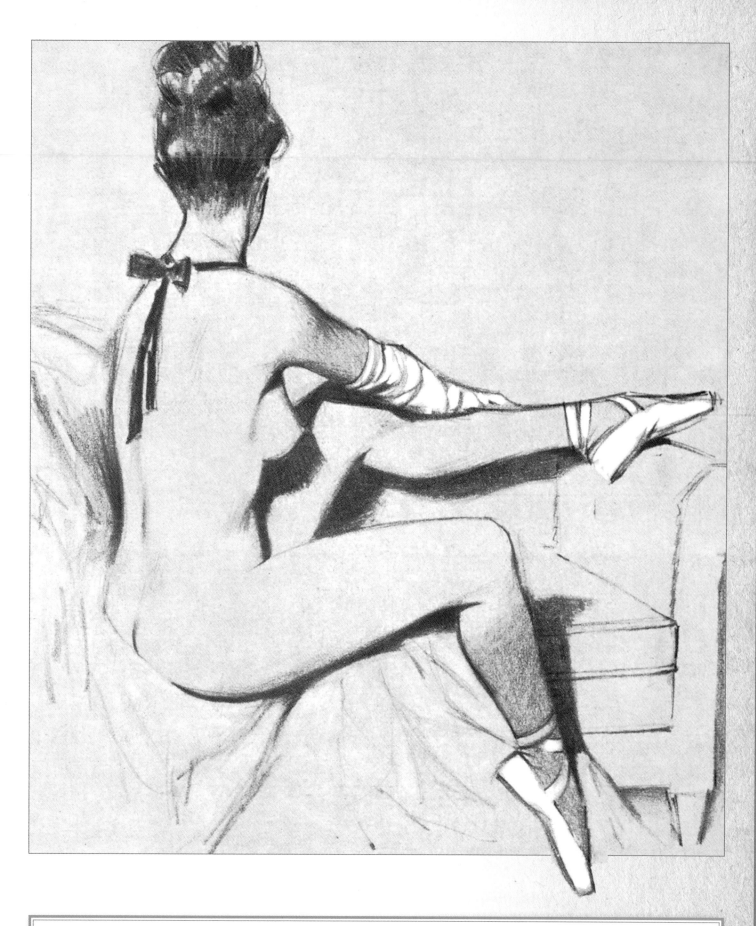

DETERMINING SHAPE AND FORM

The next time you are going to make a figure drawing, tie ribbons around the model's waist, throat, upper arm, wrist, thigh, and calf. When the model has taken the pose you wish, study the ellipses formed by the ribbons. Some will remain elliptical, some will be flattened, and some will be stretched, but each will give you valuable information about the shape and direction the form is taking.

Sepia Pastel on Tracing Paper

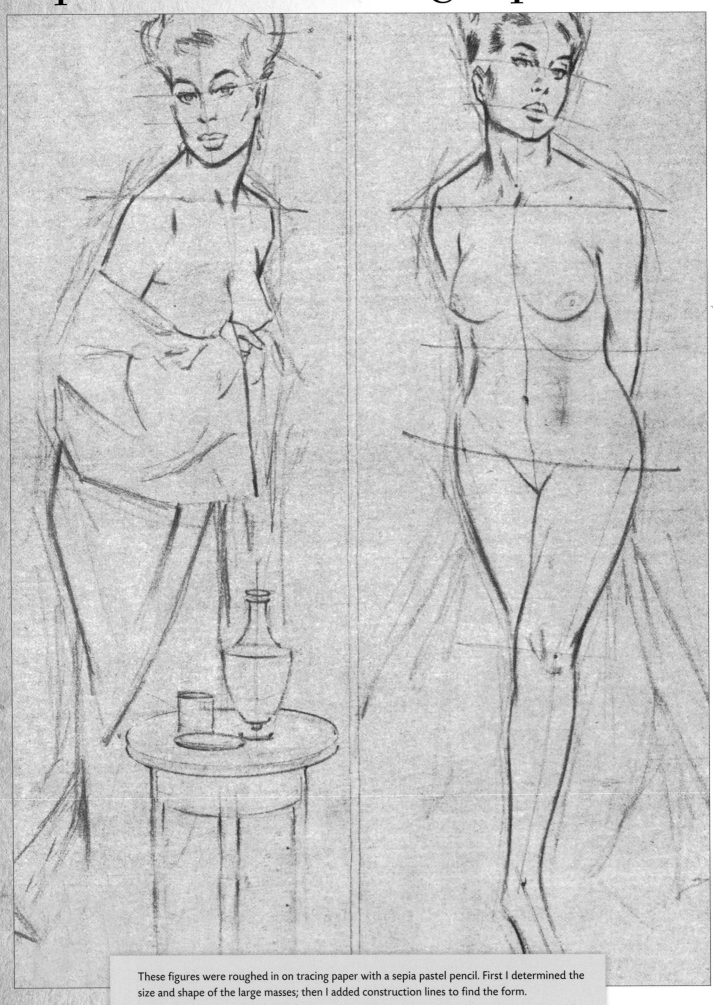

These figures were roughed in on tracing paper with a sepia pastel pencil. First I determined the size and shape of the large masses; then I added construction lines to find the form.

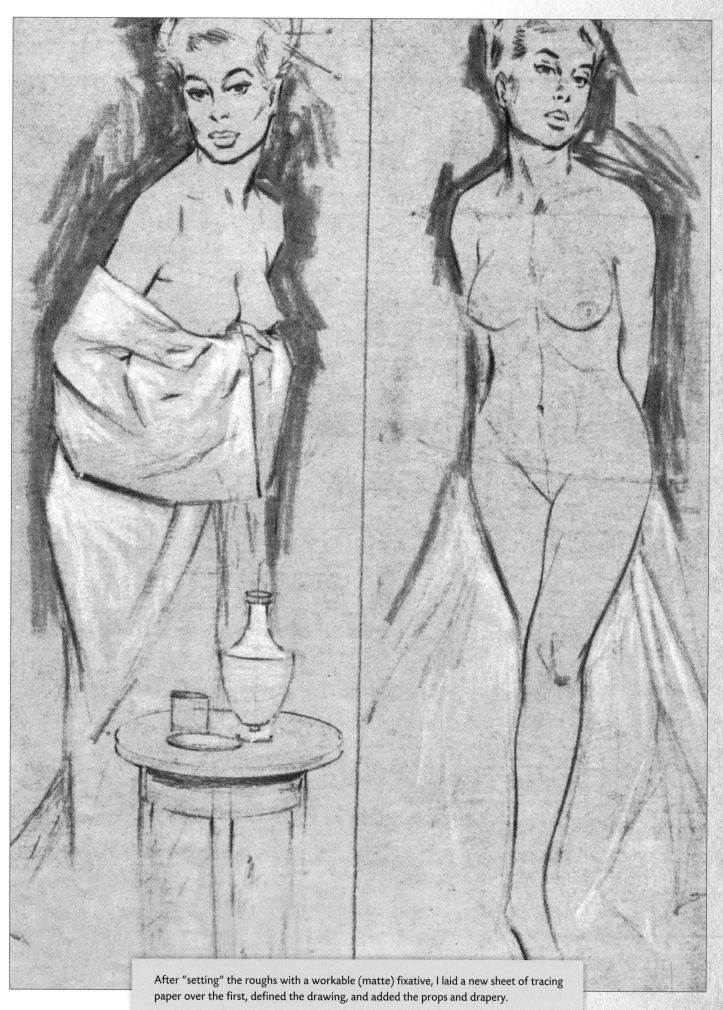

After "setting" the roughs with a workable (matte) fixative, I laid a new sheet of tracing paper over the first, defined the drawing, and added the props and drapery.

Color Pastel

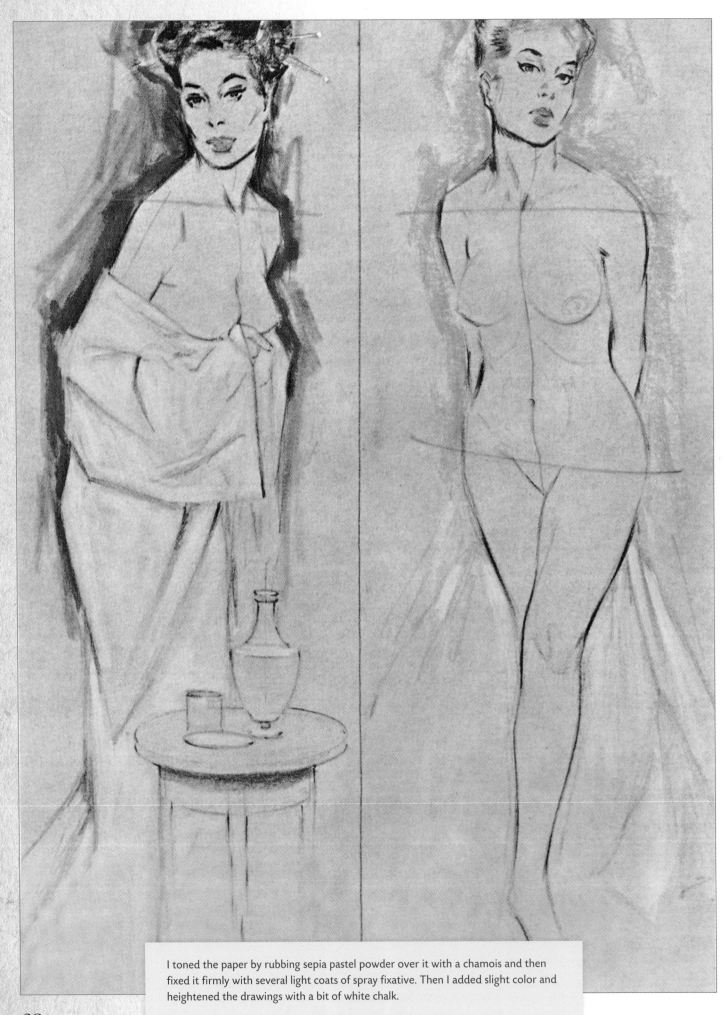

I toned the paper by rubbing sepia pastel powder over it with a chamois and then
fixed it firmly with several light coats of spray fixative. Then I added slight color and
heightened the drawings with a bit of white chalk.

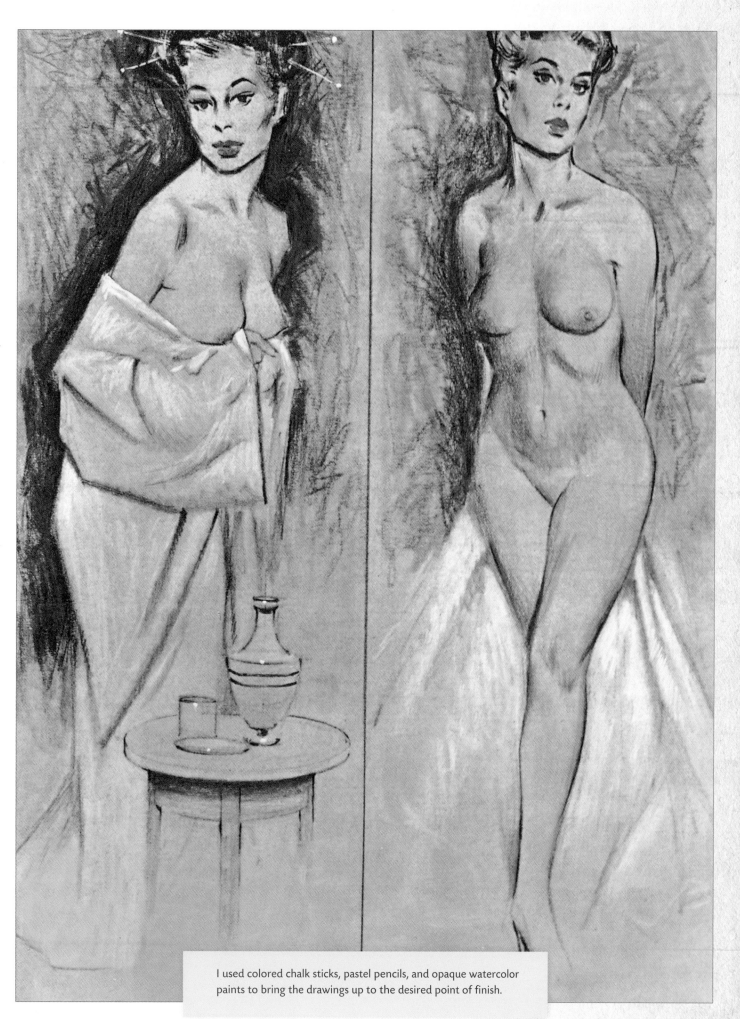

I used colored chalk sticks, pastel pencils, and opaque watercolor paints to bring the drawings up to the desired point of finish.

Sitting Woman

I find it disconcerting to face a blank canvas without making preliminary notes and sketches, even though the final painting may be a departure from the original idea that was in sketch form. I often complete 15 to 20 pages of sketches similar to this rough study (at left) before starting to paint. Many times the first sketch I draw is the one I paint from, but I do explore other possibilities.

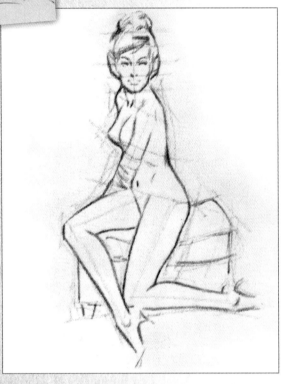

I started by drawing a lay-in sketch for a clothed figure.

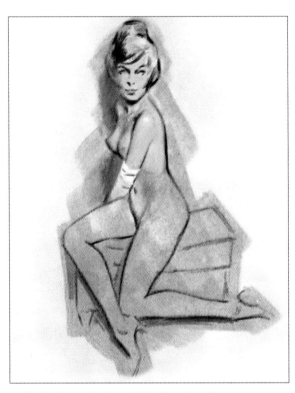

I added color and indicated the form by value.

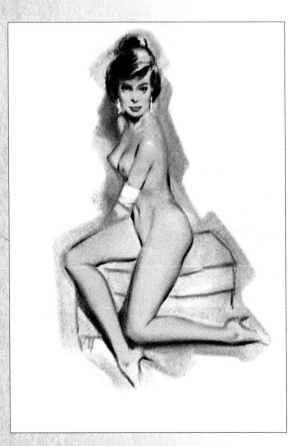

At this stage, the painting is nearly a finished nude.

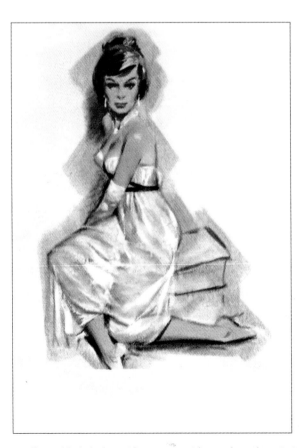

Finally, I added clothing. If you start with a nude underpainting, the folds and form of the drapery will be more believable.

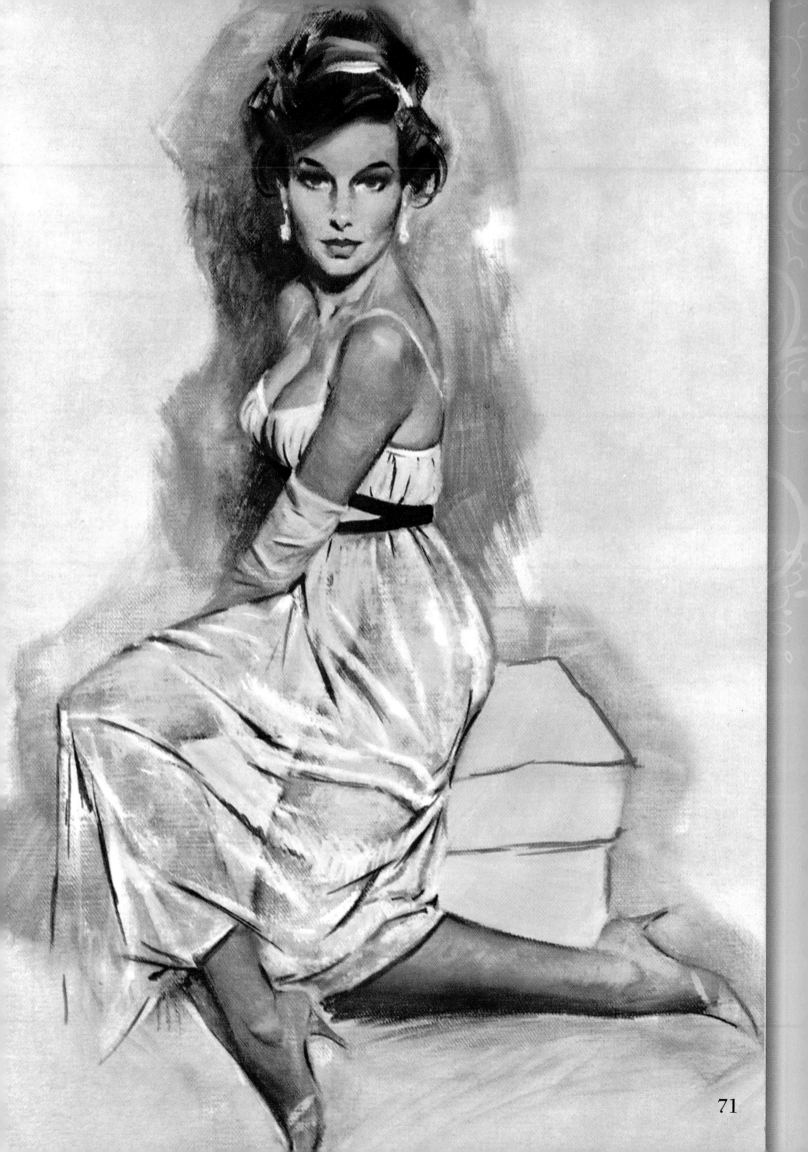

Sitting Nude

As you see in the finished painting, I eliminated the dark area behind the figure, which helped open up the space between the model and the background to keep the figure from looking "pasted" to the canvas. For the local flesh color, I used Mars brown, burnt umber, and titanium white. For the highlights on the hair and the figure, I used cadmium green pale and white. Many artists may not have black on their palette, but I find it a useful tinting agent. Beautiful silvery grays can be made with ivory black added to cadmium green pale, ultramarine, burnt umber, and the ochres. Just use it sparingly.

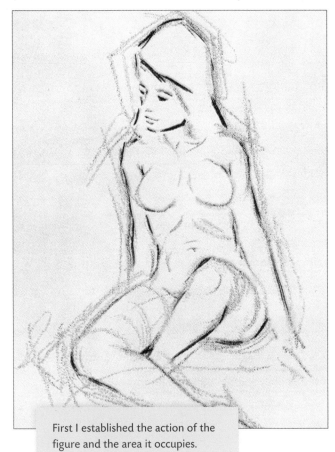

First I established the action of the figure and the area it occupies.

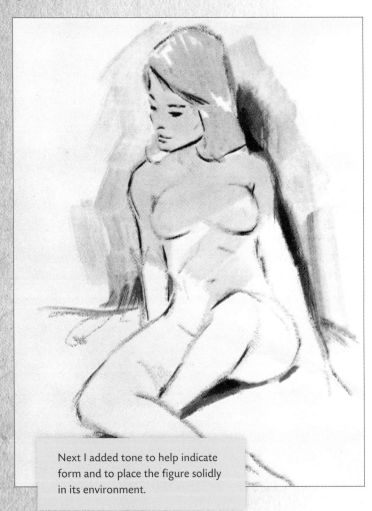

Next I added tone to help indicate form and to place the figure solidly in its environment.

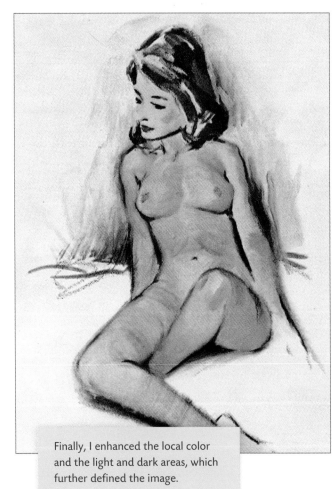

Finally, I enhanced the local color and the light and dark areas, which further defined the image.

Palette

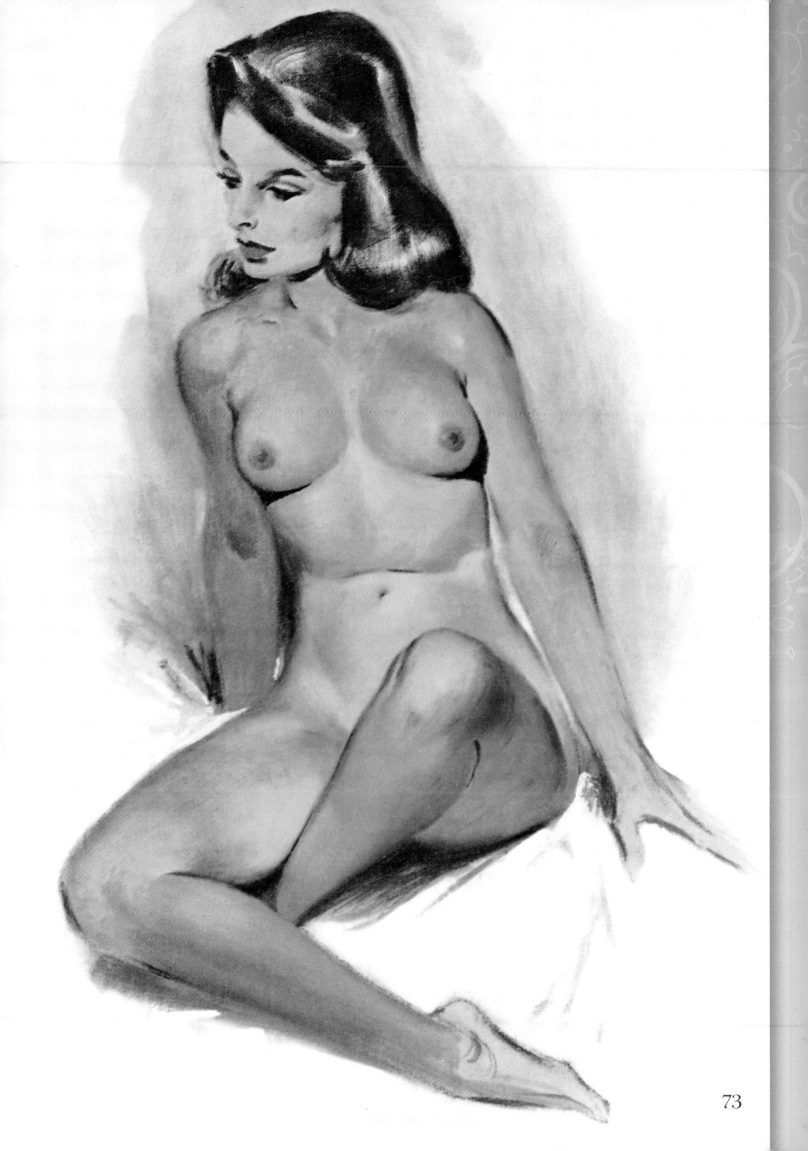

Gallery

74

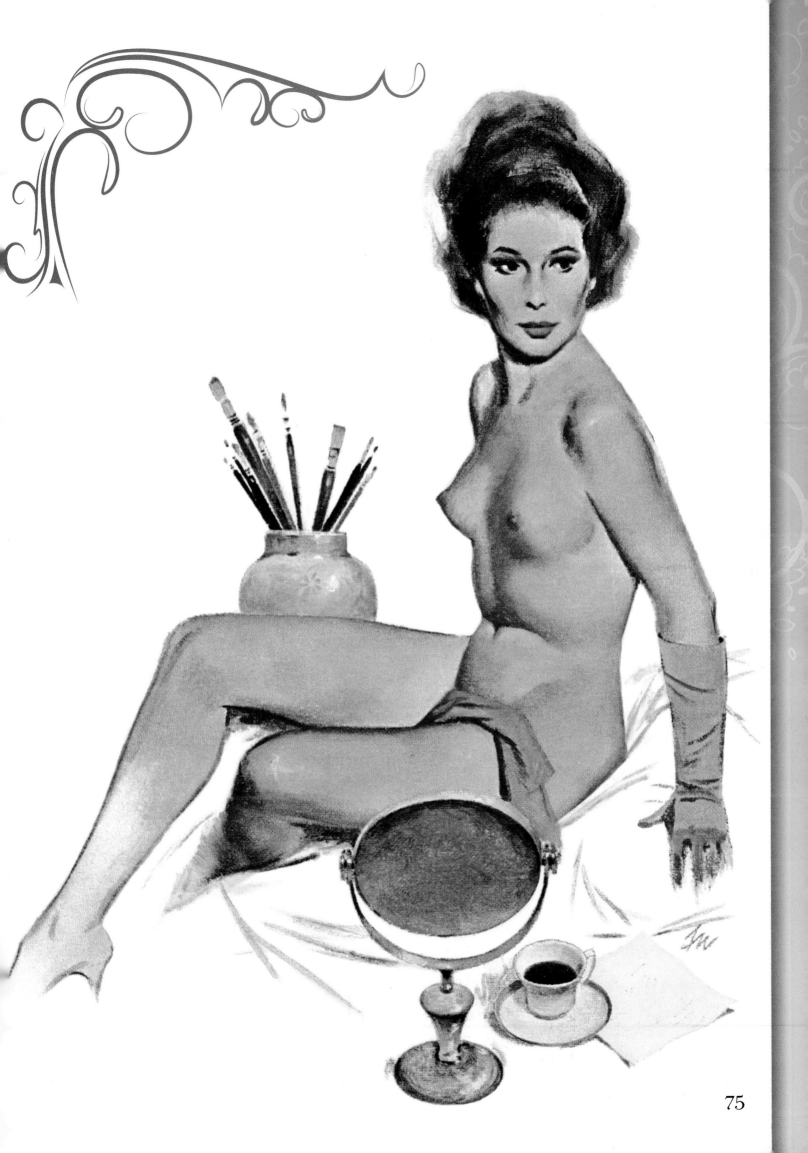

Palette

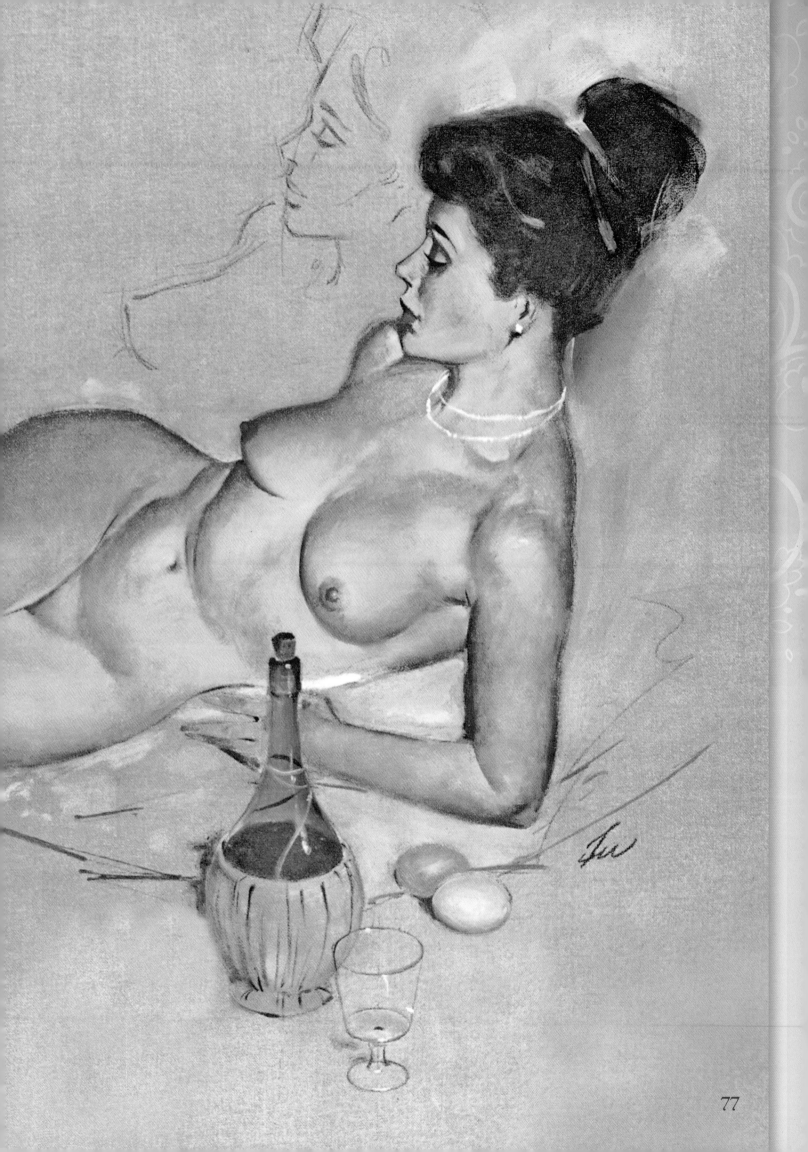

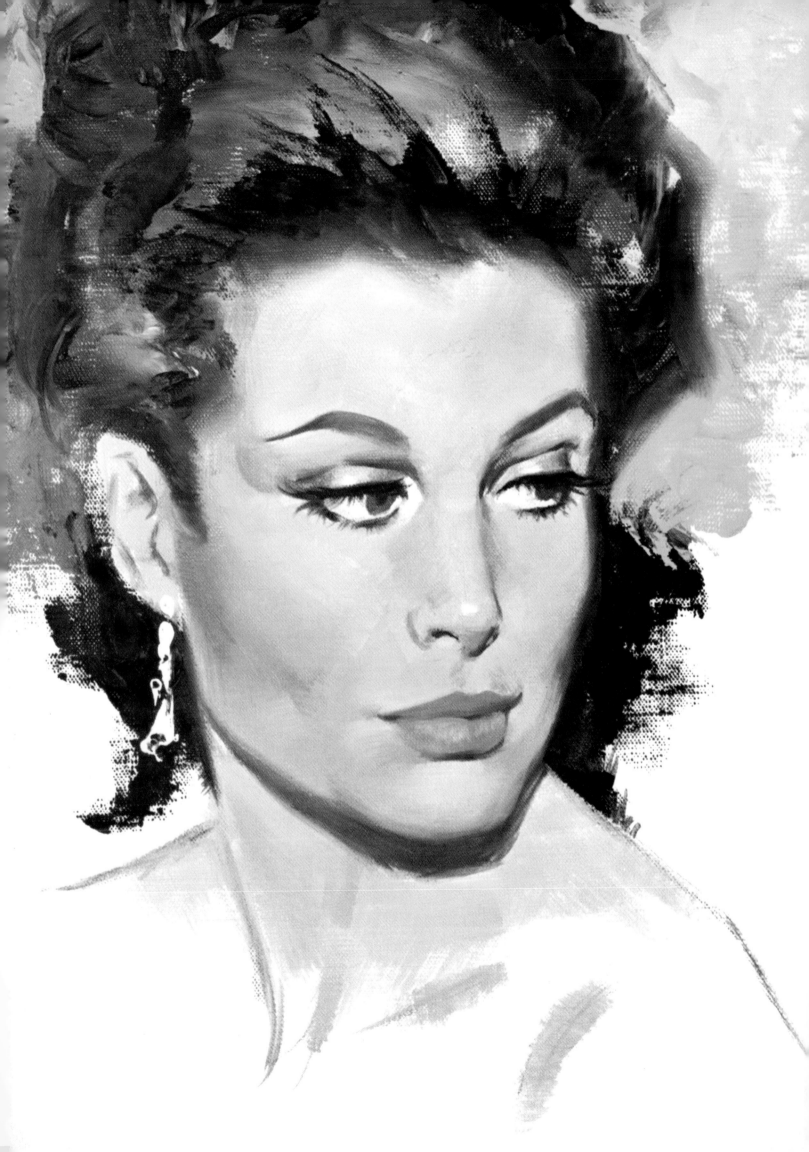

Chapter 4:
Oil: Faces & Features

with Fritz Willis

Painting the human face is no different from painting
any other subject; the key is to look carefully at the features
and paint what you see. Capturing a person's likeness on
canvas is a rewarding experience, and a finished portrait
is a very personal piece of art, whether it is painted as a
commission or kept as part of your portfolio. Because every
successful painting starts with a solid drawing, this chapter
includes some basic drawing techniques. I've also included
detailed descriptions of facial features and facial structures, as well
as tips on how to reflect your subject's personality. Remember to
practice—the more you paint, the better your portraits will be!

—Fritz Willis

Planning a Drawing

When you are planning a drawing or a painting of a head, be sure to work out the proper placement at the beginning. If the head is placed too low in the picture plane, it will appear to be falling off the bottom. If it is placed too high, it will appear to "float" on the paper or canvas.

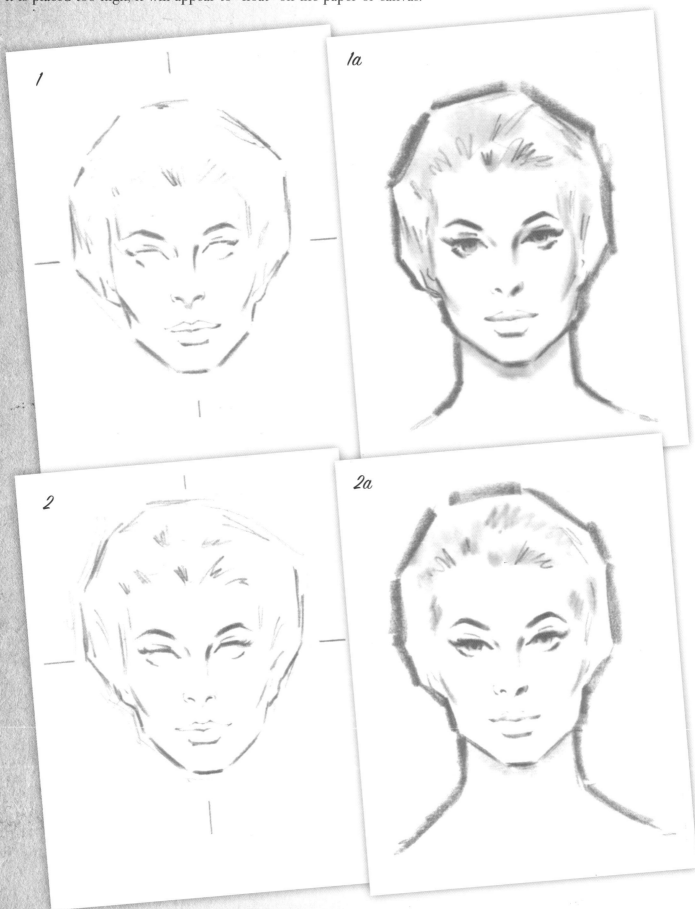

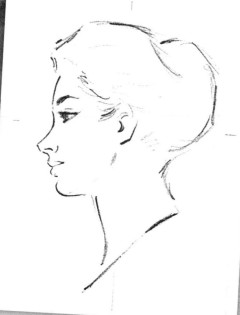

Profile

When painting a head in profile, leave slightly more background space in front of the subject than behind it. In the drawing to the left, the head is in the center, which makes the space in front too tight.

The head below is placed just to the right of center, which creates a more pleasing composition. This may seem a minor point, but many otherwise good paintings have been weakened by poorly placed subjects.

On the opposite page in the first set of sketches, the head is in the center of the frame, but it appears to be well placed (figure 1). When the neck and shoulders are added, however, the composition becomes too bottom-heavy (figure 1a).

In the second set of sketches, the head seems to be placed too high, but the space below is necessary to accommodate the neck and shoulders (figure 2). In the final frame (figure 2a), the head is now in the proper place for a well-balanced design. When the neck and shoulders are added, there is enough space to support the subject.

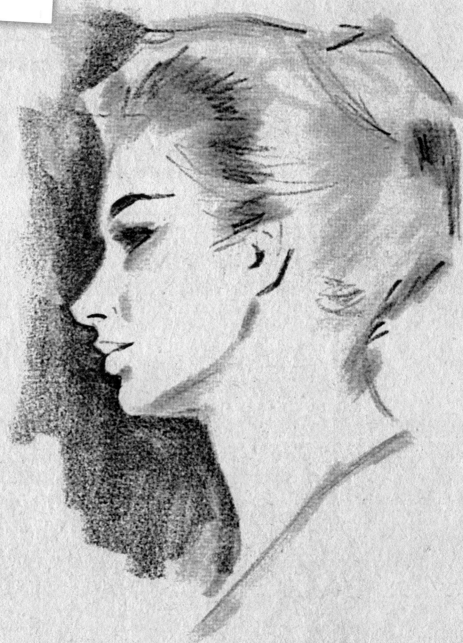

Lips

Pay close attention to edges when painting lips. Hard edges all around will make the lips look "pasted" on. Only use hard edges to define the shape of the top lip. Use soft edges everywhere else, as shown in the painting at right.

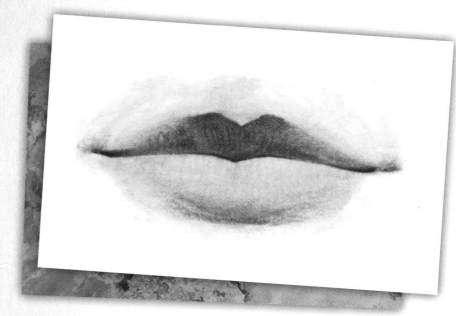

Palette

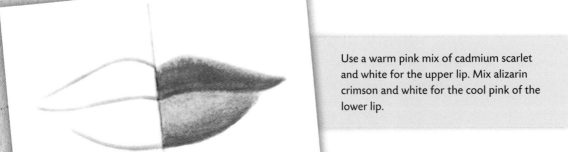

Use a warm pink mix of cadmium scarlet and white for the upper lip. Mix alizarin crimson and white for the cool pink of the lower lip.

For natural-colored lips, like those at right, use a mixture of Venetian red and white.

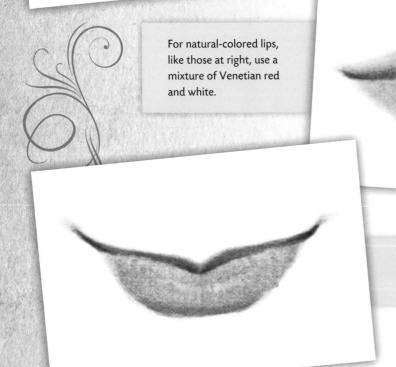

Do not use pure white for highlights on the lips; use pale pink instead.

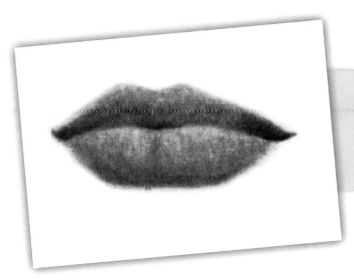

Soften the edges of the lips, blending the lip color into the surrounding flesh tones. You can paint a well-defined line at the center of the mouth, but be sure to soften the edges toward the outside corners.

Lips that are too red will look artificial. Although the combination of Venetian red and white creates a good natural color, you can add warmth by including a bit of cadmium scarlet.

The upper lip should be slightly warmer in color and darker in value than the lower lip. Mix alizarin crimson and white for the lower lip, and add cadmium scarlet to warm the upper lip. Also use alizarin crimson for the darkest accents in the corners of the mouth and at the separation between the upper and lower lips.

Remember not to make the highlight on the lips too bright.

83

Eyes

Study the different eye positions on these pages. Notice that the upper lid always slightly overlaps the pupil and iris. This keeps the eyes looking natural. The upper lid also casts a subtle but effective shadow on the eyeball. The upper lashes are heavier and fuller than the lower lashes, so they should always be darker. Also notice that the lower lashes become longer and fuller toward the outside corner of each eye.

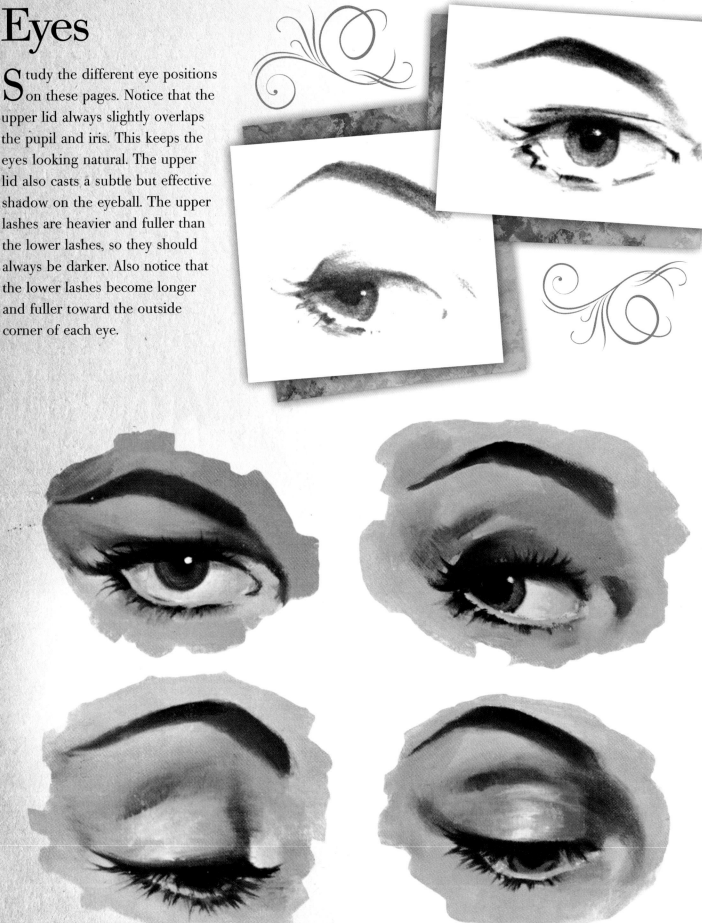

The colors on the upper lids will affect the expression of the face. Be careful when painting eyelids that have been made up with colored eye shadow. Some colors add sophistication, but bright colors and overpainted eyes can appear clownlike.

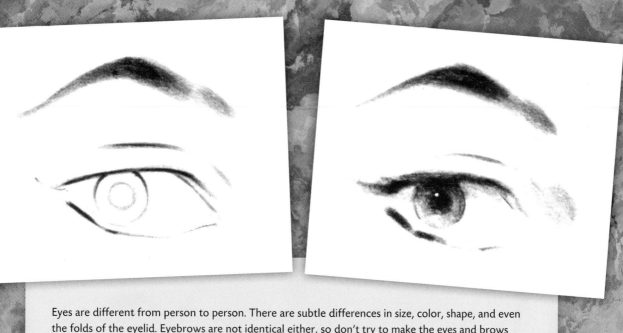

Eyes are different from person to person. There are subtle differences in size, color, shape, and even the folds of the eyelid. Eyebrows are not identical either, so don't try to make the eyes and brows match perfectly. A face that is perfectly symmetrical is seldom interesting.

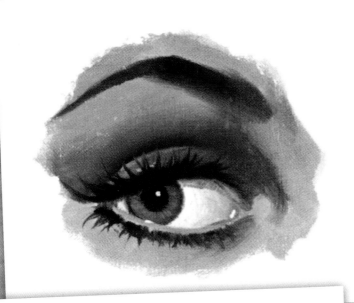

Place the highlight in the eye carefully, and don't make it too large, or the eye will appear glassy. For the desired look, put a small highlight in the area where the inner edge of the lower lid meets the white of the eyeball.

Don't make the "white" of the eye pure white; it should actually be very close to the lightest value of the subject's skin tone.

If your subject is in bright light, the pupil will contract. To make the eye more visually appealing, make the pupil larger than it actually appears.

The iris of the eye has a soft edge. It is not just a disk of color sitting on the surface of the eyeball; it is an area of color within the eyeball. The pupil also has a soft edge, so let it blend into the iris, and let the iris blend into the white of the eye.

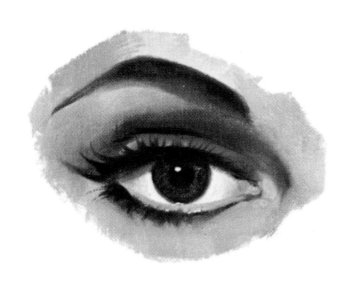

The Nose & Hair

The shape of the nose differs from person to person, but it also changes with age. A soft, round nose is typical of youth, and the defined angles of a chiseled nose denote maturity.

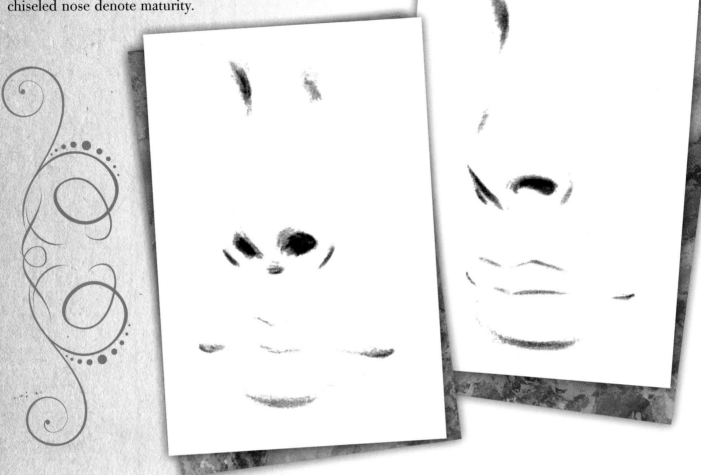

In the mature face, the bone structure of the nose is more evident, and the part of the nose directly between the eyes is narrower than it is in youth. (The space between the eyes is also narrower than in a baby's face.)

In a young face, the nose is shorter, with softer, rounder planes and often a slight upward tilt at the tip. (Take care not to tilt it too much!) Treat the nostrils delicately, without giving them too much emphasis.

Unlike the eyes and the mouth, the nose is practically immobile and has very little to do with the expression on a face. It is, however, an important feature for establishing the character and nature of the model and for capturing a likeness.

Throughout life, the nose and ears continue to grow, so a long nose and large ears are an indication of more advanced age. The nose of a very elderly person also tends to droop a little at the end.

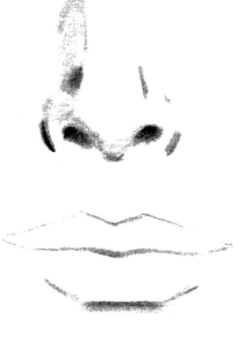

Hair is an important element of the head, and it can be used to express elegance or simplicity, maturity or youth, sophistication or innocence. But don't let a hairstyle influence your impression of a model's personality. Take artistic license, and style the hair so that it expresses the feeling you get from your subject. Always make the hair an attractive and interesting frame for the face.

These six drawings use the same basic head and face, but each has a different hairstyle. As you can see, changing the hairstyle affects our impression of the model's entire character. Styles change with fashions, so avoid using extreme, high-fashion hairstyles, as they will date your painting.

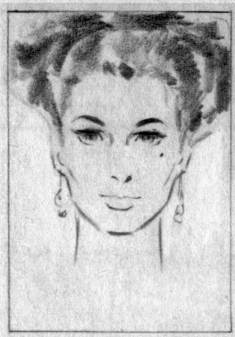
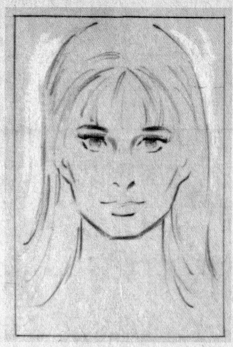
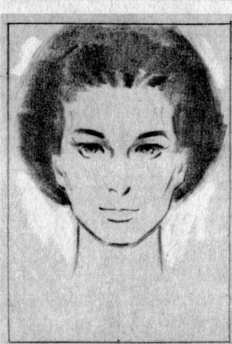
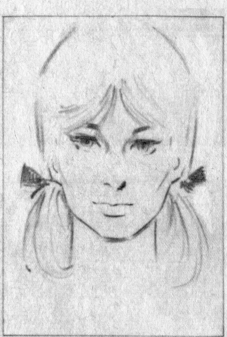
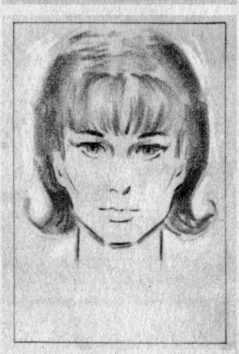
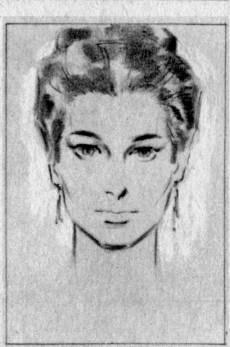

Facial Structure & Personality

It is easier to capture a likeness when working from a model who has clear, definite facial characteristics. The bone structure in these faces is quite evident. The soft treatment of the hair framing the faces also accents their angular structure.

Notice the different personalities conveyed in these two drawings. The rounded forms and soft shading on the head below contribute to the model's sense of innocence, whereas the sharper angles of the drawing at right add a look of maturity. Be aware that angled lines drawn too sharply will create a hard look, entirely changing the model's personality.

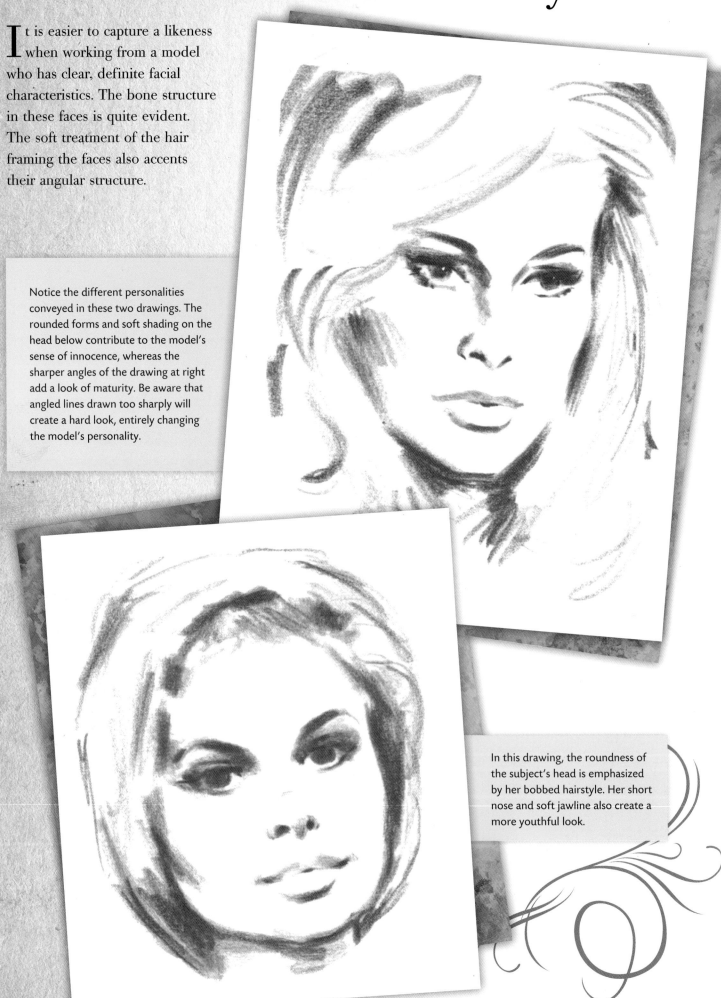

In this drawing, the roundness of the subject's head is emphasized by her bobbed hairstyle. Her short nose and soft jawline also create a more youthful look.

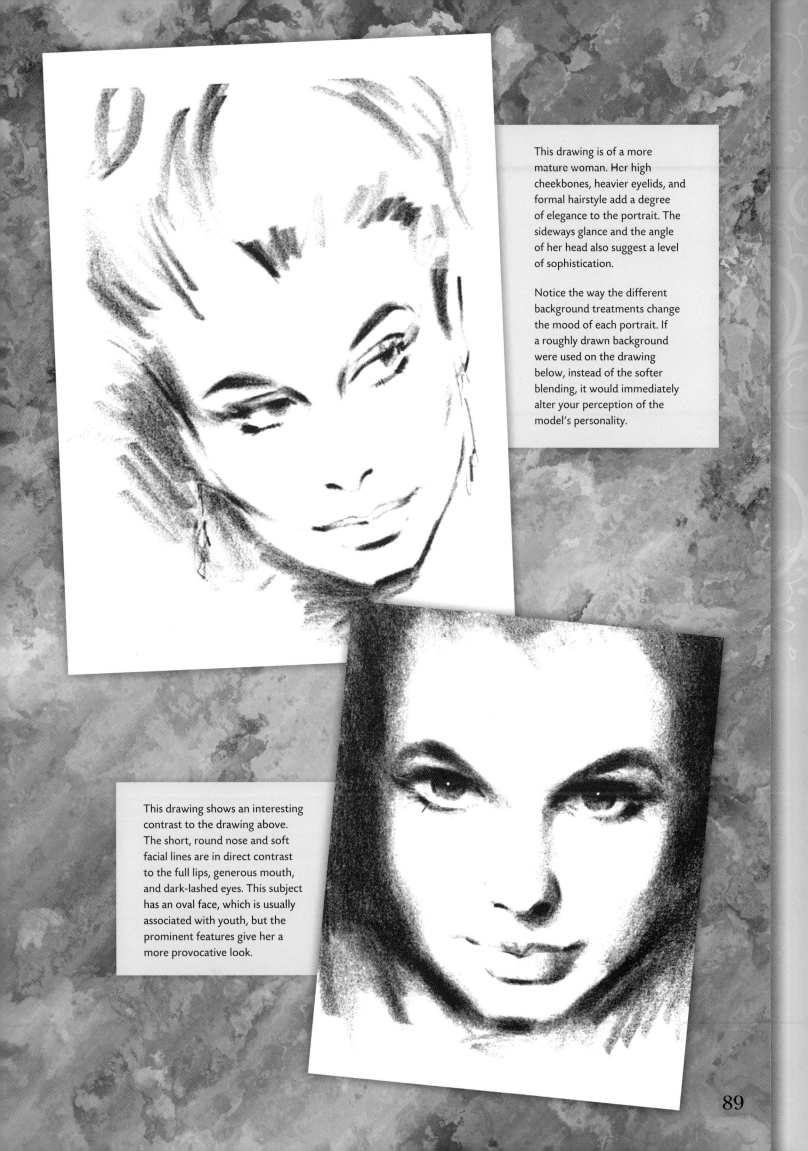

This drawing is of a more mature woman. Her high cheekbones, heavier eyelids, and formal hairstyle add a degree of elegance to the portrait. The sideways glance and the angle of her head also suggest a level of sophistication.

Notice the way the different background treatments change the mood of each portrait. If a roughly drawn background were used on the drawing below, instead of the softer blending, it would immediately alter your perception of the model's personality.

This drawing shows an interesting contrast to the drawing above. The short, round nose and soft facial lines are in direct contrast to the full lips, generous mouth, and dark-lashed eyes. This subject has an oval face, which is usually associated with youth, but the prominent features give her a more provocative look.

Using a Brush & Painting Knife

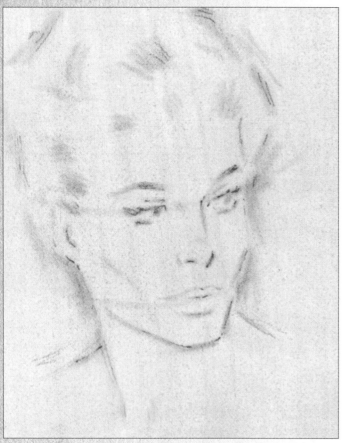

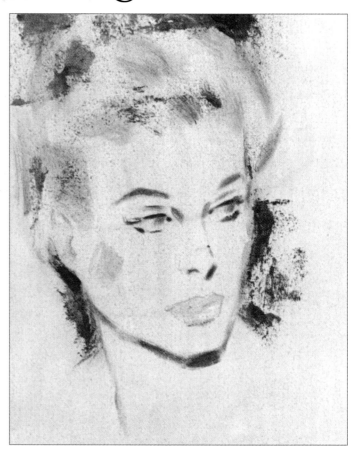

For this oil portrait, I lightly sketched the head and neck on an 8" x 10" canvas board. Then I sealed it with several light coats of matte spray fixative.

Next I sketched the features with a small pointed sable brush; then blocked in the dark values and background with a trowel-shaped painting knife.

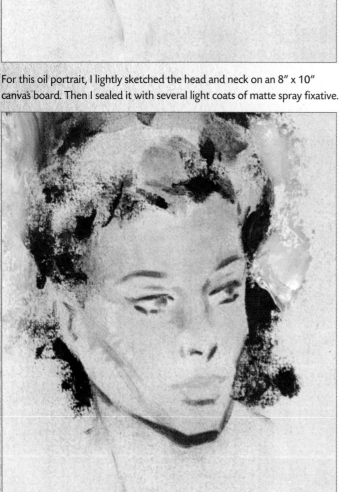

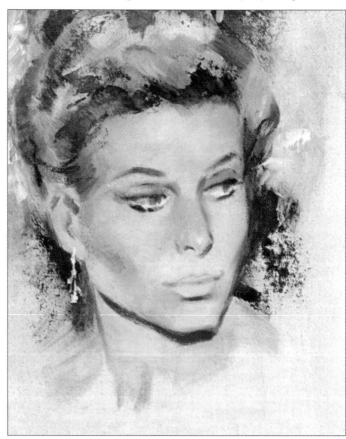

I started building up the colors with the painting knife using cadmium orange, yellow ochre, and titanium white for the flesh tones; raw sienna and burnt umber for the hair; and terra verte, cadmium green pale, and burnt umber for the background.

I continued developing the portrait with a combination of brushstrokes and knife work. I used the brush to smooth out the transitions between values in the face, and used the knife to create texture in the hair and the background.

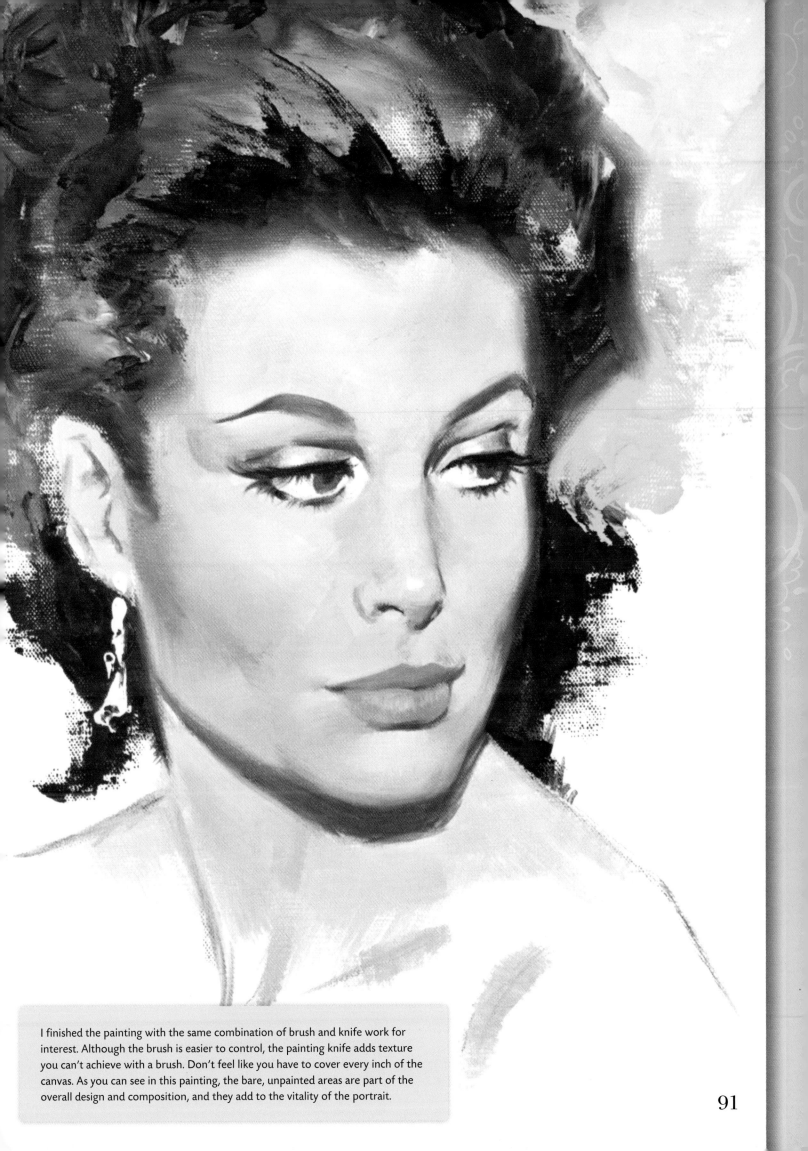

I finished the painting with the same combination of brush and knife work for interest. Although the brush is easier to control, the painting knife adds texture you can't achieve with a brush. Don't feel like you have to cover every inch of the canvas. As you can see in this painting, the bare, unpainted areas are part of the overall design and composition, and they add to the vitality of the portrait.

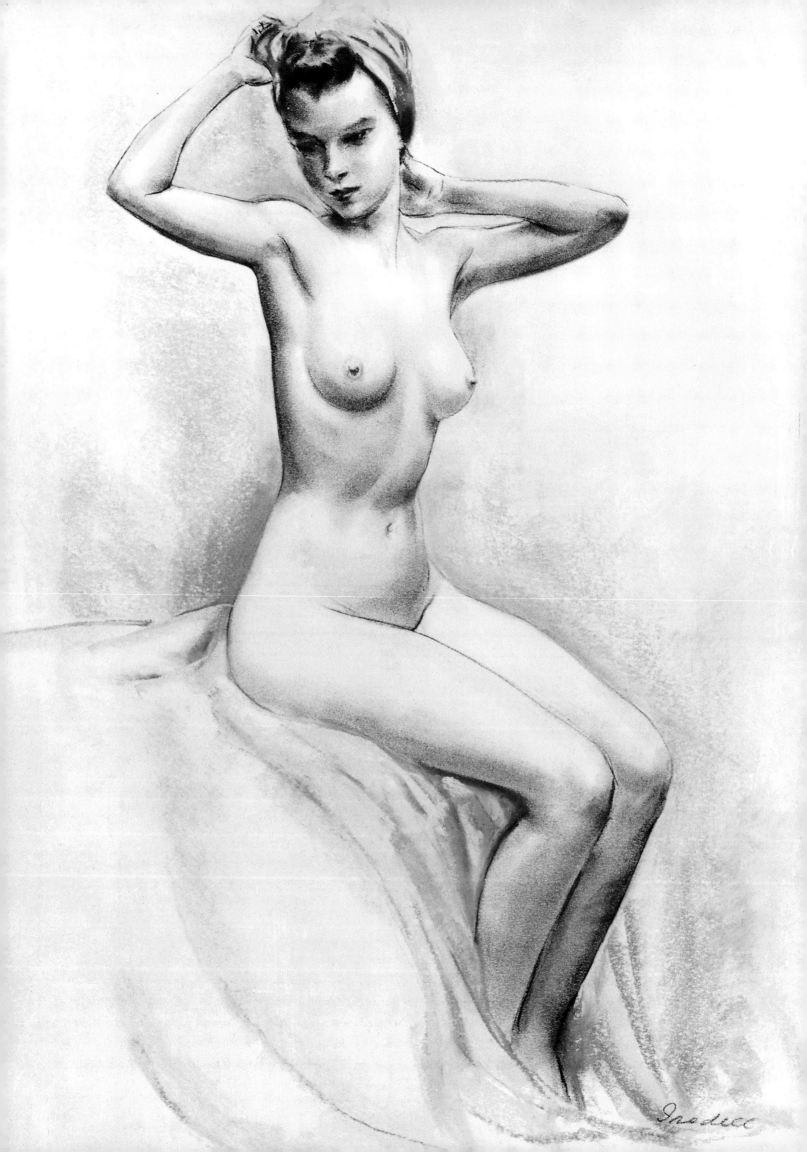

Chapter 5:
Female Figures
with Russell Iredell

The female form is a fascinating drawing subject. Artists have rendered the female figure for centuries, and now you too can learn how to capture its natural beauty and elegance on paper. In this chapter, you'll learn to draw female figures in a number of different poses and in various styles, from thumbnail sketches to finished drawings. Included are simple instructions on how to use proportion, perspective, shading, and lighting in your renderings, as well as ways to incorporate knowledge of basic anatomy to make your drawings even more realistic. You'll also learn a number of techniques for creating special effects with pastel and charcoal. With continued study and practice, your technique will improve over time. For now, enjoy your new drawing adventures!

—Russell Iredell

Proportion

Before an architect can build a skyscraper, he or she must know about the framework and material of the building. The same goes for an artist who wants to draw the female figure. It is helpful if you know something about the bones, muscles, and tissues of the body, including their size, function, weight, and texture. Large bones are rigid and are moved in their sockets by muscular contraction. Intelligent observation as you draw will tell you a great deal, perhaps more than a book on anatomy. Note how near some bones are to the surface, including the shoulder, elbow, wrist, thigh, knee, ankle, and pelvic bones.

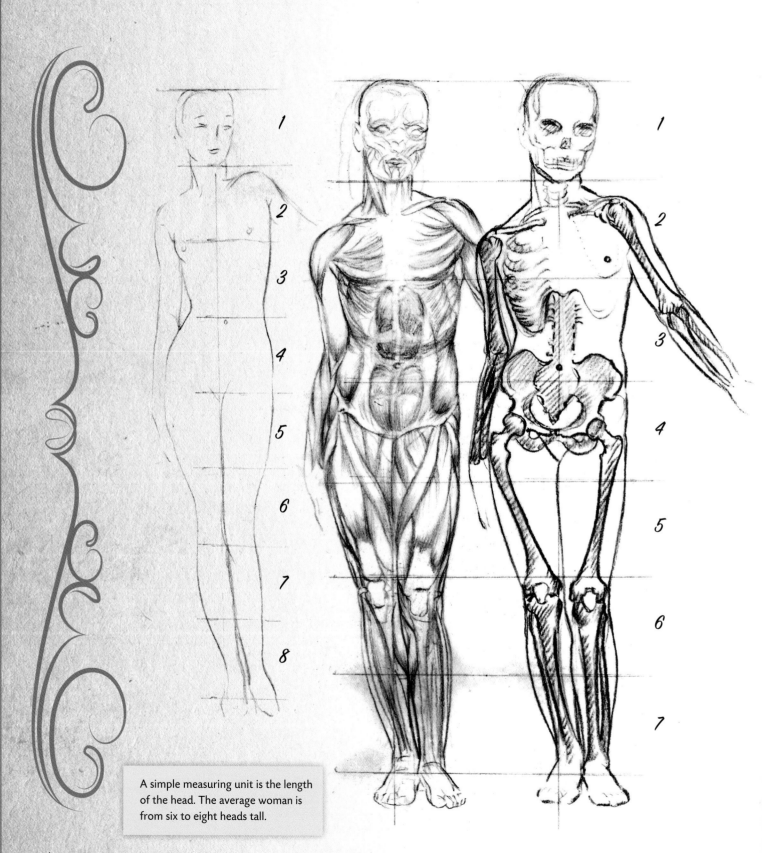

A simple measuring unit is the length of the head. The average woman is from six to eight heads tall.

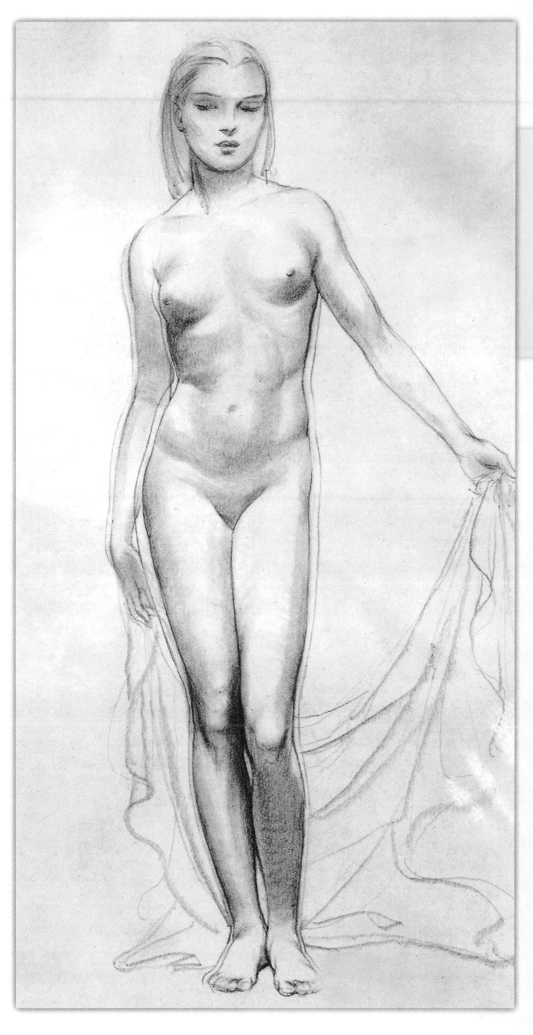

The shoulders are usually about two-heads wide; the waist is approximately one-head wide; and the hips are about one-and-a-half-heads wide. However, the distance from the chin to the pelvic bone is approximately one-and-a-half to two-heads tall, which is the same from the pelvic bone to the knee cap, and from the knee cap to the heel.

Thumbnail Sketches

Before you start drawing, it is good practice to jot down small thumbnail roughs of your composition. They will save you laborious changes later and help you see and plan the larger design.

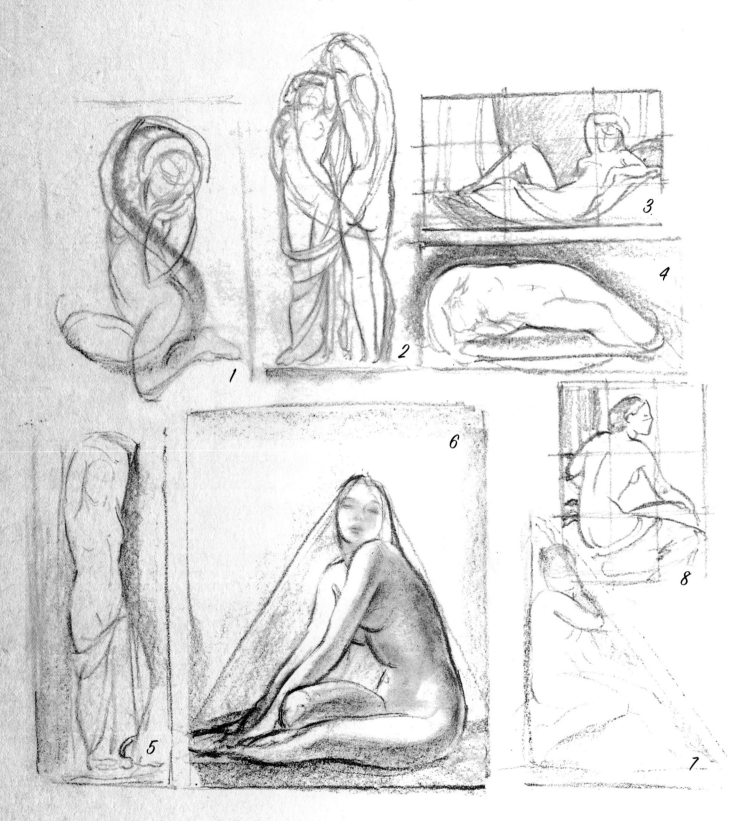

Composing a Figure In composing a figure, large curves and spiral lines help to give action (figures 1 and 2). Horizontal forms show repose (figures 3 and 4). Vertical forms show height (figure 5), and triangular forms show solidity (figures 6 and 7). Gridlines can also help you determine where to place a form so that it fits well in relation to the space surrounding it (figure 8).

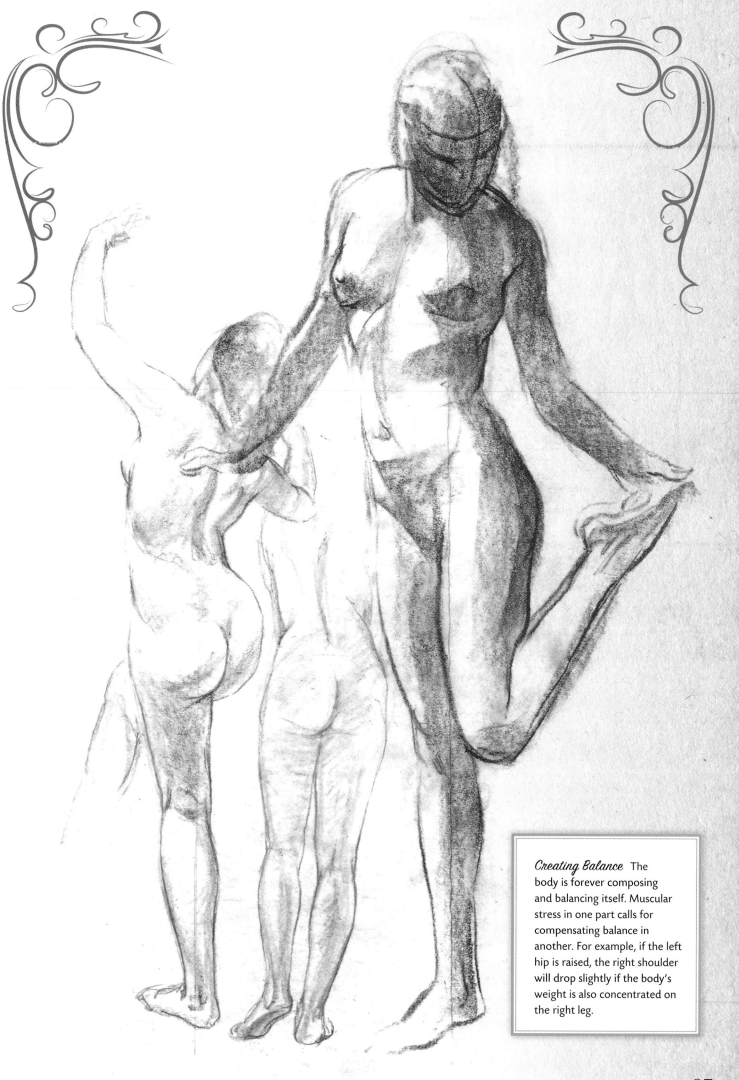

Creating Balance The body is forever composing and balancing itself. Muscular stress in one part calls for compensating balance in another. For example, if the left hip is raised, the right shoulder will drop slightly if the body's weight is also concentrated on the right leg.

Lines & Form

Whan drawing, think of the body as a series of cylindrical forms or rounded oblongs. The arms, the legs, the neck, and even the fingers and toes are in this general form. The head is oval shaped. The eyes are balls that are set in concave sockets. The nose is a cone-shaped projection. As you draw, be conscious of the body's solidity, its weight, and the weight of its parts. Don't be afraid to make light, structural lines; they will help you to realize form and are easily erased if necessary.

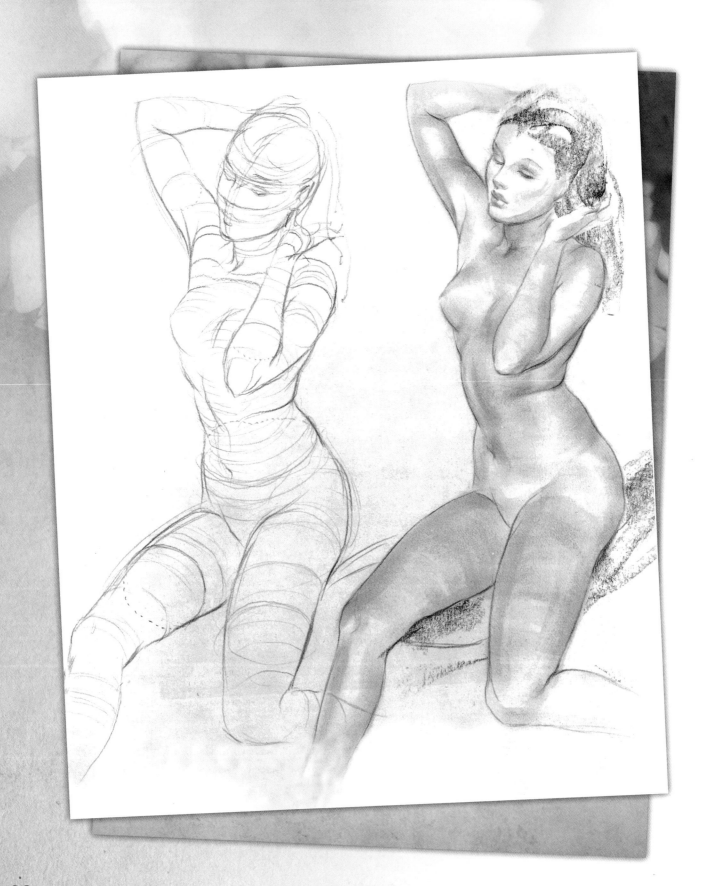

Light & Shadows

There are three basic forms in nature: the sphere, the cube, and the cone. The cylinder and oblong are but extended combinations of these. Learn to recognize basic and structural forms in larger as well as in smaller areas. Light is crucial in drawing. A circle is not ball-like until we make it look solid by indicating the effect of light upon it. Shadows also have light in them because of the reflection of other forms. A strongly lighted solid form can be expressed graphically by the shape of cast shadows alone (figure 1). By adding a third plane or middle tone, it is easier to capture a more realistic three-dimensional effect (figure 2). Carried further, reflected light in the shadows and texture in the light is required (figure 3).

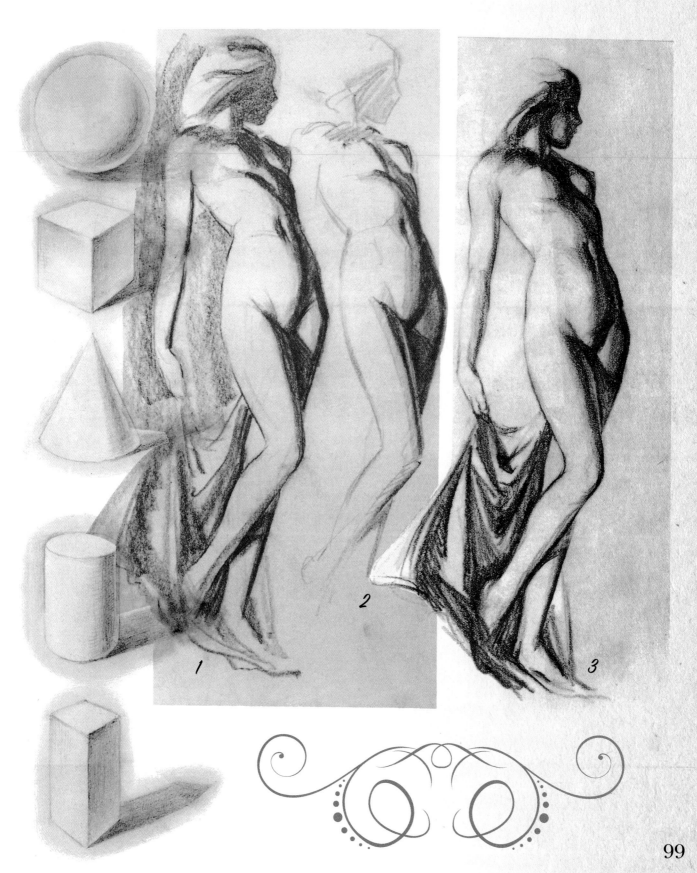

1

2

3

Standing Poses

The large sweeping curve was my first line, followed by the others around it. Notice how extended lines seem to flow into others and how the smaller curves complement and balance them, knitting the whole together in a few, quick strokes. Note how the lines are accented at important points at the ankle, knee, and shoulder and how the center line of gravity helps locate shoulder, breast, waist, and ankle on that line. This should take but a few minutes. Only speed will catch movement. Too much detail in the finish can spoil the spontaneity and make action appear static. Blow away excess charcoal before you use more indelible material.

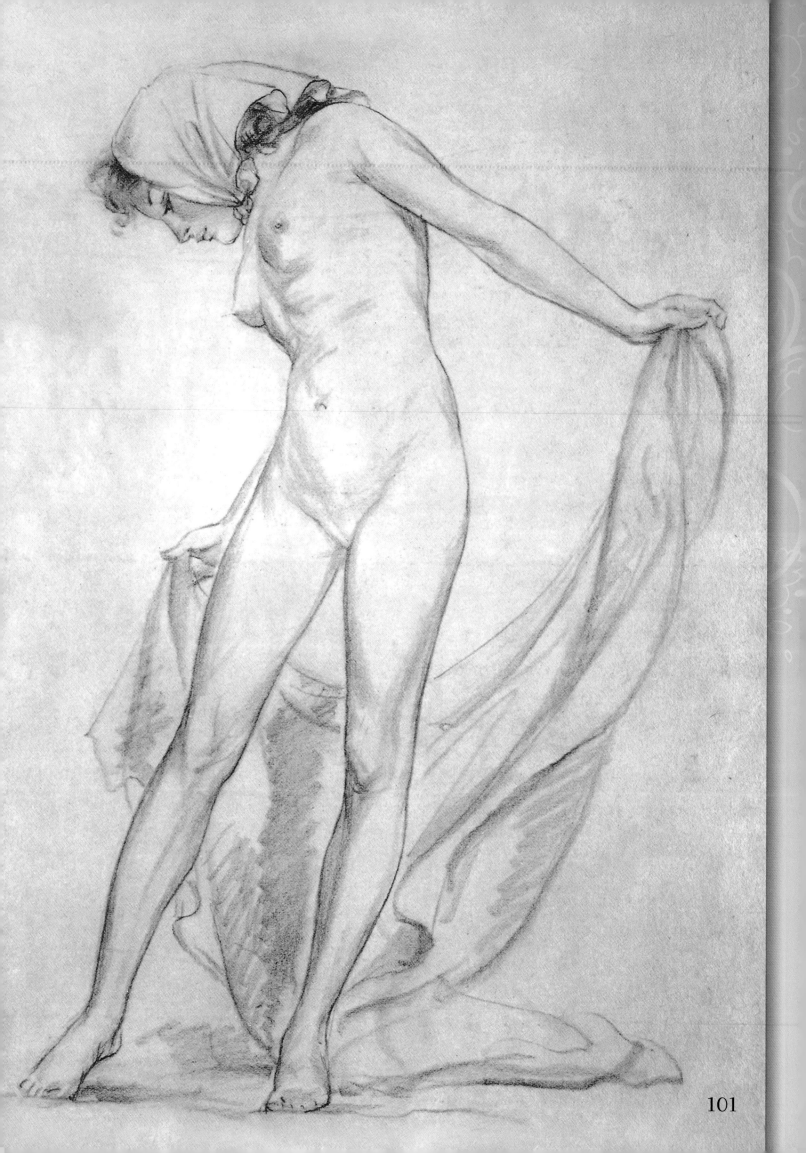

There is a marked difference in the look of legs supported by high heels. Figures 1 and 2 below are the same legs and are drawn the same size. Note the difference in contour in the figure wearing heels: how the knees are forced back and the arch of the instep is accentuated. The leg muscles of the toe dancer should appear to be well developed to support the weight of the body.

When you have decided what you want to draw, you must establish the scale of your composition by indicating its limits. Pick up charcoal on your finger or use the point and lightly suggest the main forms with sweeping curves or straight lines. Lightly accent points of the bony structure. Take your measurements from these, rather than the muscular edges. As you correct and develop the structure, break down the curves into a series of straight lines; then refine them after the main sketch is blocked in.

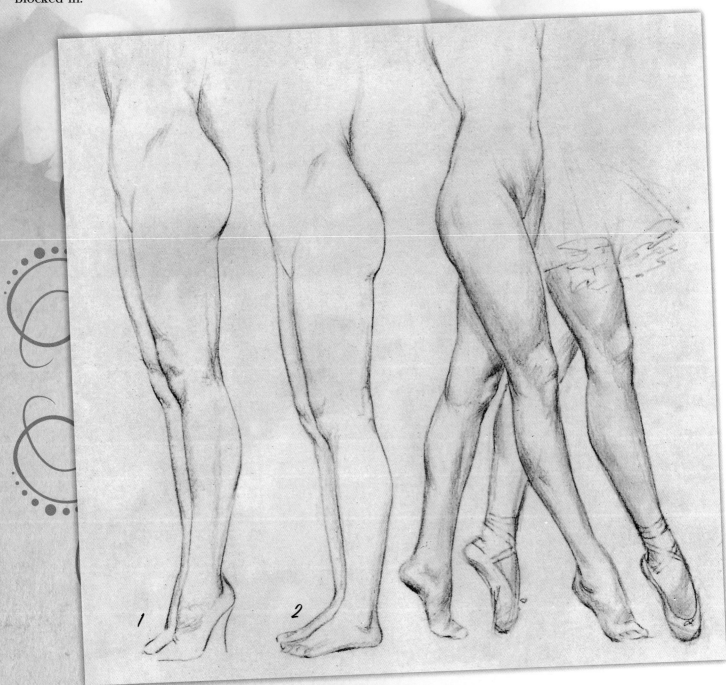

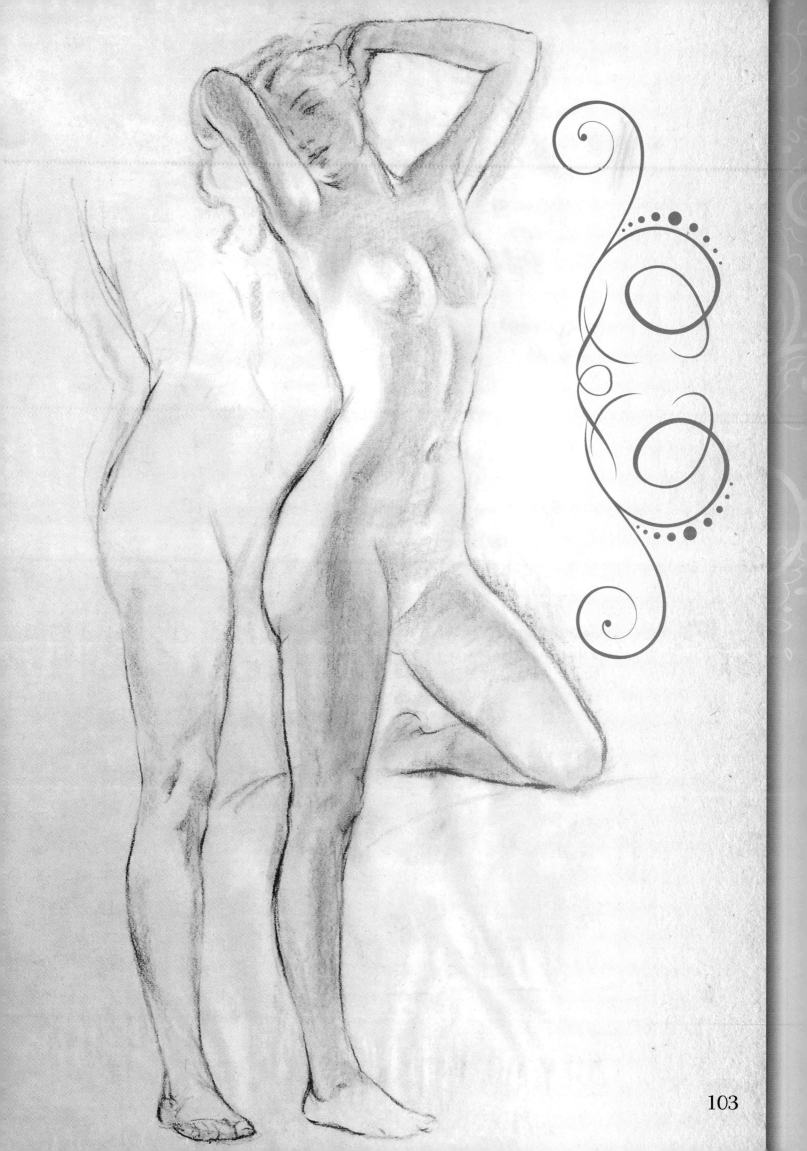

Frame within a Frame

This composition involves the use of a frame within a frame. I have tried to make the face the center of interest by framing it in the space formed by the arm. The strong vertical line in the back of the dressing gown helped give stability to the composition. The three double lines in ink are added to show the large movements that give the drawing action and design.

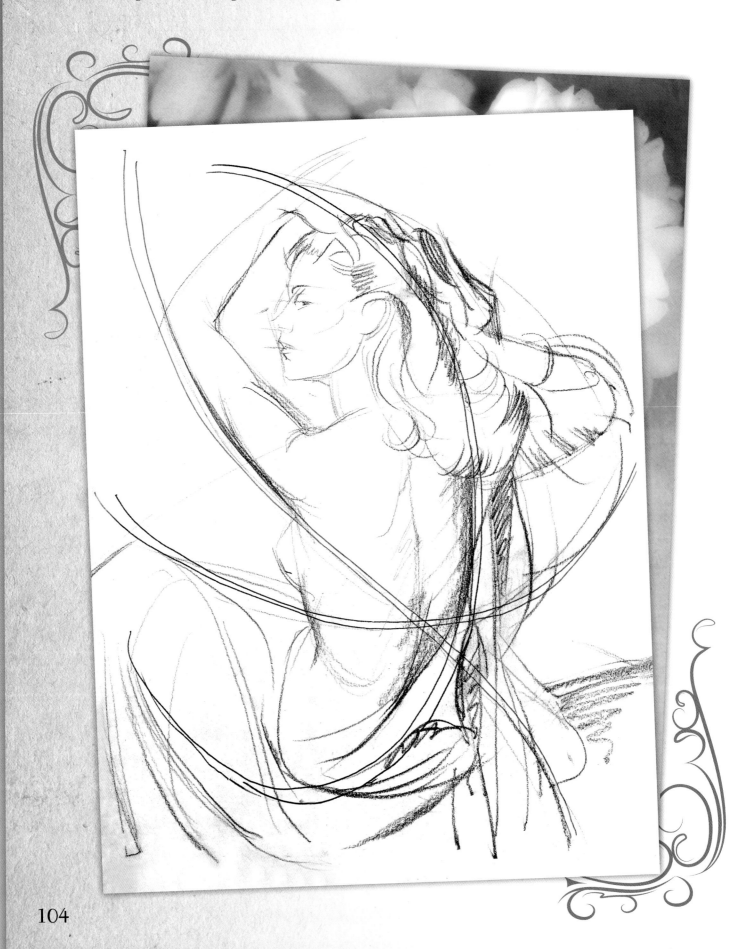

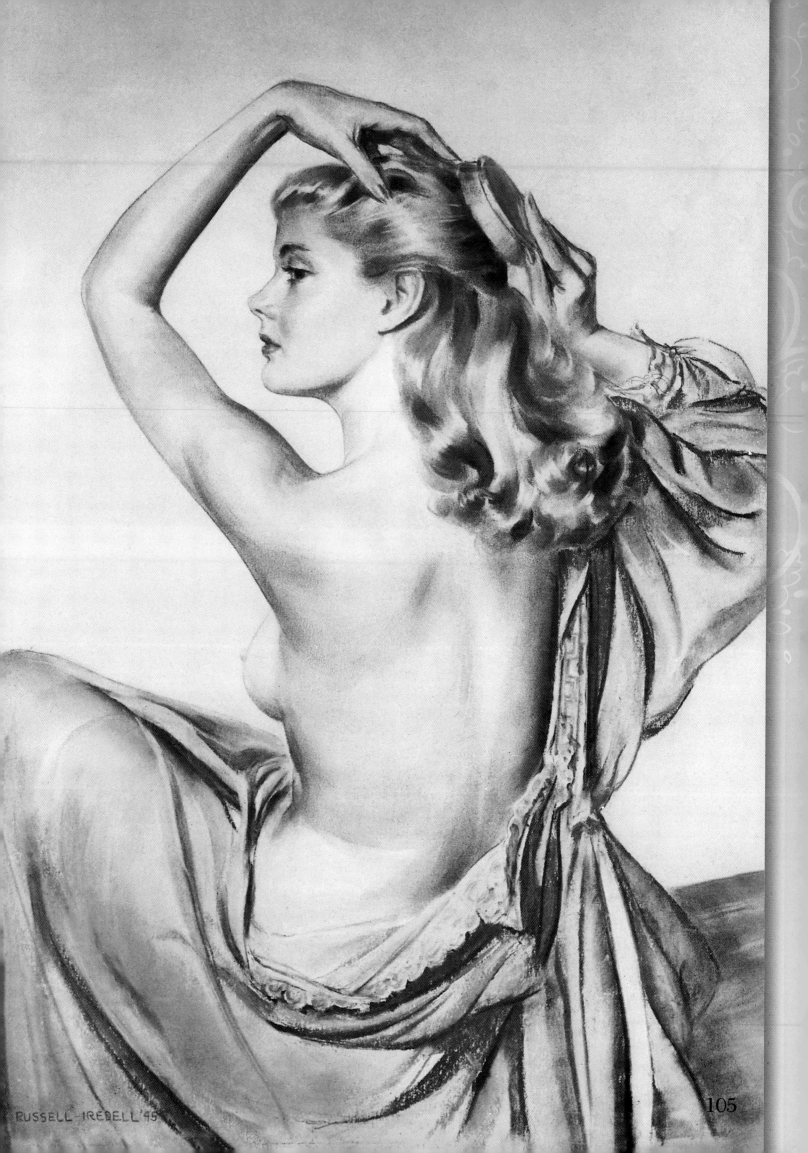

RUSSELL IREDELL '45

105

Reclining Poses

This figure occupies an oblong shape about twice its height. The action appears cradled in the large curve of the base. I noted the points indicating the limits of the structure and drew the straight lines in charcoal from point to point to determine their relation to each other. I then drew the shape of the deepest shadows and roughly filled them in to give the whole composition more substance.

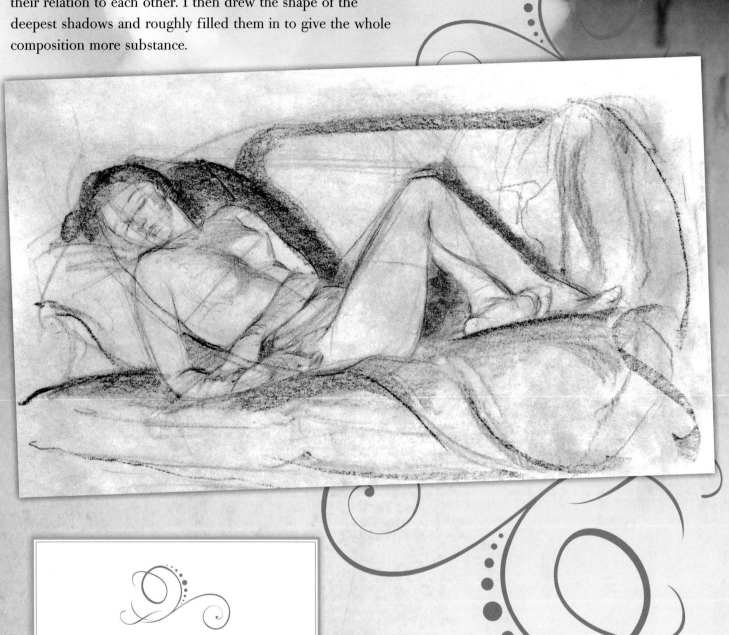

Critiquing Your Work It's important to step back from your work now and then and critique it as though it were somebody else's. Turn it upside down and look for weaknesses in structure and composition. Hold it up to a mirror to gain a fresh viewpoint.

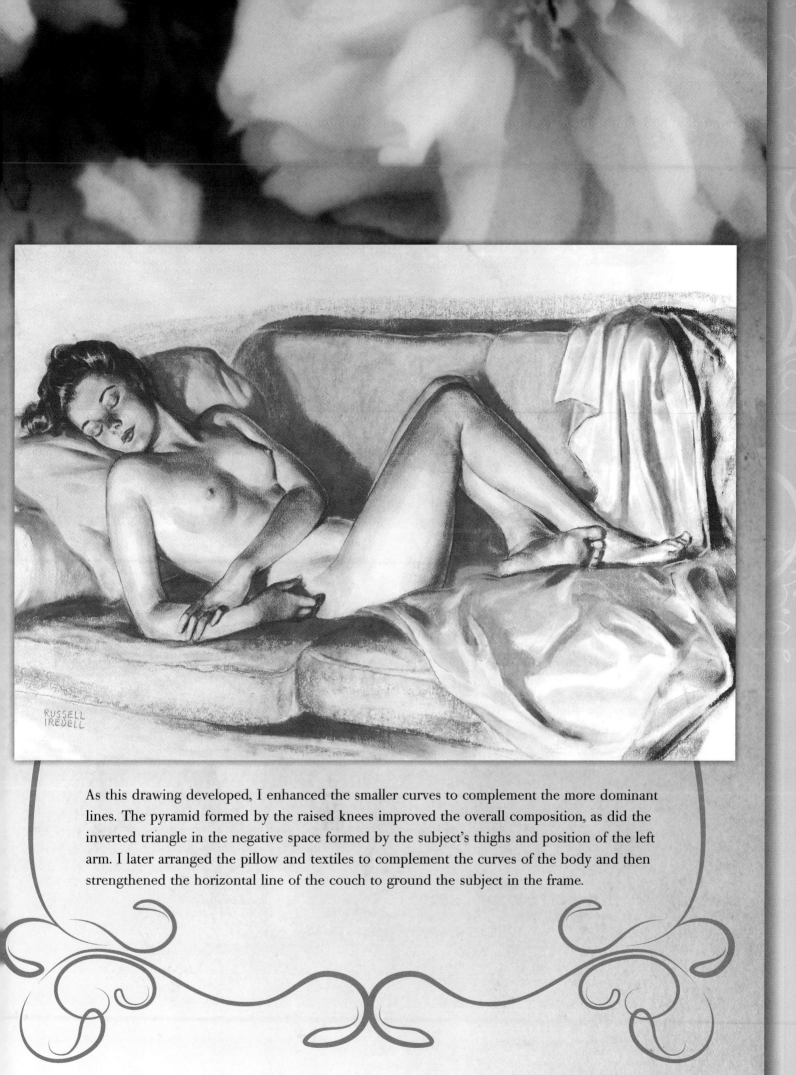

As this drawing developed, I enhanced the smaller curves to complement the more dominant lines. The pyramid formed by the raised knees improved the overall composition, as did the inverted triangle in the negative space formed by the subject's thighs and position of the left arm. I later arranged the pillow and textiles to complement the curves of the body and then strengthened the horizontal line of the couch to ground the subject in the frame.

107

The reclining pose is not an easy one to start. In this composition there are no marked breaks and no strong shadows in the lighted form until the plane recedes at the knees. Draw lightly, as an unmarred surface is desirable, and the subtle planes and delicacy of lines are important. The slight suggestion of a curtain in the background helps compose and locate the figure, as do the lines of the material under the figure. In the drawings below, the under-line of the arms and the structure lines of the torso were defined first (figure 1). Then broader tones were laid down in place of the rough sketches, and other important lines were further accented (figure 2).

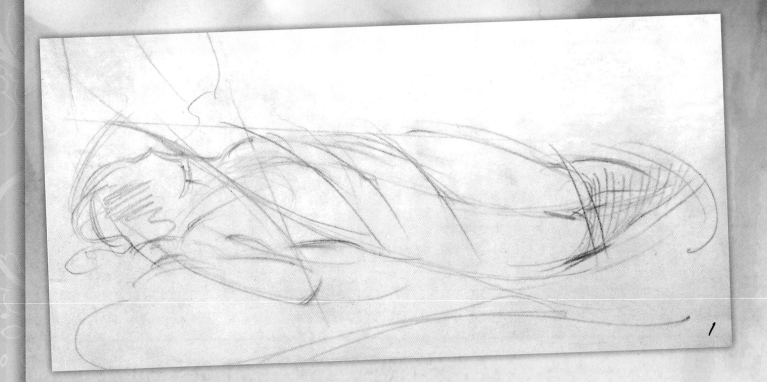

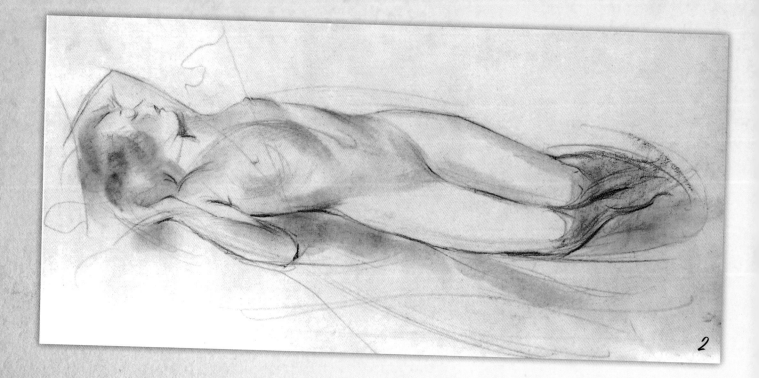

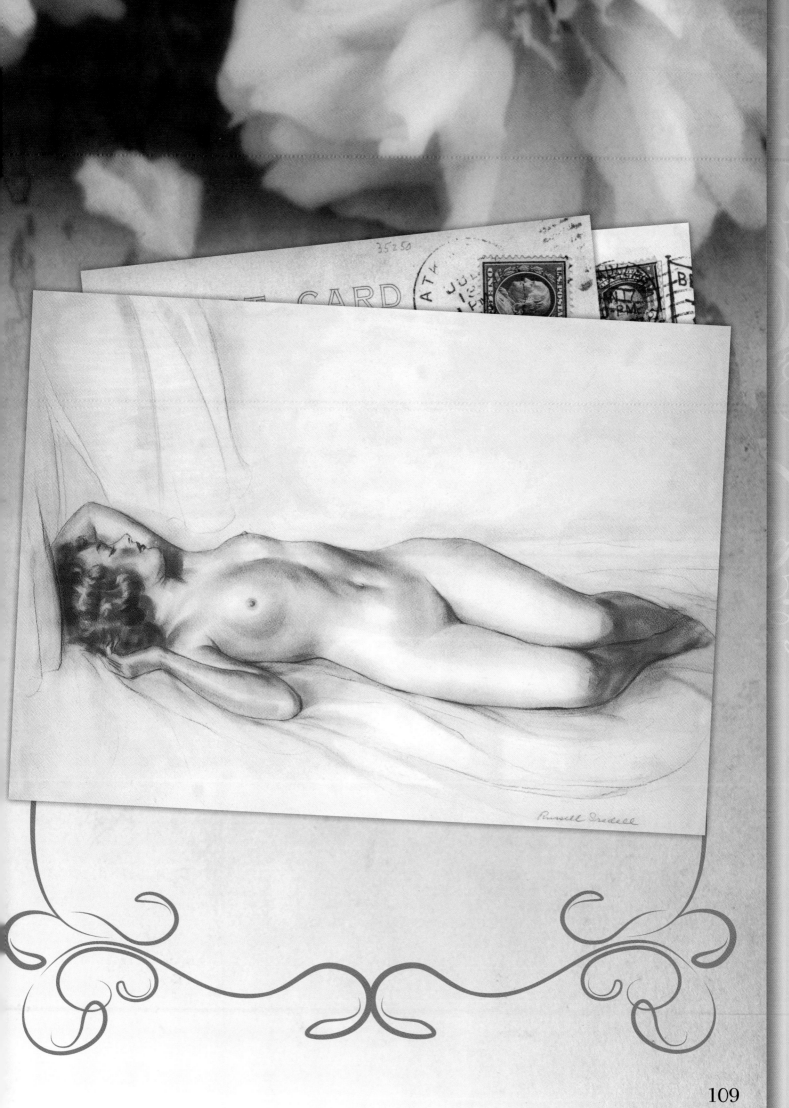

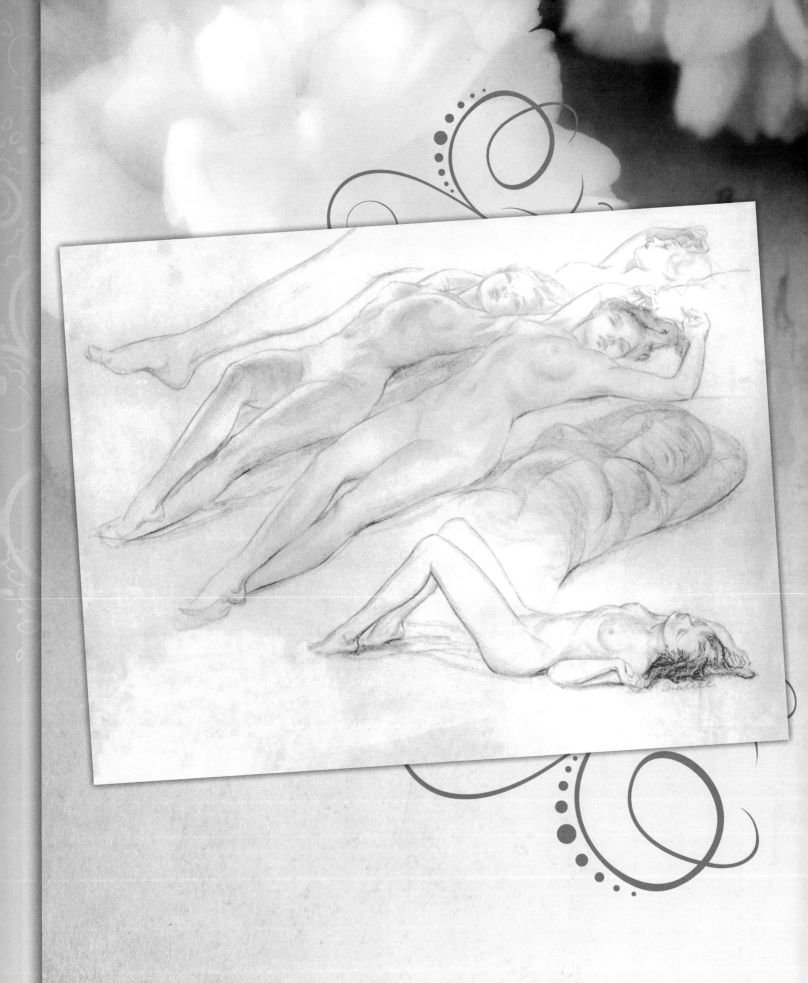

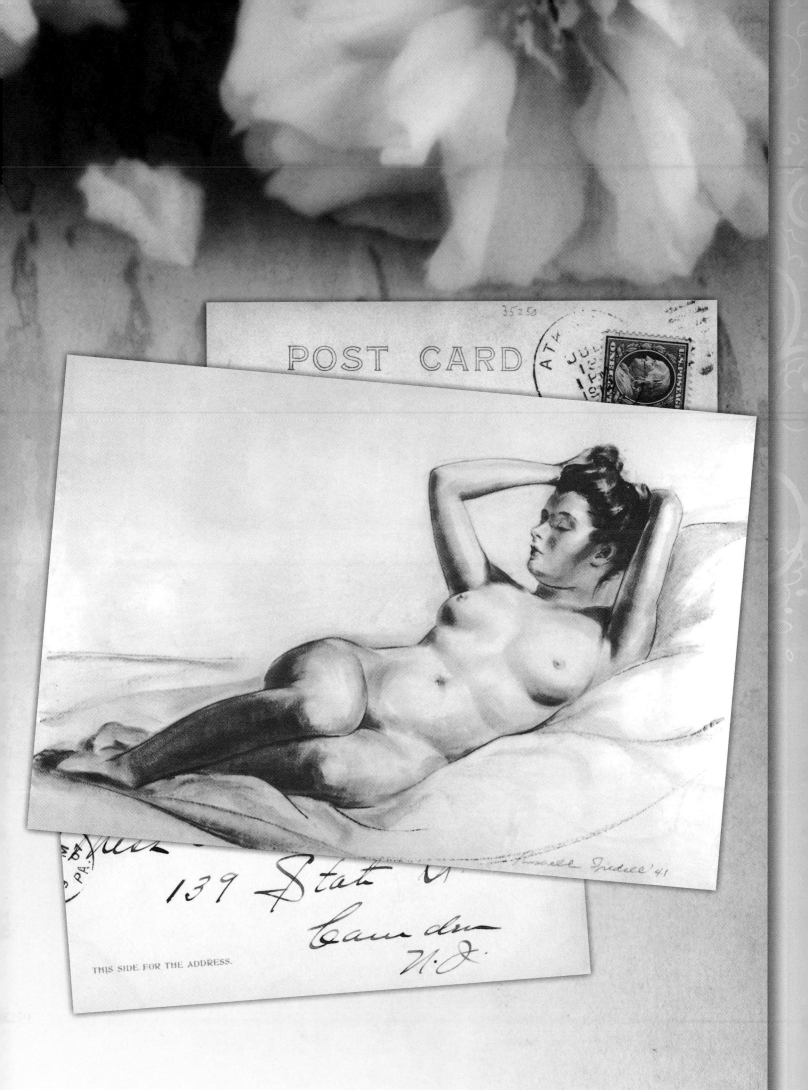

POST CARD

THIS SIDE FOR THE ADDRESS.

139 State

Camden

N.J.

Sitting Poses

The curve formed by the arms helps denote action, and the vertical line of the back is accented early to create a fixed line. The faint lines from the elbow to the knees help locate their relation to the action.

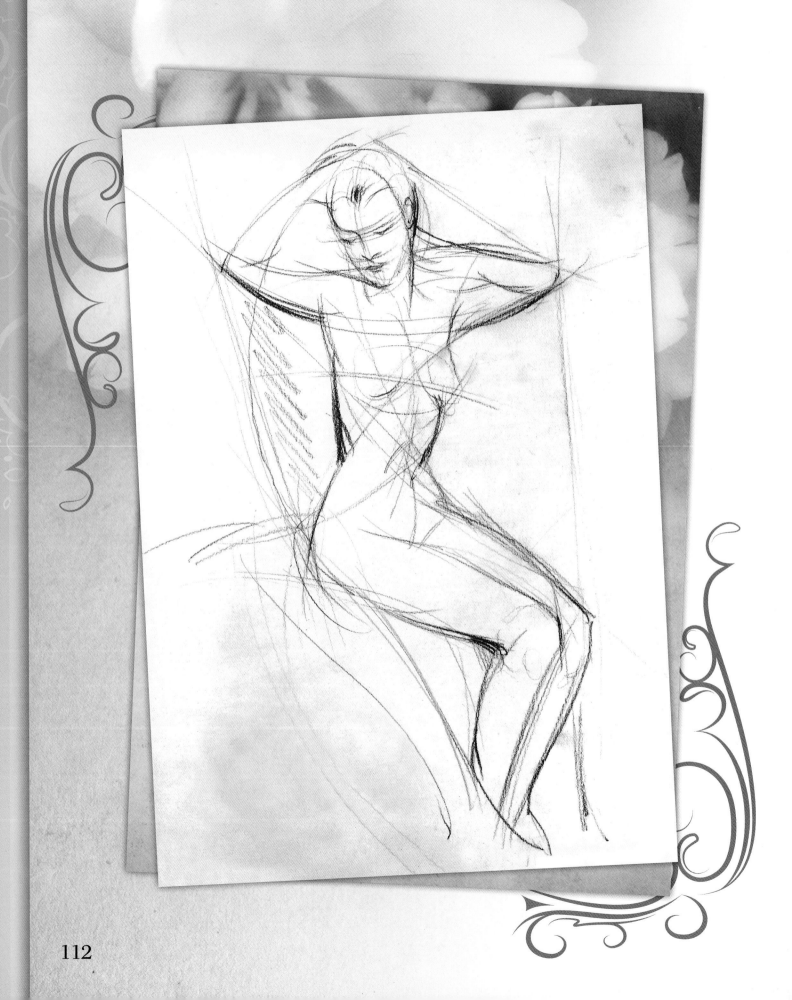

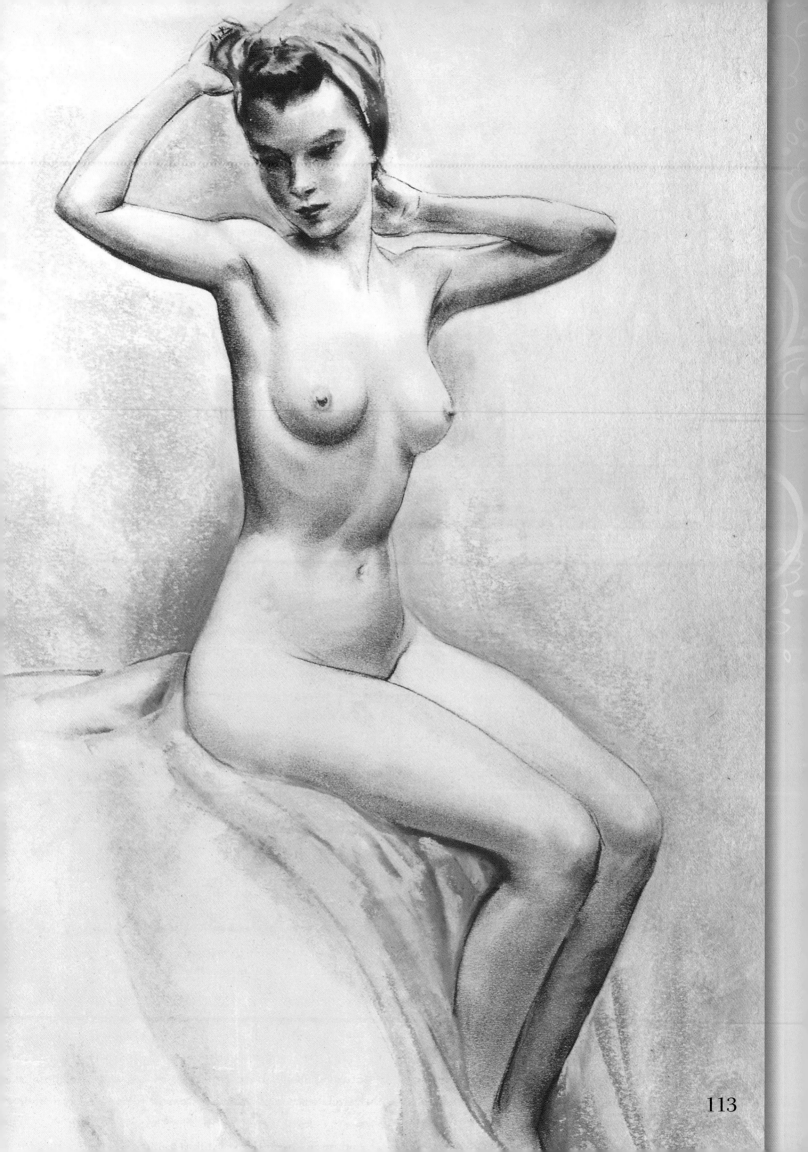

As your drawing progresses, check your proportions and correct them as necessary. While drawing in one place, be conscious of other related points, particularly where bones are near the surface. The collar bone, shoulders, elbows, hips, knees, and ankles come in pairs, so it's helpful to draw each pair together. Squinting your eyes can help you distinguish the larger forms even better. Draw the shape of strong shadows and furnish them quickly with a tone.

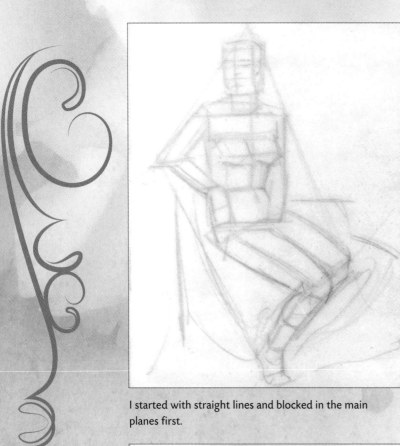

I started with straight lines and blocked in the main planes first.

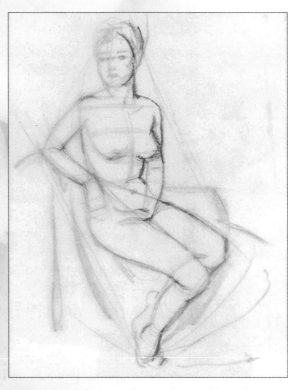

I then replaced the severe lines with curved lines that carry through into other forms.

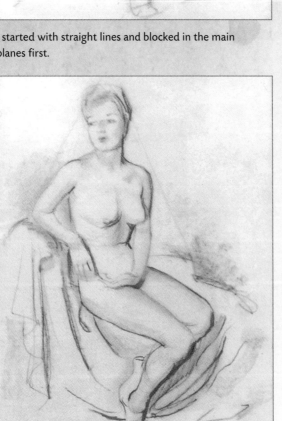

Here I accented shadows and other important lines; then I added a middle plane.

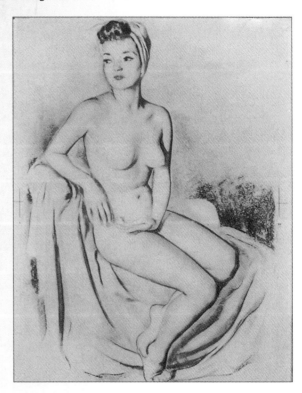

Near the finish, I added a third tone and indicated reflected light in the shadows.

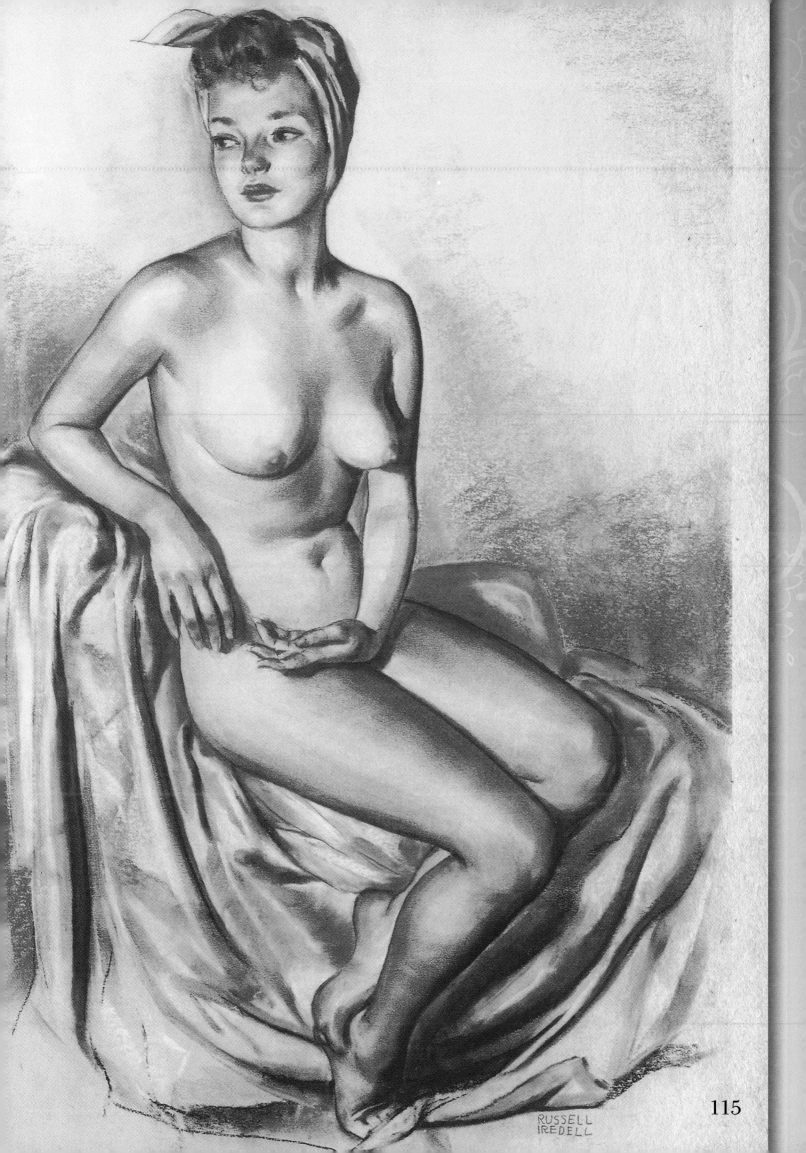

RUSSELL
IREDELL

This pose is a fine example of a classic seated composition. It requires nothing more than a poised model and a loosely draped sitting area.

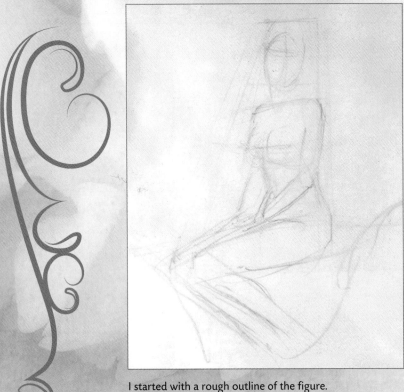

I started with a rough outline of the figure.

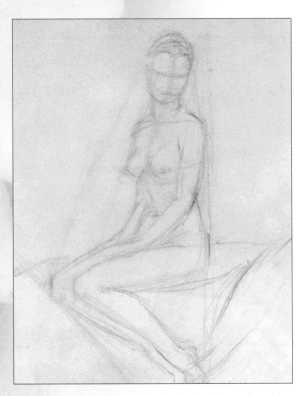

I added a strong horizontal line to the back to anchor the figure into the frame.

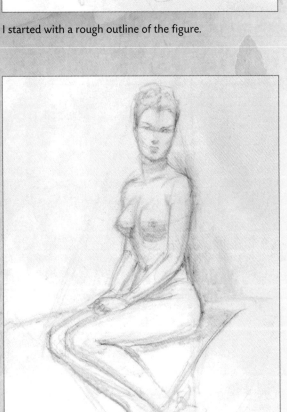

Here I started to rough in the details.

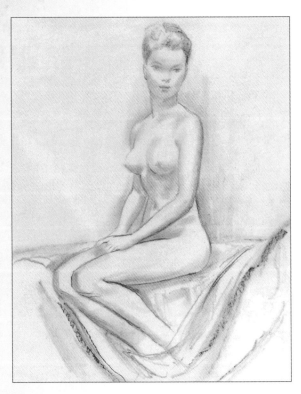

I began to accent lines in colored pencil, and I used pastel tones for the planes.

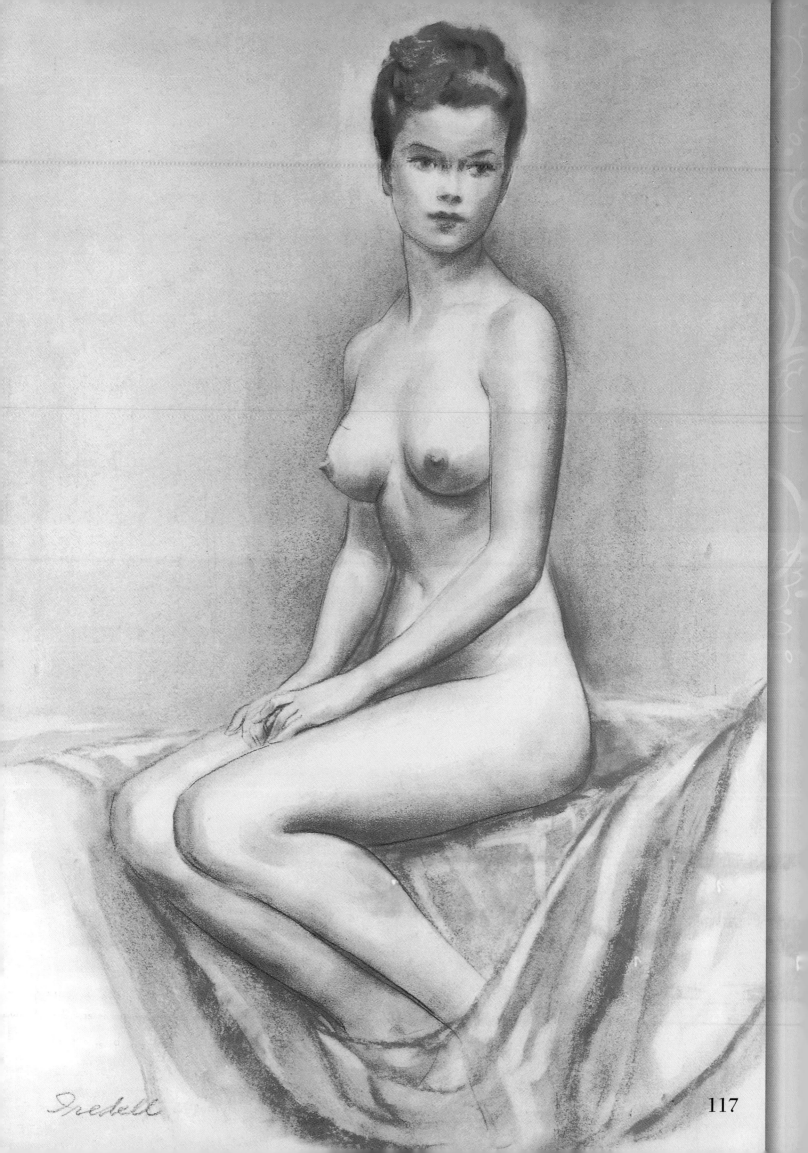

Iredell

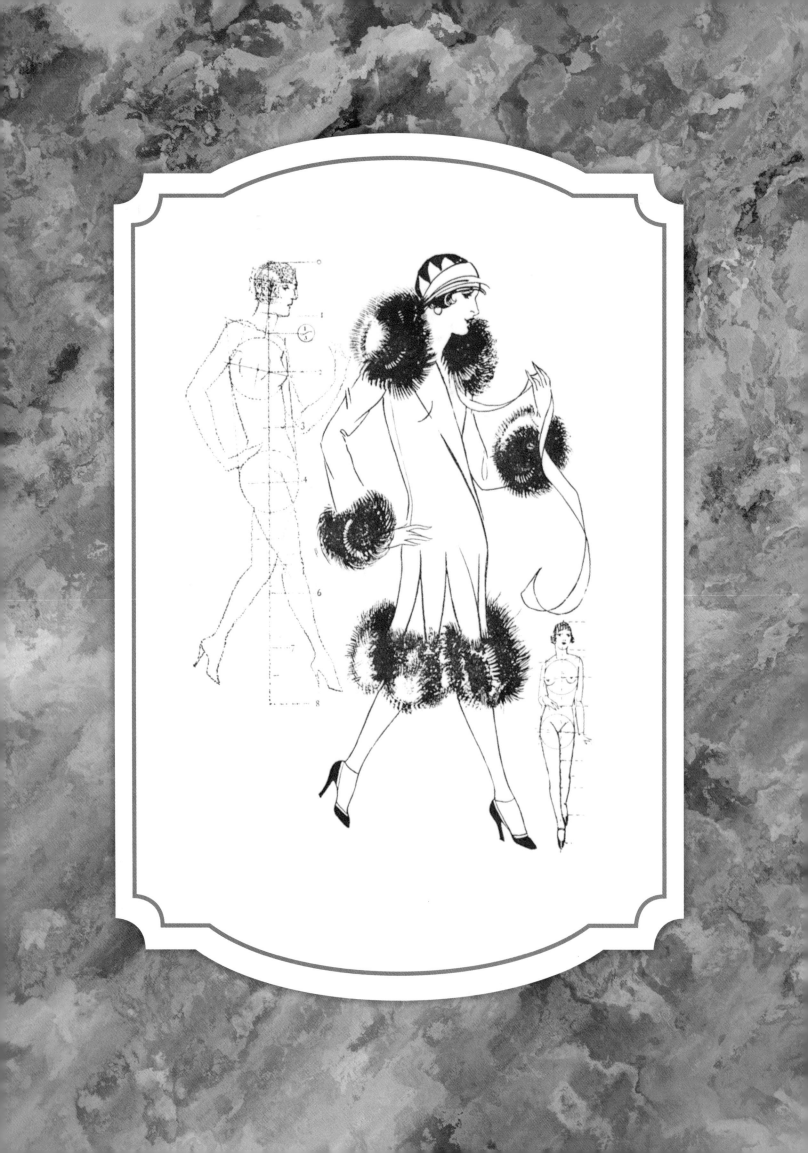

Chapter 7: Vintage Art Gallery How to Draw the Figure

with Walter T. Foster

The art contained on the following pages is from deep within Walter Foster Publishing's archives. Date stamped December 3, 1926, the art in this featured gallery comes from a package of templated charts with diagrams that Walter T. Foster created as a means of teaching others how to draw. He called his personalized method of instruction the "W.T. Foster System of Teaching Commercial Art and Cartooning," which, according to the packaging, "eliminates guesswork, giving you the proportions of the head and figure in any position or action, which takes years of study to accomplish under present methods." Walter sold the charts for ten cents each or 12 for one dollar, and he even welcomed phone calls "between 4 and 8 p.m." from those desiring more direction.

Various Poses

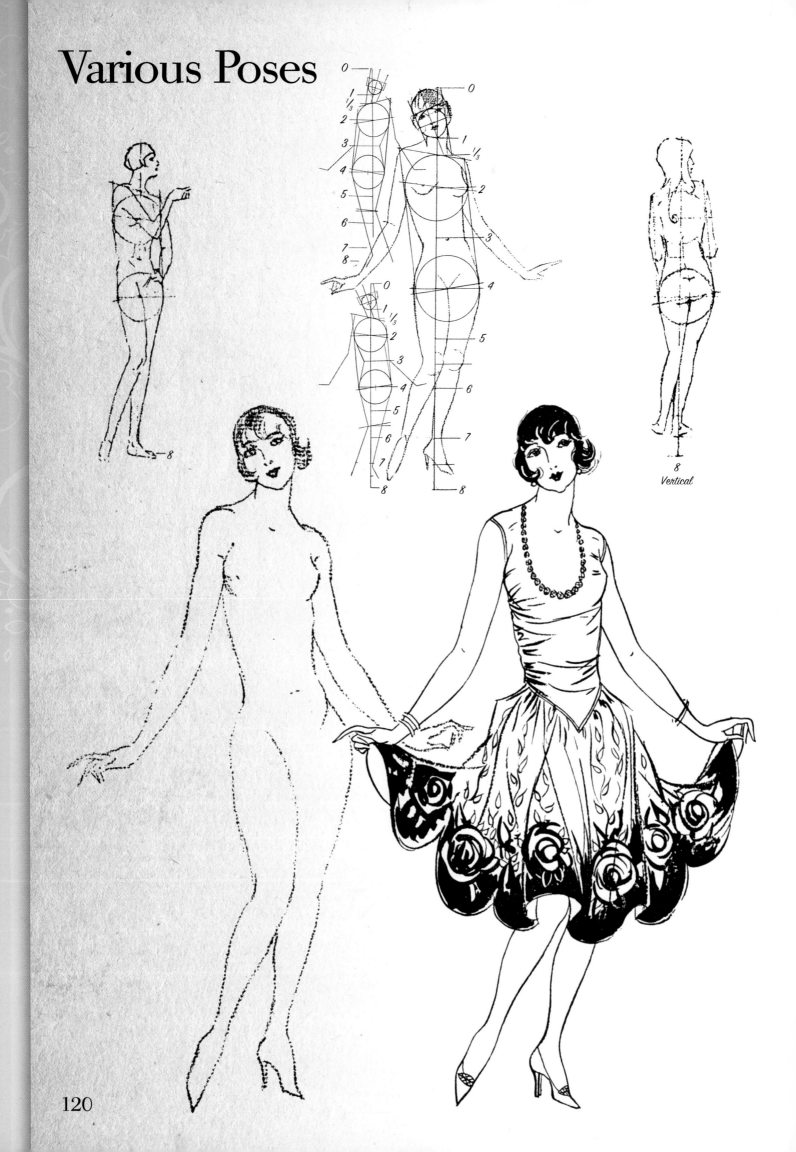

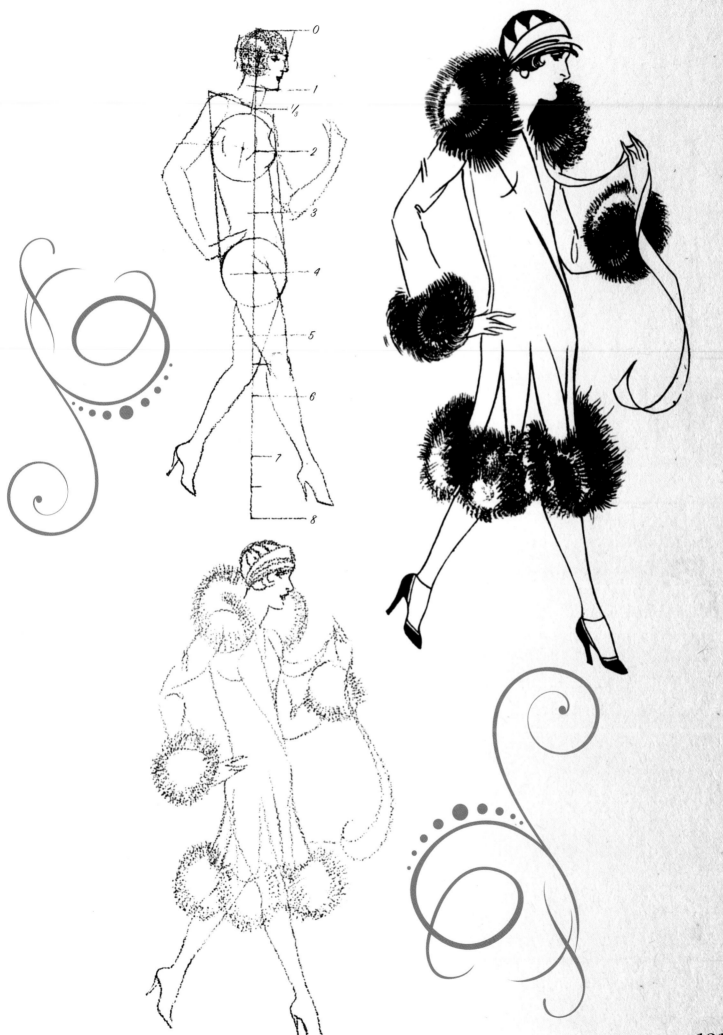

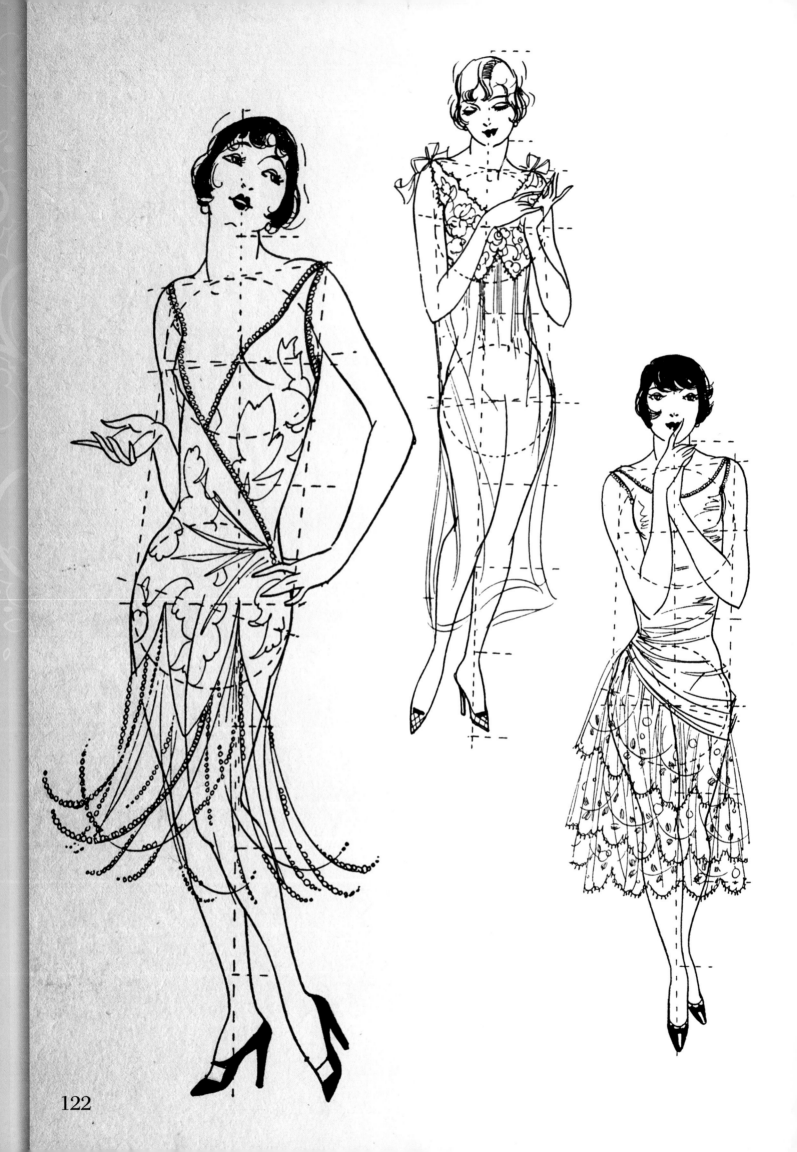

122

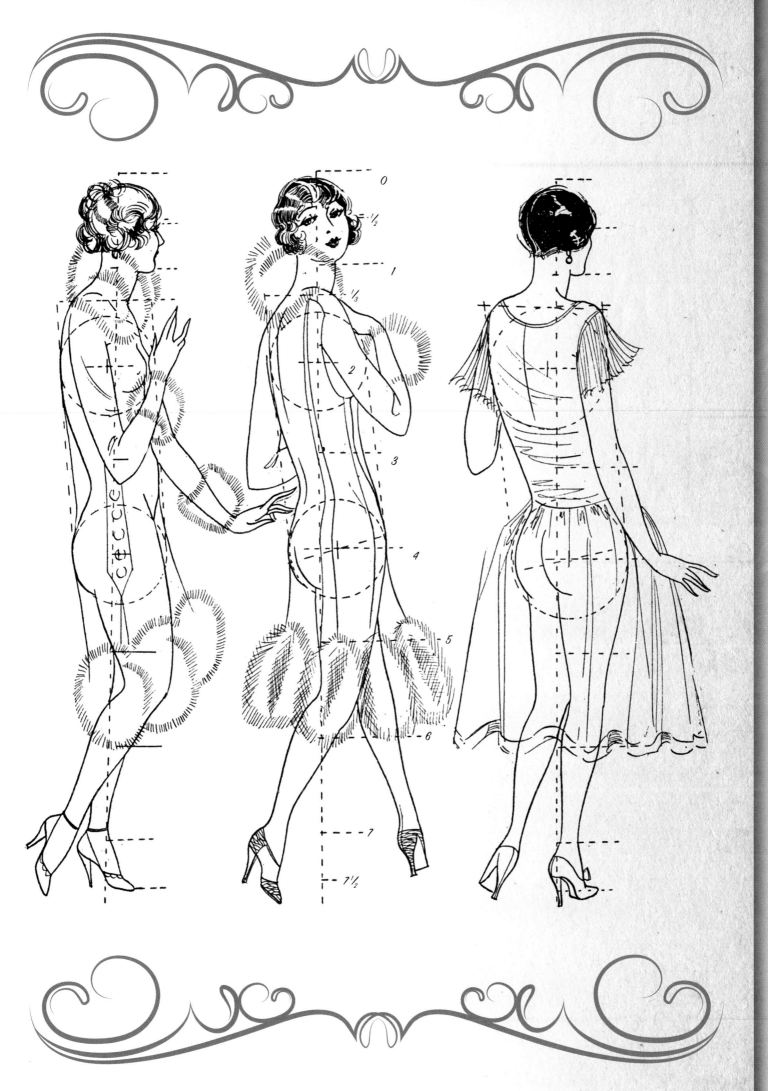

Finished Fashion Illustrations

The original chart says that the "fashion illustrations shown here are made by different artists to show you a variety of techniques and styles of drawings used, the majority being made by New York and Chicago artists."

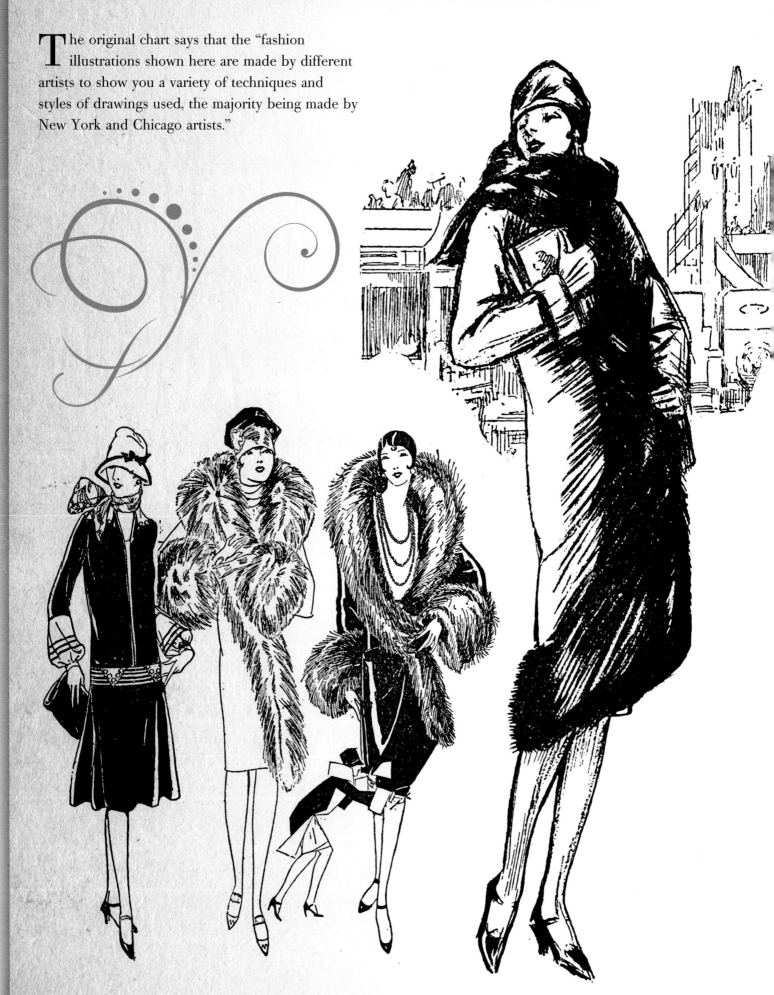

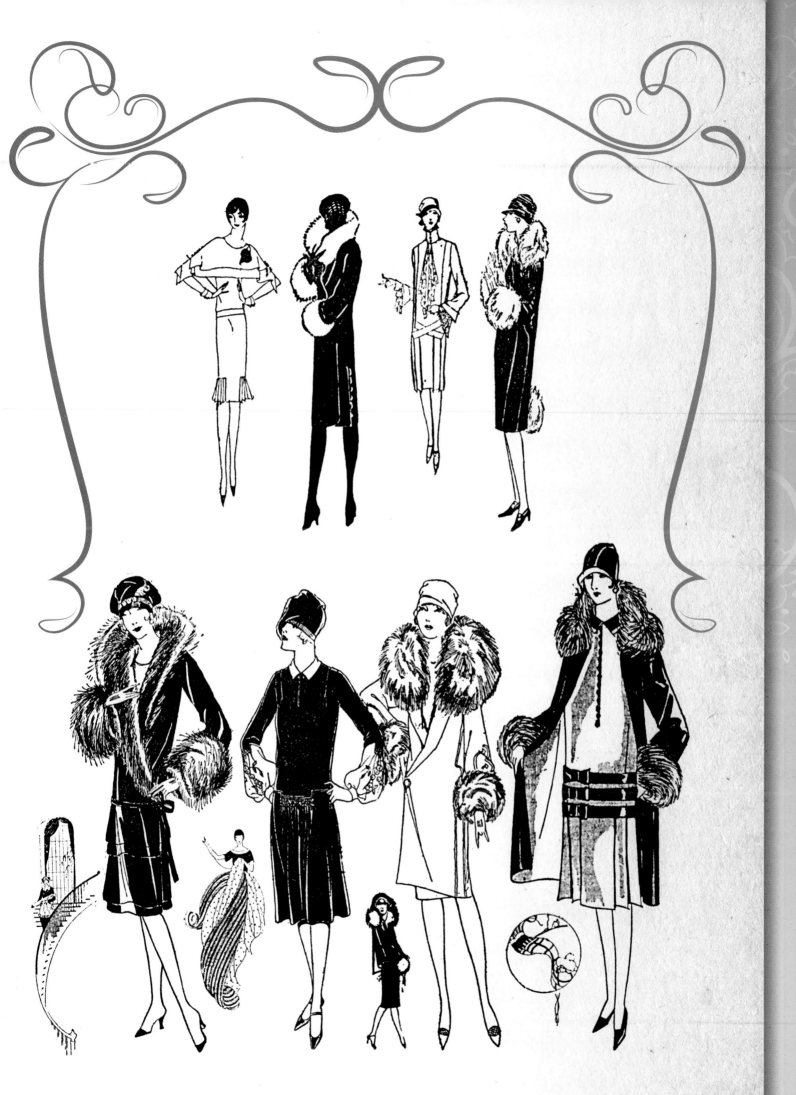

Finished Heads & Faces

According to the original chart, the faces featured in this gallery are "a few heads made by students using the W.T. Foster System of Teaching Commercial Art and Cartooning."

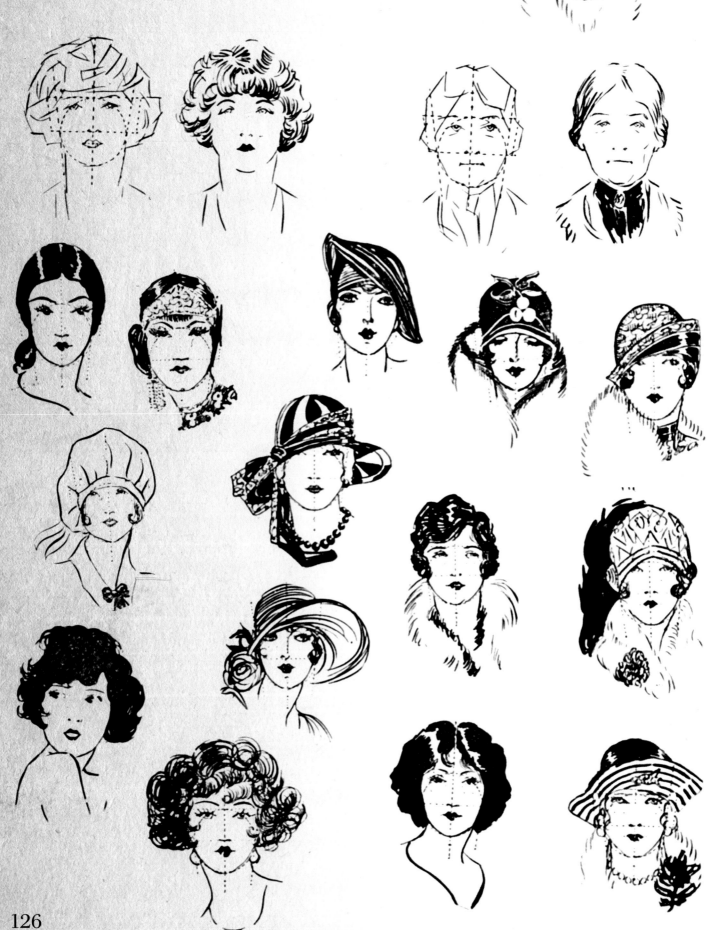

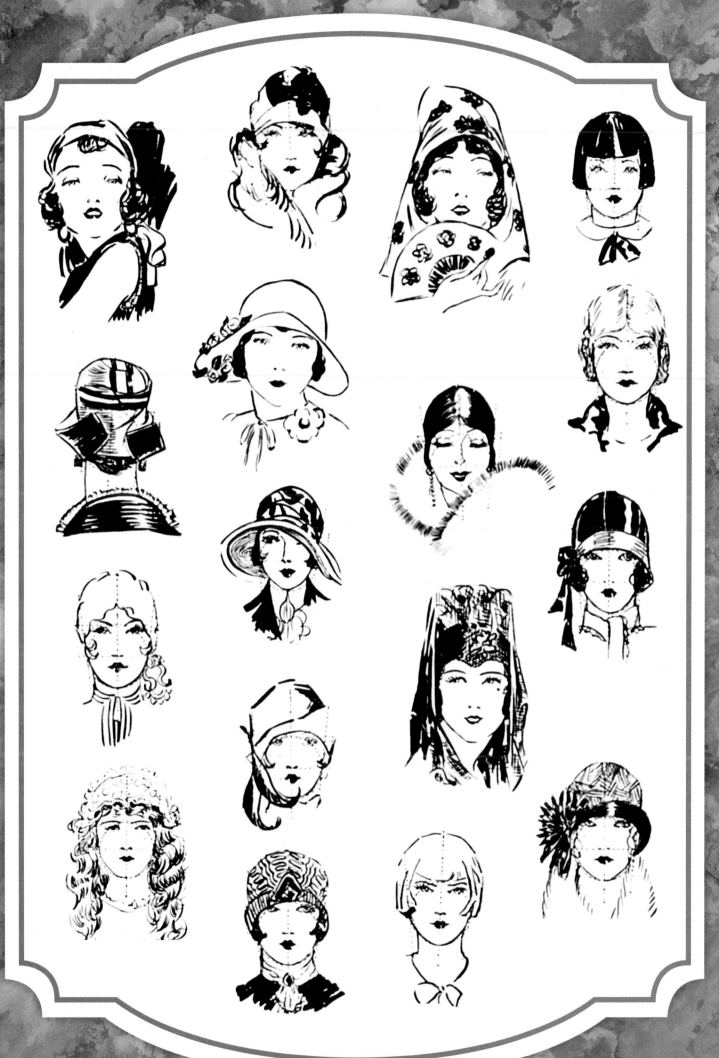

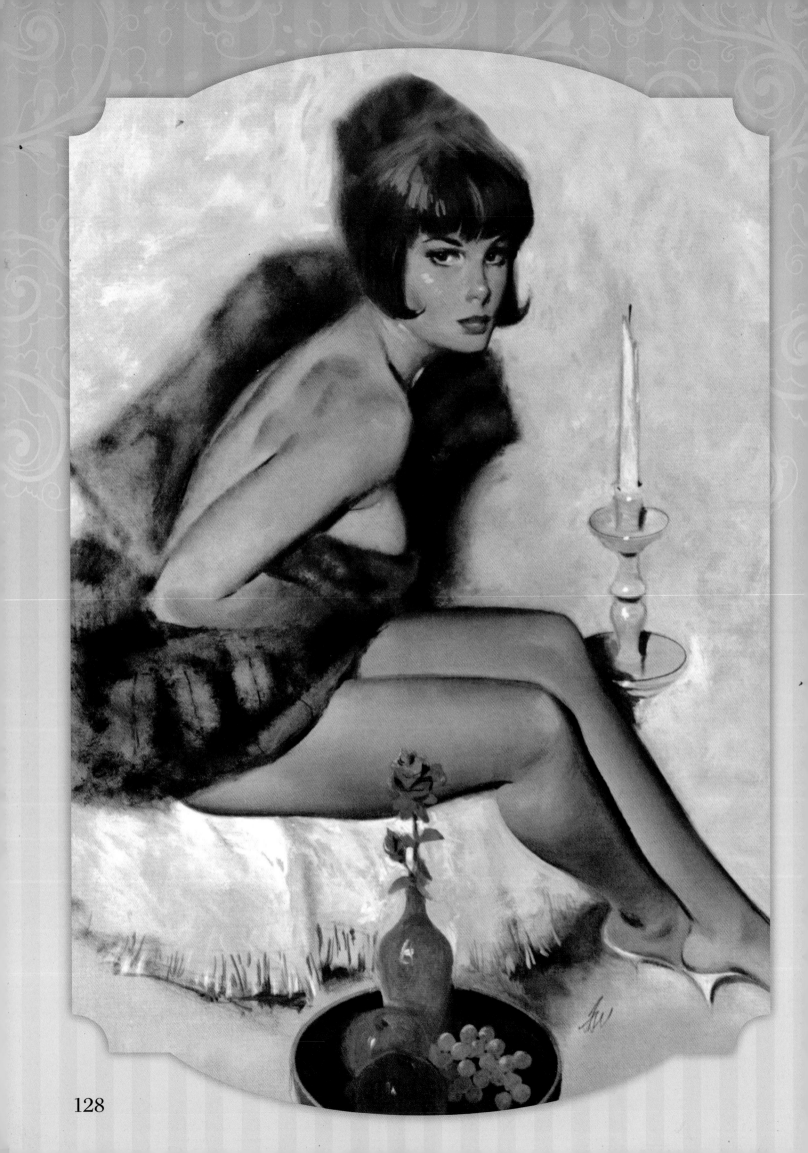